Digital Capture After Dark

Amanda Quintenz-Fiedler
Philipp Scholz Rittermann

Digital Capture
After Dark

rockynook

Amanda Quintenz-Fiedler, Philipp Scholz Rittermann

Editor: Joan Dixon
Copyeditor: Aimee Baldridge
Layout: Petra Strauch
Cover Design: Helmut Kraus, www.exclam.de
Printer: Tara TPS through Four Colour Print Group, Louisville, Kentucky
Printed in Korea

ISBN 978-1-933952-66-6

1st Edition 2013
© 2013 Amanda Quintenz-Fiedler, Philipp Scholz Rittermann

Rocky Nook, Inc.
802 E. Cota Street, 3rd Floor
Santa Barbara, CA 93103

www.rockynook.com

Library of Congress Cataloging-in-Publication Data

Quintenz-Fiedler, Amanda.
 Digital capture after dark / Amanda Quintenz-Fiedler, Philipp Scholz Rittermann.
-- 1st edition.
 pages cm
 ISBN 978-1-933952-66-6 (pbk.)
 1. Night photography. 2. Photography--Digital techniques. I. Rittermann, Philipp
Scholz. II. Title.
 TR610.Q56 2012
 778.7'19--dc23
 2012026409

Distributed by O'Reilly Media
1005 Gravenstein Highway North
Sebastopol, CA 95472

Table of Contents

Authors

Amanda Quintenz-Fiedler is a writer, photographer, and educator. She is a regular contributor to such publications as *Rangefinder, Digital Photo Pro,* and *Photographer's Forum.* She is the author of *Ten Photo Assignments* and co-author of *Capture: Digital Photography Essentials,* both published by Rocky Nook. She has shown her photographs at group exhibitions around the country and continues to create work in both digital and analog media, focusing on concepts such as modern attitudes, personal demons, and stunted dreams.

Quintenz-Fiedler teaches in several colleges in the San Diego area, holds workshops, and lectures on the arts of photography and writing. She lives in Carlsbad, CA with her beloved husband, Steve, and cherished son, Connor. Her photographic work can be viewed at *amandaquintenz.com*

Philipp Scholz Rittermann's work spans opposite ends of our environment, from nocturnal scenes of industry to views of pristine landscape. His work is held in over one hundred public, private, and corporate collections, including MoMA, New York, and the Bibliotheque Nationale in Paris, France. Scholz Rittermann exhibits in national and international venues, and was honored with a mid-career survey at the Museum of Photographic Arts in San Diego, which published the monograph *Navigating by Light.* He has been teaching photography for over thirty years in the U.S. and abroad.

In 2011, the Museum of Contemporary Art San Diego exhibited large-scale photographs from *Emperor's River,* a new multi-year project he has been conducting in China.

Scholz Rittermann is represented by Scott Nichols Gallery, San Francisco, CA, and can be contacted at info@rittermann.com. His work can be viewed at *rittermann.com*

Contributors

Kevin McCollister was raised in Cleveland, Ohio, and worked for several years as a deckhand on the Mississippi River. He later lived in Boston, Massachusetts where he studied film and drama at Harvard Extension. Employed by the Writers Guild of America, he has lived in Los Angeles for more than two decades. McCollister's book of photographs, *East of West LA,* is available through IFSF publishing, and his continuing work can be viewed at *eastofwestla.com*

Michael Penn is a self-taught photographer who focuses his lens on Philadelphia and New York City. Preferring to photograph at night, he feels the senses come alive when the sun goes down. Using compact cameras, he can go undetected when capturing the city streets. His work can be viewed at *michaelpennphotography.com*

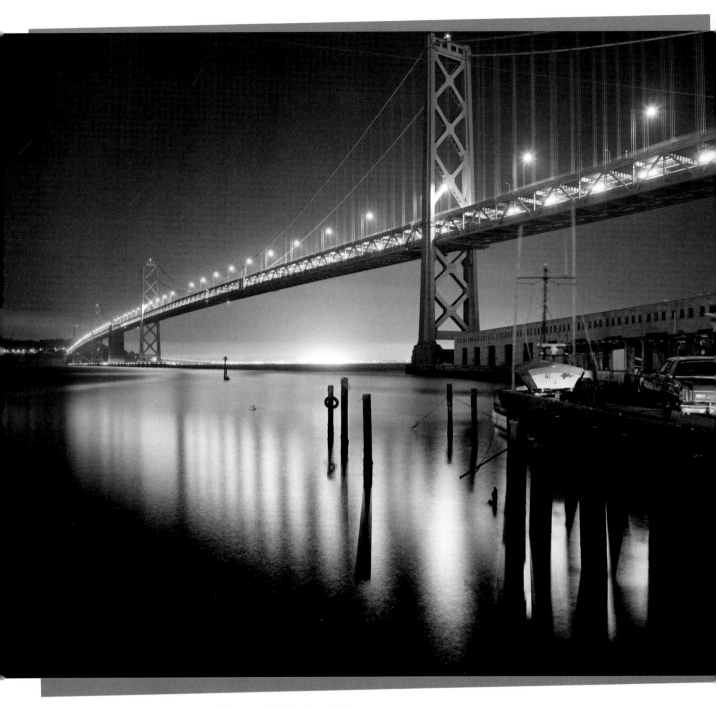

Bay Bridge, San Francisco, California © *Philipp Scholz Rittermann*

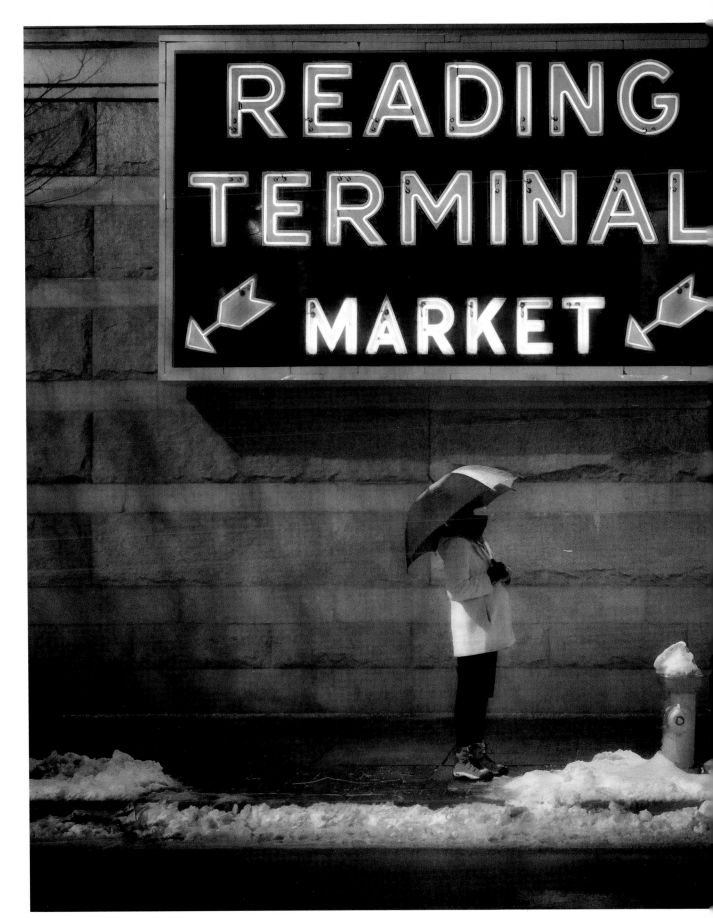

About This Book

THIS BOOK IS A COMPILATION of the night and low-light photographic experiences and techniques of Philipp Scholz Rittermann, Kevin McCollister, Michael Penn, and Amanda Quintenz-Fiedler. As each of these four photographers approach night and low-light photography differently, the challenge for writer Amanda Quintenz-Fiedler was to put together a comprehensive text that encompassed as much cumulative knowledge from these talented photographers as possible.

The result is presented as a variety of techniques regarding equipment choice, technical approach, subject matter, and production practices. In the later chapters, specific attention was given to world-renowned night and low-light photographer Philipp Scholz Rittermann's post-production techniques. Mr. Rittermann also provided the lovely foreword to the text.

Photographers Michael Penn and Kevin McCollister provided an array of images and communicated their practices to Mrs. Quintenz-Fiedler so that she could include their approaches in the book.

Mrs. Quintenz-Fiedler then compiled the knowledge, images, screenshots, and technical practices of each contributor to create *Digital Capture After Dark*. It is their intention that your night and low-light photographic experiences be enhanced by this information, and that your enjoyment of this book will be enhanced by the beautiful images within its pages.

and factories; car headlights and taillights, construction sites, billboards — and the list goes on. In fact, the world's urban centers are lit with so much electric light at night that they are clearly visible from space. All of these light sources can create complex reflections and strange, sometimes multicolored, shadows. Add atmospheric conditions like clouds, rain, snow, fog, or smog, and you have a nocturnal world full of possibilities for photographic exploration.

Foreword by
Philipp Scholz Rittermann

THE WORLD IS DIFFERENT AT NIGHT, and so is our mental state. For the most, part our circadian rhythms direct us to be busy during the day and to rest at night. But throughout history, many artists, writers, and composers created some of their most profoundly moving works at night. Perhaps this is possible because the pressures and distractions of the day fade with the setting sun, allowing the mind free rein to wander, to imagine, and to see things differently.

This altered state of mind is what makes exploring nocturnal surroundings so interesting. On an instinctive level, leaving illuminated surroundings and stepping into a world of shadows takes us out of our comfort zone. Everything looks different at night. Our imagination kicks in, filling in what we can't see, making up scenarios, and anticipating what might be out there, just beyond the recognizable.

In my early 20s, I saw a film called *The Third Man,* a film noir classic. The dramatic shadows of people that were cast on walls, the edges of lit faces, and the silhouettes of shadowy figures lurking in the background fascinated me. At the time, I was living in northern Germany. It was winter, the days were short and gray, and the outside world looked oppressively dull and murky. But at night things changed. Industrial areas and everyday neighborhood streets, which I hardly noticed during the day, suddenly looked dramatic, like the sets in a noir movie. Bridges with lights ablaze, arcing over deep shadows; reflections of railway tracks or water glistening beneath them; backlit silhouettes of bare trees; smoke stacks and steam vents—all became irresistible subjects for me. Nighttime made a wealth of mysterious stuff appear practically right outside my door. The same dull surroundings I had dismissed as having no visual interest during the day transformed into an arena of great visual promise at night.

As I started photographing, I also began looking at the night photographs of Brassaï, Andreas Feininger, George Tice, and others, and realized there was a plethora of nocturnal imagery out there. It was exciting to realize that there were indeed others who thought photographing at night was a worthwhile pursuit! So began an enduring nocturnal exploration which has led me through natural, urban, and industrial landscapes, using long exposures, experimenting with movement, and painting with light.

If you have ever camped out in the wild, be it desert or mountain, plain or coast, you probably noticed that all of your senses were heightened, especially after sunset. Your senses of smell, sight, and hearing were keen; you were on alert. Peering into the gloom surrounding your campsite, you may have tried to make out shapes in the dark and gauge distances. Maybe you were lucky to be camping under a clear sky, with a full moon, far from city lights. Perhaps the moon was so bright you could almost see color in the landscape, almost...

Night transforms urban settings as well. Instead of the sun—that single orbiting light source during the day—urban and industrial landscapes are littered with light sources at night. There is lighting for streets, security, and traffic control; homes, office towers, airports,

Part I: Preparations

GO OUT AND BE A PHOTOGRAPHER. That's what we want you to do. When the sunlight fades and the artificial lights come on, we want you to explore, engage in, discover, and capture the world around you. Getting out there and trying different things to photograph your vision is the most important step in learning. And sometimes, taking that leap with camera in hand when you have no idea what you're doing can be the most meaningful, educational, and rewarding of experiences. When you try something new, each time you fail, you get that much closer to success.

So, first and foremost, get out there and start making an effort! Don't just stand around and overanalyze the process. We are here to help you, but getting away from the theoretical and showing up at the shutter is the only way to progress. You will learn from anything you point your lens at.

That being said, we do intend to help you hone, craft, and perfect your own technique with a series of helpful tips about the type of equipment you should invest in, various settings to look for, and knowledge that will help you with digital low-light photography. Also offered is a list of caveats, things to avoid, and what to be aware of while you are getting out into the world of night photography.

The contributors to this book have a variety of approaches and styles that will open your eyes to the possibilities. Whether you want to stalk down alleys with a point-and-shoot in hand like Kevin McCollister, get to know the living and breathing city of your birth like Michael Penn, create multilayered, vibrant composite images with your DSLR like Philipp Scholz Rittermann, or try a bit of everything like Amanda Quintenz-Fiedler, this book should help you on your way.

This first section is geared toward the preparations you will ultimately need to make, but don't think all of these ducks must be in a row before you take the plunge. Many of these tips and tricks will help you more after you have started to swim, and getting your feet wet is the most important step.

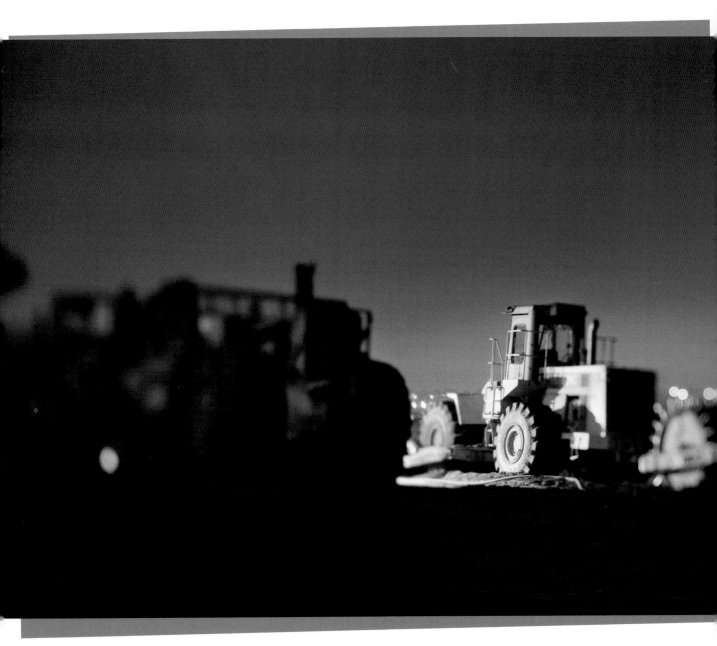

Earth Movers, Carmel Valley, San Diego, California © Philipp Scholz Rittermann

Chapter 1
Equipment

1.1 Introduction

The goal of this book is to help you unleash your imagination by stepping out of the day and into the night. The world that opens up to you at night can be spectacular and mysterious, and it can also present many photographic obstacles and pitfalls. This chapter should help prepare you for your first sojourn.

If you are used to setting your camera's exposure mode to automatic, this is the first thing you will have to change. To photograph in the dark, you need to understand your equipment and work within the constraints of digital capture to circumvent the obstacles you are going to face between the possibilities you see and the reality of your equipment's capabilities.

In this chapter, we discuss camera equipment and how to go about choosing the various components you will need to photograph at night. Many digital cameras are up to this task, so you needn't purchase the latest, nor the most expensive, model. Besides your camera, start gathering a toolbox of other equipment that will help you collect the images you envision. The following are points to consider when choosing your equipment.

1.2 Choosing a Camera

There are many affordable digital point-and-shoot and entry-level digital single-lens reflex (DSLR) cameras on the market today. To help make sense of the wide assortment, you can educate yourself about the performance of different makes and models by reading camera reviews on websites like dpreview.com, imaging-resource.com, and many others. These sites archive their reviews, which provide information about older models if you are shopping for used equipment. Sometimes buying last year's model will meet your needs and save you some money, which can be put toward the purchase of additional equipment, such as a suitable lens or a tripod.

The following section includes some of the elements you should consider while you research and purchase your night photography camera, but of course you should also consider your personal constraints and needs along with the recommendations we make here. Use this as a guide to put together your first functional night photography system.

Handling and Ergonomics

One of the most important considerations in choosing a camera for photographing at night is how well it handles in the dark. This may seem like a common sense statement, but it can often be overlooked when you are searching for a new camera system, especially if you are looking primarily online and not interacting with your potential purchase in a hands-on environment.

Generally speaking, DSLR cameras are larger than compact cameras and have better ergonomics, making them easier to operate in the dark. The larger the controls are, the easier they are to manipulate without light or in other

Figure 1-1:
Dusk Skyline,
French Concession,
Shanghai, China
© Philipp Scholz
Rittermann

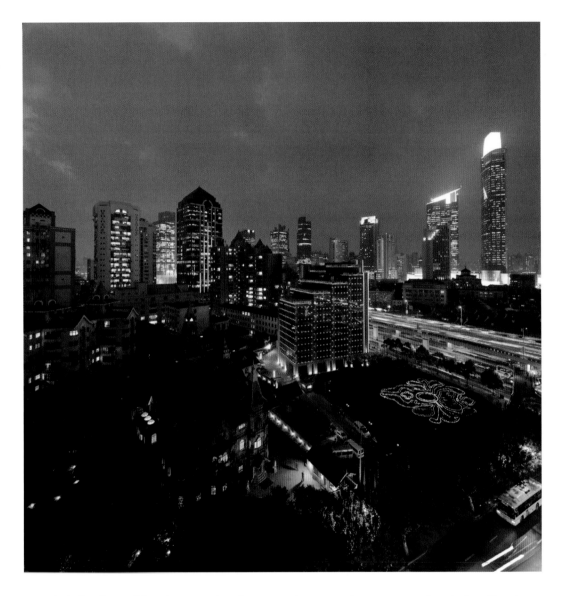

expected situations—like when wearing gloves. But smaller point-and-shoot cameras can be more surreptitious and subtle, so depending on where you want to go and the type of photograph you are hoping to capture, that might be the way to go.

When you are looking for a camera, we suggest that you get out to a camera store and feel the prospects with your own two hands. Ask yourself some simple questions: Are the controls easy to find and use? Can you easily

change modes, menus, and controls without having to hunt for the information? Do you like the feel?

Consider buying your new or used camera from a reputable store. There are advantages to a brick-and-mortar business when it comes to honoring warranties, providing guidance in using your equipment, and helping you find compatible pieces of equipment for your night photography kit, all of which may make a slightly higher price worthwhile. If no store is available

in your area, consider renting before you buy a pricey lens or camera. Online businesses like lensrentals.com, borrowlenses.com, or thelensdepot.com may have what you are looking for.

Ultimately, how you interact with your camera can make or break your first night photography experiences. The last thing we want is for you to become frustrated early on because of a poor or hurried equipment choice. Take your time to evaluate your purchases! You will benefit greatly from having the right equipment in your hands.

Viewfinders/Live View

One of the most interesting things about night photography is gathering information you *can't* see naturally, thereby creating new and unusual versions of your surroundings. In the dark, it is difficult to rely on what your eye sees through the viewfinder to make the right choices about composition and lighting. Because of this constraint, the more you can see through the viewfinder, the better your chances of creating the image you desire.

DSLRs have far better viewfinders than compact cameras. Composing an image in the dark is tricky enough, which makes having a good viewfinder even more important. When shopping for a camera, pay close attention to how well you can see through the viewfinder, especially if you wear glasses. An additional benefit of DSLR viewfinders is that they are designed to display information about important camera settings right in the viewing window so you can make adjustments while composing your view, without having to take your eye away from the viewfinder.

Modern DSLRs have a live view function, which displays a preview of the scene you are about to photograph on the rear LCD of your camera. Much like the camera settings information you see when you look through the viewfinder, live view can be set to superimpose this

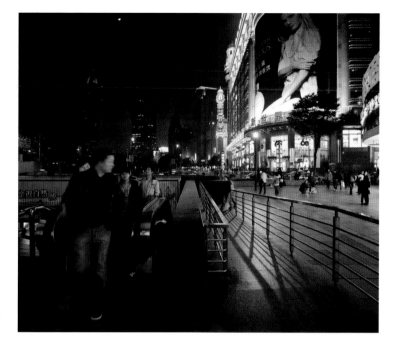

Figure 1-2:
Shoppers, Nanjing Rd., Shanghai, China
© Philipp Scholz Rittermann

information on the LCD. An additional useful feature is the ability to zoom in to your scene to help you accurately focus your lens. (We'll discuss more about the need for manual focus in chapter 2.)

Manual Controls

Most photography is accomplished during daylight hours or in well-lit studios and interior spaces. Cameras are primarily designed to handle well-lit conditions with ease and are generally not optimized for night photography. One of the most important characteristics of successful night photography is the ability to manually control your camera. Without the ability to adjust your camera manually—long shutter speeds, bracketed exposures, and manual focus, to name a few necessities—you won't be able to get the images you want, and this book will have limited applications for you. Automatic cameras, which don't have manual override capability, can certainly be used for night photography, but the results will be different and limited.

© Kevin McCollister

Manual Exposure Control

You must be able to set your own exposure times on your camera and override any automatic settings. Modern cameras try very hard to make your work easy by automatically metering your scene and determining appropriately averaged exposures, but with low-light and night photography, those algorithms characteristically fail. The timing of your exposures is the single most important function you must control, so your camera really should have this capability.

Long Exposure Capability

If you are interested in creating some of the more complex images discussed in this book, you will need to have the capability for long exposures. Even if your camera has manual exposure control, that does not necessarily mean that it can handle extremely long exposures. Most current DSLRs have long exposure capability. To capture images such as blurred motion or star trails, your camera should be able to keep the shutter open for minutes to hours at a time. This is achieved using the BULB or B setting, in combination with a cable release (see "Other Equipment" later in this chapter).

Some cameras have a built-in ability to make timed exposures as long as 30 or 60 seconds, but this is no substitute for the BULB setting. (The term *BULB* comes from the early days of the medium, when photographers made long exposures by squeezing and holding a rubber bulb that was connected to the camera shutter with a flexible hose. The shutter remained open for as long as the bulb was squeezed.) If your camera limits you to a maximum exposure time, such as 10, 30, or 60 seconds, your images will be vastly underexposed in a variety of shooting conditions.

DSLRs generally have a good manual interface for all important camera functions, whereas point-and-shoot cameras do not. When you are looking for a camera, be sure that you have the flexibility to choose as many functions as possible. Although some point-and-shoot cameras have some manual controls, be sure to evaluate their potential against the rest of the criteria listed here. In general, point-and-shoot cameras can be used for quickly snapped night images that are grainy and not perfectly crisp. There is certainly a place for those images, but if you want ultimate control, DSLRs are more capable of creating high-quality images at night.

There are several manual controls that you should consider.

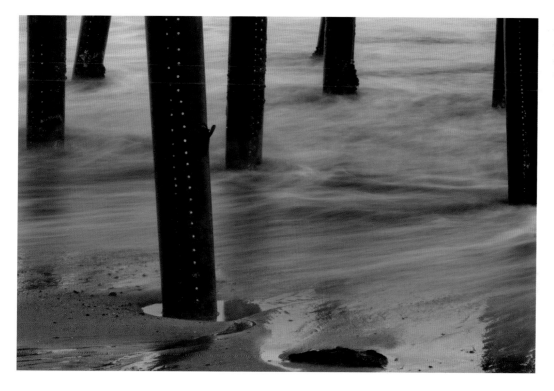

Figure 1-3:
*Under the Pier,
Sunset © Amanda
Quintenz-Fiedler*

Lens Interchangeability

Although you can start photographing at night with a camera body and just one lens, it is good to be able to upgrade as your photography progresses and more resources become available to you. Again, in this situation, a DSLR is the most versatile option for your new venture.

DSLRs are designed to be system cameras, allowing you to use a variety of different lenses with the same camera body—from wide angles to telephotos, in both primes and zooms.

Compact point-and-shoot cameras have built-in zoom lenses that are quite flexible, but they cannot be removed or replaced, so you are stuck with a specific focal length range and lens quality until you purchase a whole new camera system.

We will discuss other important characteristics of suitable lenses later in this chapter.

Sensor Size

The physical dimensions of, and the number of pixel sites on, an imaging sensor are critical to the quality and quantity of detail you can resolve in your images. The larger the physical dimensions of the imaging sensor, the cleaner the rendered image will be. Don't be misled by advertised megapixel counts in compact cameras. By necessity, these cameras have tiny imaging sensors that tend to be crammed with too many pixel sites. This leads to noisy images, especially when making long exposures as in night photography.

DSLRs have larger imaging sensors, which translates directly to higher image quality. Simply put, a 10 megapixel DSLR will deliver a far superior image in every respect than a 10 megapixel point-and-shoot camera, especially in low-light situations.

The recent emergence of mirrorless interchangeable lens cameras (MILCs) is worth

© Michael Penn

Sensor Signal-to-Noise Ratio

There is another important factor you should consider when choosing a camera for night photography—digital noise. This has nothing to do with how loud your camera's shutter is. It pertains to the signal-to-noise ratio of your camera's imaging sensor.

All electronic equipment has a base level of noise, much like the hum a stereo system emits when the volume is turned up but there is no music playing. When the signal is low (such as the dim light of a night scene), your camera requires a long exposure to record the image. The longer the exposure takes, the more the camera's inherent noise interferes with the low signal strength of the scene, resulting in grainy artifacts. As previously mentioned, there is a time and place for such images, and they can have a beautiful character and ambiance, but noise should be something you choose to work with, rather than something you are stuck with.

As mentioned in the discussion of DSLRs, large imaging sensors have better signal-to-noise ratios than small imaging sensors. There is also a direct correlation between improved noise performance during long exposures and modern sensors. Initially, digital camera manufacturers emphasized increased resolution (more megapixels) of the imaging sensors in their cameras. In recent years, however, the focus has turned to improving the noise performance, low light sensitivity, and dynamic range. The latter refers to a sensor's ability to record detail in highlights and shadows. This is an important consideration in all kinds of photography, but it is critical for the high-contrast situations often encountered at night.

All of this means that you should carefully read reviews of the cameras you are considering for purchase. Pay special attention to the age of the technology they incorporate. The newest imaging sensors and onboard analog to digital converter (ADC) combinations will perform

mentioning here. Most of these cameras have larger imaging sensors than point-and-shoot cameras, but the sensors are still considerably smaller than those in full-sized DSLRs. To be fair, we should say that MILCs are a vast improvement over regular point-and-shoot cameras, and they are getting better all the time, but as of this writing DSLRs consistently outperform MILCs and point-and-shoot cameras when it comes to noise levels in low-light conditions and finer quality detail in the resulting images.

better in all three categories—noise performance, low light sensitivity, and dynamic range.

The following are some ways to minimize digital noise:

- Choose a camera with a large imaging sensor.
- Get a camera with a newer imaging sensor because it can handle noise better than an older sensor.
- Avoid underexposure (more on this in chapter 2).
- Use the camera's native ISO setting when possible (more on this in chapter 2).

Good Battery Life

Long exposures use up battery power. It's a fact of life. Long exposures made in cold weather shorten battery life even further. It is important that you choose a camera with good battery life, or buy extra batteries, or both. You don't want the battery to run down with the perfect image framed in your viewfinder. Bringing extra batteries with you is cheap insurance.

Mirror Lock-Up Feature

Mirror lock-up, which is useful for night photography, locks the mirror of your DSLR in the up position before making an exposure. When you use longer focal length lenses, the slightest vibration can cause your image to be blurred. The mirror lock-up feature allows the vibration caused by the movement of the mirror to subside before you make an exposure. If the camera you are considering has live view, this acts as a de facto mirror lock-up function. Live view is a standard feature in modern DSLRs, even in entry-level models, and as mentioned earlier it can help you establish focus in dimly-lit scenes.

Price

Unfortunately, all dreams must ultimately face the reality of pragmatism. As with most products, you get what you pay for, so the more expensive the camera, the more the manufacturer has dedicated time and effort on research, development, cutting-edge technology, and usability. What's good about getting a more capable camera is that it will serve your other photographic needs as well as the rigors of night photography. Be sure to take your time and exercise due diligence before you buy a camera.

If your budget is constrained, you may want to start with a reasonably priced, manually controlled point-and-shoot camera, though you will be losing out on some of the other functions we recommend for night photography. You will pay a premium for the compactness of an MILC while gaining nothing in terms of image quality over a DSLR, but if you already own an MILC, then by all means try it out at night and see if it performs well enough for your purposes.

Consider that the DSLR market is very crowded, which has forced the price of entry-level and midlevel cameras to drop considerably. Because it is hard to stand out in a crowded marketplace, every year camera manufacturers roll out new models with more features in an effort to outdo their competition. This has caused entry-level cameras to become packed with features that were available only in top-of-the-line models just a few years ago. And there is always the option of researching an older model camera to get what you need for a reduced price simply because there is something newer on the market, and stores, distributors, and other photographers may need to get rid of their inventory to make way for the latest and greatest equipment. This frenzied competition among camera manufacturers can easily work to your advantage.

Most recently, a new generation of MILCs has become available. These now have sensor

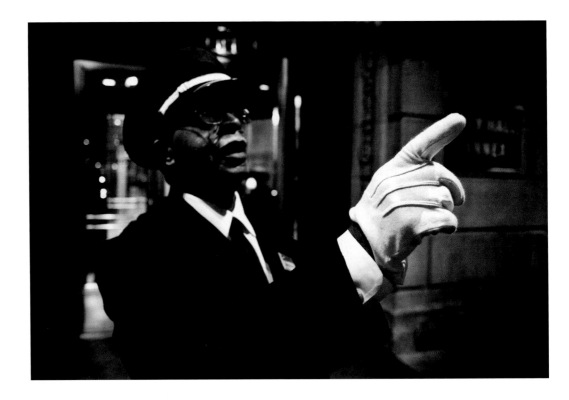

characteristics that are comparable to high-end DSLRs when it comes to image quality and signal-to-noise-ratio at high ISOs. Their compact sizes are appealing, but the range of available lenses is still limited. Moreover, their price tags are also comparable to high-end DSLRs.

1.3 Choosing Lenses

The next most important thing is to choose the right lens. If you have the best camera body on the market with a cheap lens attached to it, your images will only match the quality of the lens. The same applies to a fantastic lens on a poor digital camera body. Ultimately, your images will only be as strong as your weakest photographic link. With that in mind, you should consider a few things in choosing your camera and lens system so that your combined cost meets your overall budget and provides you with the best system you can afford.

Lens Speed (Light-Gathering Power)

The light-gathering ability of a lens is measured by the maximum aperture of the lens. Fast lenses gather more light than slow lenses. For example, an f/2.8 lens requires only half as long an exposure time as an f/4 lens to result in the same exposure. In other words, it is twice as fast. But fast lenses are pricey, and although they are nice, they aren't necessarily a must-have. Fast lenses are indispensable if you need to keep your exposures short, for example in surveillance photography. But for many situations we encounter in night and low-light photography, a high-quality, slower lens might be a better option.

The main point is for you to get started with basic equipment and add more sophisticated gear later, especially with the versatility of a DSLR camera, as mentioned previously.

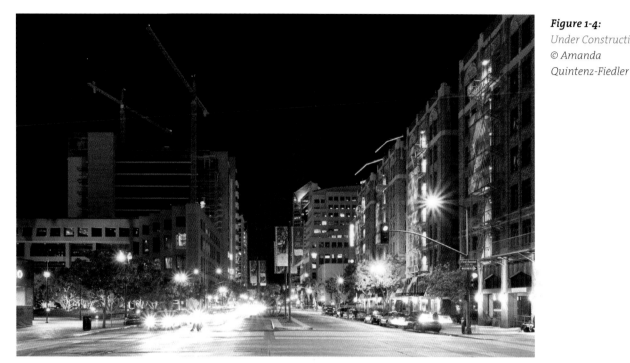

Figure 1-4:
Under Construction
© Amanda
Quintenz-Fiedler

Flare

Photographing at night will reveal how well a lens handles flare and reflections. Inexpensive kit zoom lenses that are packaged with camera bodies are especially prone to this problem. Stray light (e.g., a streetlight just outside the image area) striking the glass elements of a lens will bounce around inside the lens and cause unwanted reflections. These reflections are hard to spot in the viewfinder and even in images on a camera LCD display. Although there are strategies to minimize flare, which we discuss in chapter 2, we recommend that you evaluate how prone a lens is to flare before you buy it. As with digital noise, there are times when flare can enhance an image, but you should be in control of it rather than at its mercy.

The good news is that there are some very high-quality lenses that are also inexpensive. Fixed focal length lenses (referred to as prime lenses) are often less expensive than zoom lenses. Their construction is simpler, and although they don't offer the convenience of a zoom lens, they are usually sharper than a standard kit lens. Importantly, fixed focal length lenses are less prone to flares and reflections, and they are generally faster than zoom lenses. Fixed focal length lenses—such as a wide angle 35mm f/2, a standard 50mm f/1.8, or a telephoto 85mm f/1.8—are plenty fast, compact, and relatively inexpensive. These same focal lengths in f/1.4 or f/1.2 iterations cost much more, of course, and deliver only modest gains in light-gathering power.

1.4 Other Equipment

With night photography, you need some other elemental tools to ensure the best possible night and low-light photography. Although these elements are not as critical as your camera body and lens choices, good quality equipment will make your life, and your photography, easier.

Tripod

When you are making long exposures, perhaps for minutes at a time, even the slightest movement will interfere with the crispness of your images. Because of this, an important addition to your night photography kit is a sturdy tripod. Not all tripods are created equally. Stability and portability are both important and should be considered in that order.

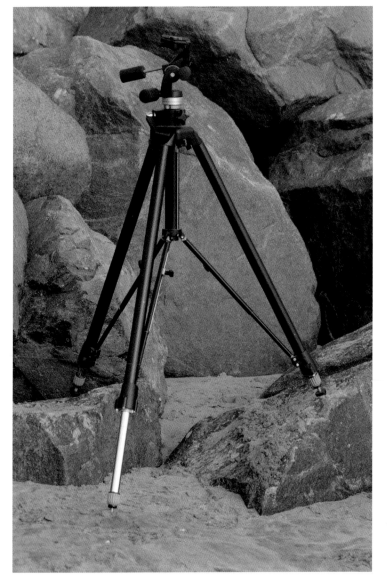

Carbon fiber tripods are very light and sturdy, but they can be very expensive. Aluminum tripods are just as stable, a little heavier, and much less expensive. Your budget will dictate what you can afford, but remember, what matters the most is how stable the tripod is, so don't skimp on your purchase.

The most stable tripods have round leg sections with friction-fit collars to tighten the legs.

We highly recommend that you get your hands on different tripods before you choose which one to buy, just as with cameras and lenses, so you can evaluate the fit and function. To choose a tripod, set it up to your typical working height; tighten the leg sections, the tripod head, and the column; and then gently apply side-to-side and up-and-down pressure to the head to see if it moves—it shouldn't! There may be some flexing, but it should be minimal. Most important, there should be no wiggling, creaking, or slipping—in other words, no play at all, because this translates to blurred images.

Many tripods have a center column, which allows the camera to be raised higher than the platform, which sits at the apex of the legs. This extension capability can come in handy, but it comes at the expense of stability. The slightest breeze can cause vibration, which will blur your images.

To ensure the greatest overall stability for long exposures, invest in a stable tripod that is tall enough to set your camera at a comfortable working height without having to raise the center column.

Figure 1-5: *This tripod, which was used while shooting many of the images in this book, is a Manfrotto studio tripod with a three-way head. Notice how the tripod can be easily stablized on uneven terrain.*

Another important factor to consider is that you might not always have the luxury of setting your tripod on a level surface. Tripods that allow you to set the legs at different angles and heights are useful for uneven terrain. Also, being able to set a tripod to a very low height is desirable. Low-angle points of view can be dynamic and dramatic.

Cable Release

Even the slightest movement or vibration of the camera during exposure will have a detrimental effect on an image. A cable release allows you to trip the shutter without shaking the camera, giving you another line of defense against a blurred final image. Consider buying a cable release that has a built-in timer (also called an intervalometer). You can find inexpensive cable releases with built-in timers from third-party manufacturers to fit most cameras.

To use a cable release properly, it should hang loosely between you and the camera, thereby avoiding the transfer of any vibrations from your hands to the camera. This is important for all long exposures, for capturing a series of perfectly registered exposures, and for capturing a series of exposures at regular intervals.

Lens Hood

Working with night and low-light photography is all about the interplay of highlights and shadows. Of course we want to capture the shapes, lines, and textures created by multiple light sources at night, but we don't want extraneous light sources to cause flares and distracting reflections in our images.

A lens hood shields the front of a lens from stray light and helps to prevent flares and reflections. The best lens hood for a particular lens is one made specifically for that lens by the manufacturer of that lens. This is especially true for lens hood designs made for zoom lenses.

The most efficient hood designs have a petal shape, which eliminates the maximum amount of stray light at different focal length settings.

Extra Batteries

As mentioned earlier, long exposures use up more battery power. If you use your camera's LCD screen frequently for either live view or reviewing your images, the battery life will further be shortened.

Although cold weather can provide wonderful visual opportunities, the cold can also shorten batteries battery life. In cold weather, keep extra batteries in a pocket close to your body so they stay warm.

To prepare for all sorts of unexpected situations, it's a good idea to take extra batteries for your camera and any other battery-operated devices you might have in your night kit.

Car Charger

The charger for your camera batteries probably uses household alternating current. Consider buying a small inverter that plugs into the 12-volt outlet or cigarette lighter in your car. Depending on what part of the world you live in, the inverter will turn your car's 12 volt direct current into 120 volt or 220 volt alternating current, which you can use to charge your camera, flash, and flashlight batteries.

Flashlight

Before you go gallivanting off into the dark you should remain aware of one important thing—the dark. To find your way around, you should have at least two flashlights with you for safety and for selectively lighting a scene, or painting it with light (more on that in chapter 8).

Clothing, Footwear, Food, and Drink

It makes sense to make the most of it when you go out to photograph. Sometimes it takes a bit of effort to carve out the time to escape the gravitational pull of home and work. So when you are actually out and roaming about, you will want to have everything you need to keep warm, dry, and energized to make good use of the time you have available. Sturdy shoes, rain gear, extra sweatshirts or jackets, snacks, a thermos of coffee or water, and other comfort items help make it possible to stick with it and maximize your time.

A Buddy and Mobile Phones

Depending on where you are photographing, it might be a good idea to bring along a buddy—someone who is patient and supportive. Make sure you have each other's mobile phone numbers and that your phones are on and fully charged. Your buddy can help pass the time during those long exposures, provide additional scouting help, and give you an added level of safety and security.

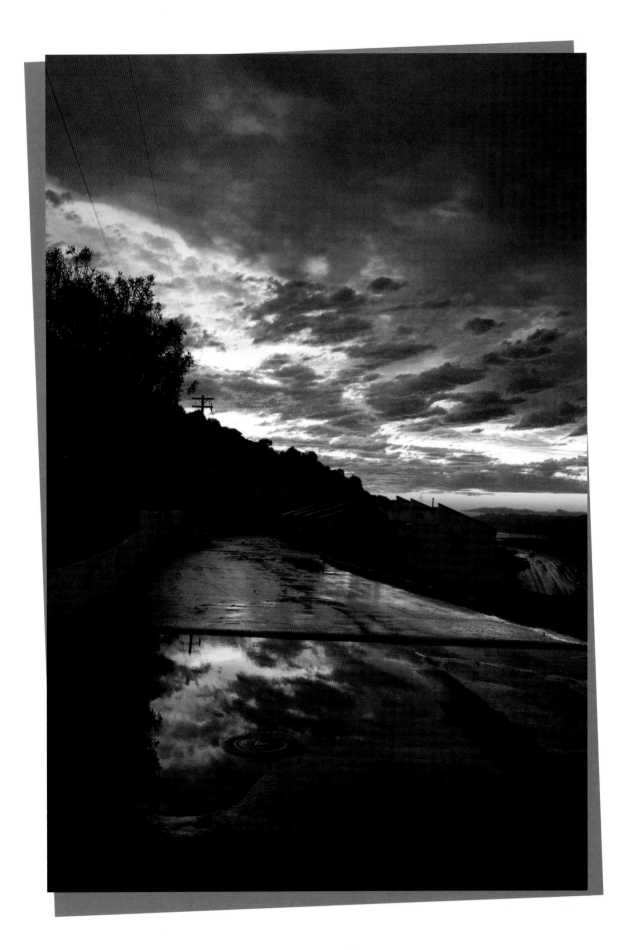

Chapter 2
Getting Started

2.1 Introduction

In the Foreword to this book, Philipp mentioned that there can be some interesting subject matter right outside your door. If you are new to photographing at night, it's a good idea to start close to home. Maybe you already have some ideas in mind for places you would like to shoot. Either way, follow your nose and start there. The main thing we want to achieve in this chapter is helping you become familiar with operating your equipment in the dark, before you try more ambitious situations. If you are not very familiar with your equipment, you can practice setting up your camera and tripod in your home, first with the lights on and then with the lights off, using your flashlight when necessary. If you are too impatient to practice a dry run, get out before the sun sets and photograph during dusk when there is still enough light to see what you are doing.

The camera settings we'll discuss in this chapter are important. To figure out how to set them, you may need to dig out the instruction booklet for your camera, or download it from the web. Make sure you know how to set RAW file mode, change the ISO, use histogram review, enable or disable mirror lock-up, use B mode for the shutter, set manual aperture, focus the lens, adjust white balance, and facilitate noise reduction. All of these items will be discussed in detail in this and the following chapters, and it is important that you have control over them before you begin photographing. If you are used to setting the camera to A for automatic mode

and snapping away, photographing at night will be a very different experience, a much slower and more contemplative one in which all decisions are made by you and not by the automatic features of your camera.

If you have a lot of equipment, choose one camera body and one lens, and leave the rest behind. It's a good idea to keep things simple for now.

2.2 Picking a Spot

Determining where you will photograph depends on a number of factors. You should initially evaluate your first experiences photographing at night by considering your comfort level with your equipment, your surroundings, your safety, and your ability to easily move around an area while looking for the right scene.

Keep an open mind, an observant eye, and gather wide—go to many locations, and make lots of over- and underexposures to ensure that you have plenty of RAW files to work with later. If you don't have a specific concept in mind, sometimes the best thing you can do is to walk or drive around and try a variety of things. The main idea is to get out and get started. Don't look for perfection at the beginning. In fact, try to avoid perfection, or you will miss many opportunities to experiment and learn from your mistakes. Instead, look for possibilities you can expand on, places that might be worth returning to, and ideas that may require a few attempts before they work out. The process of

Marbella after a Storm
© Amanda Quintenz-Fiedler

© *Michael Penn*

2.3 Setting Up

We will cover many specific lighting situations throughout the book to help you make the most of your night photography, but there are basic camera settings to understand and control from the beginning that apply to every scenario we will discuss. Whether starting with a camera-metered dusk scene, working with complex multiple exposures, or painting with light in the desert, you should apply the following guidelines to all situations to ensure the best results.

RAW Files

Using RAW format with digital capture is even more important with night photography than with day photography. Camera-generated TIFF or JPEG files severely limit what you can do with images when you process them. RAW files contain everything the imaging sensor was able to gather during an exposure, so they give you the most flexibility during post-processing. You will manipulate the original image file data to bring out details in midtones, highlights, and shadows to achieve a full tonal range in typically challenging lighting situations. The more original data you have to work with, the better chance you have of achieving a believable image in the end.

ISO

discovery on the way to achieving the images you want can be half the fun.

If you already have a concept developed you will naturally seek locations, atmosphere, lighting, and subject matter to fit your vision. Here, too, we suggest you cast a wide net initially, and narrow your focus later when you see that the images you are making actually reflect the vision you had in mind.

Nearly as important as capturing your image in RAW format is choosing the appropriate ISO. ISO stands for the International Organization for Standardization, which issues many measurement standards, including the light sensitivity of film and digital imaging sensors. We use ISO as shorthand for an imaging sensor's sensitivity to light, which can be increased or decreased. In the days before digital imaging sensors, photographers had to load their camera with film

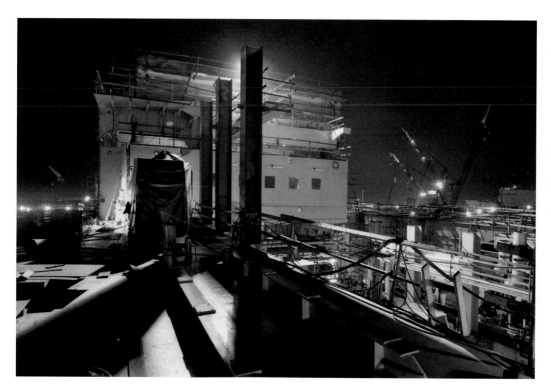

Figure 2-1:
An image captured with native ISO will have sharp detail and tonal range, as long as your subject isn't moving. Deck of the Exxon Valdez under Construction, San Diego, California © Philipp Scholz Rittermann.

that was either more or less sensitive to light, depending on what they were about to photograph. One of the advantages of digital camera technology is that we can change the ISO at will, depending on what it is we want to photograph.

The nature of a scene will determine which ISO setting you will use. A candlelit procession at night requires a different ISO setting than moving water, star trails, or the dark interior of an old factory. Our discussion will include both native ISO and high ISO.

Native ISO

Your camera's native ISO is at the low end of its light sensitivity range, usually between 80 and 200, depending on the make and model. Your camera will produce images with the best color and tonal range, the sharpest detail (of nonmoving objects), and the lowest noise it is capable of.

Of course, if you use your camera's native ISO in a dark setting, you will need to lengthen your exposure time for the imaging sensor to gather enough light to record a properly exposed image. But with a sturdy tripod, a long exposure at native ISO will produce an image with the best color, tonality, sharpness (of nonmoving objects), and noise performance possible.

High ISO

High ISO settings are useful when there is action in a scene. If you want to record that action, you will have to choose a high ISO setting to render it in a recognizable manner. Take the candlelit procession we mentioned earlier, for instance. If you aim to record the expressions of the people moving along a street, lit only by the candles they are holding in front of them, a high ISO combined with a wide aperture (more about this in a moment) and a relatively short shutter speed will be the right combination. You may even choose to handhold your camera to keep up with the action.

In these instances, you can increase your ISO setting (upwards of ISO 20,000 in some modern

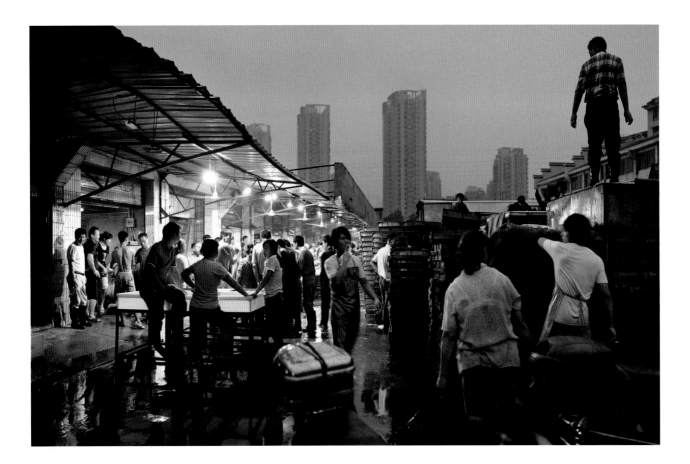

Figure 2-2:

In this scene at a fish market in China, freezing the moment was more important than using native ISO, so a high ISO was used to capture the essence of the scene. Dawn, Shrimp Market, Wuxi, Jiangsu Province, China © Philipp Scholz Rittermann.

DSLRs), which gives you the opportunity to capture extremely low-light scenes while also stopping motion, or at least limiting motion blur enough that you can accurately portray the action while conveying the feel, mood, and vibrancy of a lively scene.

High ISO settings come at a price, however. Increased color and luminance noise, decreased color fidelity, decreased tonal range, and decreased sharpness are all part of the trade-off. The newest sensors will do a far better job than older ones, but don't let any of this dissuade you from using high ISO settings when necessary. A low ISO setting with a long exposure won't work at all in some situations, so it is better to have an image with great atmosphere, expression, and vibrancy, even if it is not technically perfect. Conversely, don't use a high ISO setting unless you actually need it. If the scene you are photographing doesn't contain any action, a low ISO combined with a longer exposure will produce a much better result.

In any situation, you will determine what about the scene matters most to you. If there is motion, you may decide that you want that motion to blur in order to provide a contrast to the sharp, crisp details of the motionless surroundings. Or you could decide that the lively activity of a throng of people in a barely lit environment is what makes that image special. Either way, be sure to consider, and actively choose, the appropriate ISO for the moment.

In-Camera Noise Reduction

No matter what type of camera you have—large sensor or small sensor, high ISO or low ISO—chances are you are going to incur some noise in any low-light situation. When you want and need to correct for this, many cameras have built-in noise reduction or noise cancellation systems that work to actively combat the problem.

These programs have some disadvantages, in that they can delay the write speed of your ADC to your storage media (CompactFlash, SD card, etc.) and can drain your battery more quickly. Depending on the situation, it may or may not be worth engaging your noise cancellation. In a quickly unfolding situation, for instance, you want to be ready to keep photographing as things occur. With on-board noise reduction turned on, some cameras can take only three or four images before they stop recording more images, which can be frustrating. Read your camera manual; test how your camera's noise reduction system limits the number of consecutive images it can make.

Some cameras have automatic noise reduction features that turn on noise reduction during long exposures and leave it off during short exposures. Your camera may have different levels of noise reduction. Again, read your manual, and test your camera to see how it behaves. Very aggressive noise reduction gets rid of noise, but it often does so at the expense of color fidelity and sharpness. You will need to experiment to find the settings that best suit your needs. To get the most out of your equipment while photographing at night, get to know your equipment well.

Manual Focus

Automatic focus cameras use the level of contrast between adjacent elements to determine where the bokeh, or softness, around an image detail is diminished; in other words, when that element is in sharp focus, the bokeh is the smallest. In low-light or night photography there is often not enough light or contrast for most autofocus (AF) systems to work correctly, resulting

© Michael Penn

Figure 2-3:
Play Houses,
Carmel Valley,
San Diego, Califor-
nia © Philipp Scholz
Rittermann

in the lens focusing in and out, in and out, end-lessly searching for something to lock on to. In that situation, you have to turn AF off and manually focus the scene by looking through the viewfinder and relying on your eyes. Or, if you have the option on your camera, use the live view function to manually adjust focus until your subject is crisp. Using the magnification feature available in most live view systems, zoom in to a detail to help you focus on your subject.

When your camera's AF does function, how-ever, and you are making a series of bracketed exposures, you may have another problem. The camera may snap into focus at one position with the first shot and have a slightly different position for the second and subsequent shots. This can result in a scenario where your mul-tiple exposures don't line up perfectly, and it can cause a ghosting effect around the edges of your subject and result in long hours of tedious post-production work.

To prevent this problem, whether you ini-tially focus your image manually or with AF, make sure that you turn your AF feature off before you take your first image to ensure that there is no optical variation from one shot to the next.

White Balance

You can set your camera's white balance any way you like, as long as you are capturing in RAW format. If you are photographing in an urban environment, the prevalence of sodium vapor lights (yellow street lights) will make ev-erything appear yellow and jaundiced. You can choose a cooler color temperature to get a better preview image on your LCD. If you are photo-graphing a landscape in the wild and there are

no artificial light sources in your image, leave your camera set to daylight balance. After all, what little light is visible at night is reflected sunlight bounced onto the dark side of the earth by the moon.

The beauty of capturing in RAW is that the color temperature or white balance you used while making the exposure is not cast in stone. A RAW file has unspecific color balance, sharpness, brightness, contrast, color saturation, and noise reduction parameters. It only has a recipe attached to it, stating what the camera settings were when you made the photograph. This recipe can be modified or ignored entirely, and you can assign more appropriate color balance, sharpness, brightness, contrast, color saturation, and noise reduction parameters when you process your images on a proper monitor, not as you glance at the tiny image on your camera's LCD. The image on your LCD is a JPEG that has been extracted from the RAW file, with all the aforementioned parameters applied. But none of these parameters are an inherent part of the image; it's not cooked yet—it's just a recipe. You will alter this recipe and determine all of these parameters when you process your image in the RAW converter. For the purposes of this book, we will use the latest version of Adobe Bridge, which comes bundled with Adobe Photoshop CS5. Adobe Bridge uses the Adobe Camera Raw converter as a processor, which is a similar processor to the one employed by Adobe Lightroom.

Histograms

An essential feature of every digital camera is the histogram review function. Refer to your camera manual to display the histogram on your LCD so you can review your images in the field. Some cameras that have live view also feature a histogram preview. With the ability to look at the histogram before, or just after, you make the image, you see a graphical representation of the tonality data distribution in your image. You can use the histogram rather than trying to judge the appropriateness of your exposure based on the truncated JPEG that lights up your LCD screen.

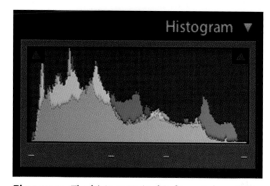

Figure 2-4: *The histogram in this figure is heavily influenced by blue tones, as you can see with the excess blue curve on the right side of the histogram. The yellow shift on the opposite side of the histogram is representative of some deep yellow tones in the shadows.*

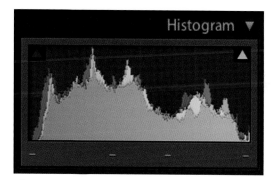

Figure 2-5: *This histogram represents the same image that has been neutralized. Notice how there are no significant color shifts in the image. Although your final result may be biased one way or another, a neutral starting point will allow you more flexibility with your final product.*

There is a caveat about your histogram display. The histogram on an LCD displays the exposure data as derived from the abridged JPEG image you see on the screen. We say *abridged* because whatever contrast, saturation, and color temperature or white balance settings

you use will influence the way the histogram is displayed. For instance, a high-contrast, high-saturation setting will clip the highlights and shadows of your image, resulting in a histogram that is missing data.

The best saturation and contrast settings for your camera, then, are neutral. This will ensure that the histogram reflects the most accurate distribution of tonality data it is capable of, and only then will it provide you with a reasonably accurate graphical representation of your exposure data.

When using a histogram, it is important to note that shadows are represented on the left side and highlights are represented on the right side. Data points to the right have more light information and detail, whereas data points to the left are composed of less light information and detail. To get the best exposures, it is important that you maximize them without overexposing, or clipping, your highlights. In other words, you should tend toward overexposure, without losing important details in your highlights. (Of course, what's important and what's not important is up to you.)

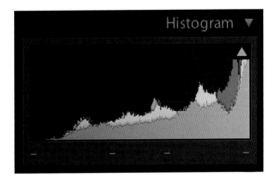

Figure 2-6: *Be careful with your exposures because an overexposed histogram may be deceiving. In this example, the white arrow in the top right corner of the histogram indicates that there is highlight clipping in the image. The prevalence of the information piled up on the right side and the illuminated white arrow indicates that there is significant clipping.*

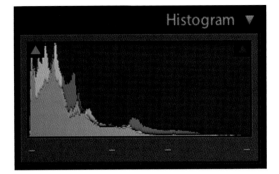

Figure 2-7: *In this histogram, the information is pushed to the left, and the blue arrow above the left side of the histogram is illuminated. This indicates that there is underexposure and clipping in the shadow tones of the image. Even without clipping, this image would be hard to work with, so try to create an exposure that leans to the right side of the histogram without engaging the clipping warning.*

When you review your histogram, you will note that the mountain range shape of tonality data has been shifted to the right, toward the highlights. By doing this, you have added more data to your shadows, which translates to more shades of gray and is a very good thing. Don't be alarmed if your shadows look too light. They can always be made darker. We call this technique "shooting to the right" (also referred to as "Expose to the Right," or ETTR), and as you now know, it has absolutely nothing to do with your political leanings. Most cameras have a highlight clipping warning feature, which can be enabled or disabled. We recommend that you enable it and pay attention to it. When you review an image with overexposed areas, it warns you by blinking or flashing in those areas. You can then make an informed decision about whether that area is important to you and adjust your exposure accordingly.

Last, you should be aware that while the image on your camera's LCD screen may look perfectly useable at night, our eyes are fooled by the surrounding darkness. Just as a properly exposed image on a camera's LCD screen doesn't look right when we are squinting at it through

the glare of the high-noon sun, our reading of a grossly underexposed image at night may be incorrect as well. So work with your histogram to verify if you have a proper exposure.

Preventing Flare

Photographing at night in urban and industrial areas with artificial light dramatically increases the chances of getting flares in your images. Of course, you want light to hit the lens—that's how images are made. But you want to do your best to prevent excess light from striking it. Bright light sources just outside your viewing angle, but close enough to strike the front element of the your lens, will cause flares and reflections that can spoil an image. To prevent this from happening, shield the lens during exposures by using a lens hood, a piece of black cardboard, a makeshift flag, your jacket, your body, or your buddy. A very useful device you can keep in your kit for this purpose is a flexible shoe mount gobo.

If none of those tricks work, reposition your camera. If that doesn't work either, take the picture anyway and worry about the flares later. The image may still be worth it.

One way to determine if extraneous light is hitting the lens is to stand in front of your camera and move your hand around the outside of the lens. Watch to see if your hand casts a shadow on the lens at any time. If it does, there is light hitting the lens that may not be coming from within the scene. Identify the offending light source and block it with one of the options we discussed.

Setting Your Exposures

Though there are certainly going to be a variety of ways to set your exposures based on the situation, there are some basic tenets that you should follow.

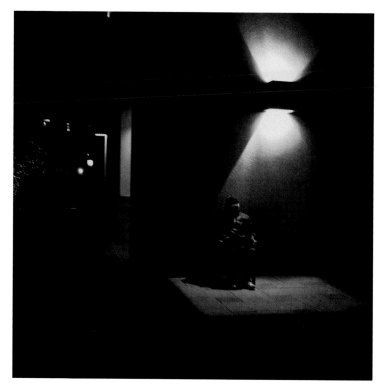

© Kevin McCollister

Initially, determine what the most important element is in the image. For instance, if you want to capture motion, that will tell you where to start for exposure time and ISO. Or, if depth of field (DOF) is most important to you, that will dictate your ideal aperture. In the following chapters, there are more specific instructions about how to use each of these criteria to get the exact exposure you want, but it is important for you to understand certain elements about exposure to get useable results.

In-Camera Metering

If your scene has enough light to get the DOF or stopped motion that you envision, use a native or low ISO setting, and use your in-camera meter to gauge the exposure time. Use your meter reading to establish your initial camera settings for aperture, exposure time, and ISO.

To get equivalent exposures of the same scene at the original meter reading, you will need to adjust the aperture, exposure time, and

Figure 2-8:
*Joor Muffler,
Escondido, Califor-
nia © Philipp Scholz
Rittermann*

light, so you will need to get eight stops more light either from your exposure time or ISO. To get eight stops more light with exposure time, double your exposure time eight times, which results in an exposure of 8 seconds. If you want to change the ISO instead, you would change ISO 100 to ISO 25,600. Because your camera might not have that ISO value, you could end up changing a combination of exposure time and ISO to maintain the right balance.

At the end of the day, what you need to worry about is that you are getting an accurate exposure. If you can still use your meter, it should help you determine the exposure while you adjust your settings. If you can't use your meter because your surroundings are too dark, you will need to review your histogram based on the information we have already provided. It is important to understand, though, how your aperture, exposure time, and ISO work together to vary the amount of light that reaches your sensor. If you adjust one element by a stop of light, you can adjust another element in the opposite direction to compensate.

Each stop of light is twice (or half) the amount of light as the previous stop. With aperture, this amount of light is determined by the volume of light that travels through the aperture opening. With exposure time, twice (or half) the length of time that the sensor is exposed to light is an additional stop. With ISO, the image sensor will become twice (or half) as sensitive to light with each adjustment.

But don't be fooled! Not every click on the lens or turn of the dial is necessarily a full stop. Most cameras have one-half or one-third stop increments for aperture and shutter speed, and some even have increments for ISO settings. The basic stops for aperture are f/1, f/1.4, f/2, f/2.8, f/4, f/5.6, f/8, f/11, f/16, f/22, f/32, f/44, and f/64. Your camera may not have this full range, but your full stops should be on that list. The reason this is important to know is that if your camera has f/16, f/18, and f/20, then going from f/16 to f/18

ISO inversely to ensure an accurate exposure. For instance, if you want to see what an image looks like both at f/2 and at f/32, you can't just change your aperture. You will also need to adjust either your exposure time or ISO to allow more or less light in, depending on how you change your aperture.

Let's say you have an appropriate exposure of f/2 at 1/30 second at ISO 100. If you want to see that exposure at f/32, that is eight stops less

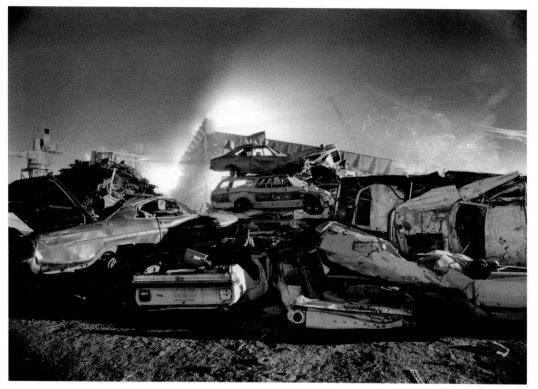

Figure 2-9:

Car Shredding Mill, National City, California © Philipp Scholz Rittermann

is only one-third of a stop, which won't allow you to get a full five-stop range of exposures. A five-stop range with f/16 in the middle would go from f/8 to f/32, *not* from f/12.5 to f/20.

Bracketing

Even when you are exposing your scenes appropriately, shooting to the right, and consulting your histogram, you will often encounter situations that have too much contrast—too big a difference between the shadows and highlights. The dynamic range of today's imaging sensors is limited and often insufficient to record detail in the shadows and detail in the highlights of many high-contrast situations we encounter at night. To get around this, you can bracket your exposures.

Bracketing is a technique that allows you to gather a perfectly registered (no camera movement between images) set of images that will later be combined into a single, expanded dynamic range image. This means that you will take a series of exposures in exactly the same location, on a tripod, with the same aperture, with AF off, and adjust only your length of exposure or ISO to allow more or less light to enter the camera.

Increasing your exposure time increases the amount of light reaching the sensor. It will add shadow detail and enable you to see into the darkest places of your scene. Decreasing your exposure time lessens the amount of light reaching the imaging sensor, and it will decrease the highlights and reveal details where you would otherwise have nothing but a distracting glare that could overpower the scene.

As viewers, our eyes are drawn to light and contrast. When our attention is drawn to a light area that has no detail or interest, it becomes an irritation, which keeps us from enjoying what the rest of the image has to offer. We are hardwired to gather most of our color and texture

Figure 2-10:
The three images shown here in Adobe Lightroom 3 are bracketed by one stop each. The first image is the base image, where the midtones are approximately correctly rendered. The second image is one stop overexposed, and the last image is one stop underexposed. You can see that all three images are perfectly aligned with the exception of the moving traffic, which can be compensated for in post-production.

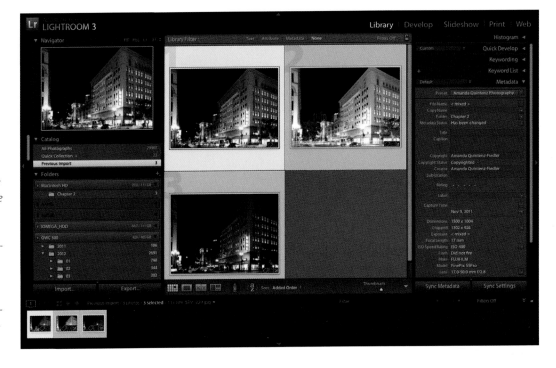

information in the midtones and shadows of a scene. Hence, we must control the highlights in an image to ensure that they add to the viewing experience instead of detracting from it. Filling our shadows with detail gives us more to explore. Some of the best nighttime images have shadow detail that emerges only after looking at the print for a while, allowing your eyes to adjust and tease a little more information out of the gloom.

Most modern cameras can automatically bracket multiple exposures. This is usually confined to the fastest shutter speed up to a 30- or 60-second range. This is an excellent option so you don't have to manually change the settings between shots, reducing the possibility that you might accidentally move your camera. Be careful to choose a bracketing and exposure mode that changes only the exposure duration, not the lens aperture or ISO of your camera. (In dire circumstances, you can use ISO to change the amount of light hitting the sensor, but it should

be a last resort and certainly should not be used for bracketing.)

When you appropriately bracket your images, you end up with a much-increased dynamic range, which, with some clever post-production, can result in a final image that more closely represents the scene the way it looked when you saw it with your own eyes.

As mentioned, it is important to not move the camera and not change the aperture when you bracket. Changes in aperture affect the optical drawing qualities of your lens, mainly your DOF, which can result in varying degrees of sharpness for some areas in your image. As you can imagine, it would be impossible to combine images with vastly differing focus qualities in any kind of believable manner. It would cause multiple strange fringes to surround the contours of an object, which should either be sharp or not, but not both. This is demonstrated in the following sequence of figures.

Figure 2-11: *This image is a composite of four bracketed exposures. However, instead of bracketing the exposure time, these images were bracketed by changing the aperture of the lens. Although it may seem like a normal high dynamic range (HDR) image at first glance, upon closer inspection you can see some awkward problems.*

Figure 2-12: *This image is one of the four starting images, with an aperture of f/11. Notice how the sign at the end of the stairs is legible and crisp. (This image was modified in post-production to bring up the tonality for demonstration purposes.)*

Figure 2-13: *This image is another of the four starting images, this time with an aperture of f/4. Notice how the sign at the end of the stairs is now blurred and the DOF of the scene is greatly reduced. (This image was modified in post-production to bring down the tonality for demonstration purposes.)*

Figure 2-14: *When these two images (and two others) were combined in an HDR image, the areas where the DOF changed between shots has a ghosted rim around the sharper elements. No matter what technique you use to combine the images, the DOF has changed, so the basic elements of the scene are different. This can be compensated for with small elements, such as one moving component, but correcting the entire image defeats the purpose of controlling the HDR exposures.*

To bracket, start with what you think is a good exposure. This can come from experimentation, evaluation of the histogram, or an educated guess. Depending on the circumstances of the light in your scene, you will be using different methods to start out, which will be discussed in later chapters.

No matter how you determine your initial meter reading, when you have decided that it is a good starting place, how you bracket is important. To get a good range of information, you want to be sure that you are getting a wide range of stops for different exposures.

Similar to how your aperture works, to get a five-stop range of light for a bracketed situation, you will need to adjust each stop of light by twice (or half) the amount of exposure time. So if your initial exposure is f/5.6 at 1 minute at ISO 100, a five-stop range with this initial setting in the middle would go from f/5.6 at 1/15 second at ISO 100 to f/5.6 at 4 minutes at ISO 100. Each stop is doubled (or halved) to achieve the next stop.

With ISO, the number would adjust in increments of 2 (or 0.5), which relates to the sensitivity of the imaging sensor. So ISO 100 to ISO 200 is one stop, ISO 100 to ISO 400 is two stops, and so on. To get a full range of stops, it's important to understand and apply the logic of how stops of light work to be sure that you are getting a wide enough range of exposures to open up both your shadow details and your highlight details.

When you understand how stops work, if you want an even further range for your exposures, you can apply the same logic and continue to add a greater stop range of over- and underexposures to your heart's content.

2.4 A Checklist for Night Photography

Here's a simple checklist to help you out on your 1st and your 50th night shooting expedition:

- First and foremost, *be safe*. If you are exploring a sketchy area, bring a buddy.
- Bring a warm jacket, flashlight, water, and snacks.
- Wear comfortable, durable shoes.
- Bring extra batteries.
- Capture in RAW format.
- For the best image quality, use a low ISO whenever you can:
- Use native ISO for tripod-based exposures.
- Use a higher ISO to stop motion or for hand-held exposures.
- Enable on-board noise reduction. (Test your camera to see how it performs with this feature.)
 If you use a tripod, check for the following:
- Make sure that it is sturdy and has a solid head.
- Use a cable release (in a pinch, you can use your camera's self-timer, though you will likely be limited to 30 second exposures).
- Beware of wind vibrating your tripod and softening your image.
- Avoid using the vertical column extension on your tripod. The more extension you use, the less stable your tripod becomes.
- Use manual focus, or use AF to get the initial focus and then turn it off for the exposures.
- Set the white balance.
- Set your camera to display a histogram upon image review. Strive for a neutral picture style for contrast and saturation.
- Shoot to the right.
- Bracket your exposures.
- Check for flare.
- Block any extraneous light sources.
- Be aware that images on your camera's LCD panel will look bright at night. Don't be fooled by this. Check your histogram to ensure proper exposure.
- Again, *be safe!*

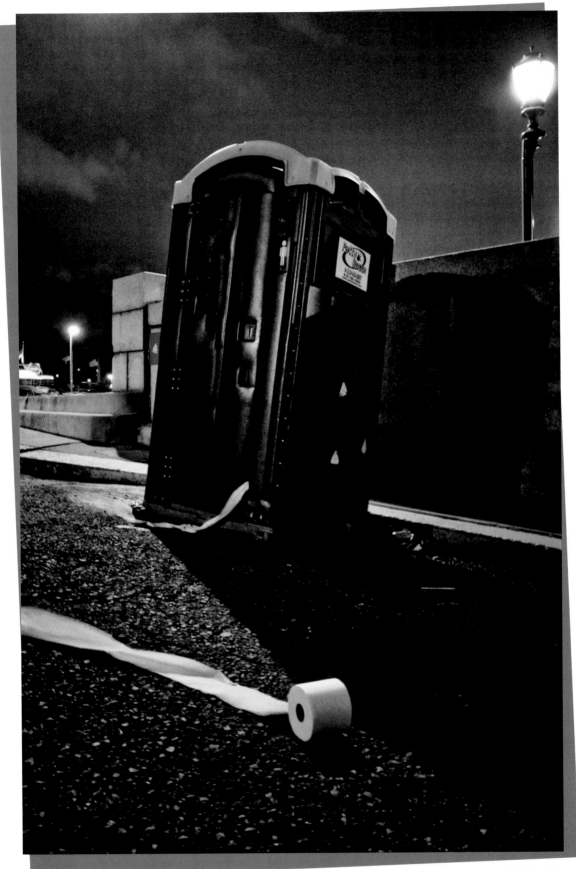

© Michael Penn

Chapter 3
Caveats

3.1 Introduction

We know you want to get out and start shooting and experimenting with your images, and we encourage that, but there are some things about shooting in low light or at night that are much more difficult than shooting during the day or in well-lit situations. We would love for you to go out and experiment, but if you get stuck or frustrated, don't throw in the towel. Read through this chapter and get acquainted with some of the pitfalls of shooting at night so you can avoid these obstacles and move forward with your image making.

You can also, of course, read up on all this material before you head out for your first shoot, but remember that there will always be unforeseen difficulties, snags, and hiccups as much as there will be wonderful accidents, revelations, and discoveries. At some point, you need to venture out into the dark! In this chapter we provide a list of some things to avoid or correct at any stage of the game. As you continue to venture into the unknown, your list may grow with your own experiences. At the end of the day, the more you go out and try, the sooner you will ultimately succeed!

3.2 Gauging Exposure

With any low-light photographic situation, getting the right exposure or set of exposures is one of the most difficult techniques to learn. It's not because your equipment isn't capable of capturing the mystical light, but because you can't necessarily trust your equipment when it wants to dictate how much light you need. In-camera meters, and even handheld meters, are made to measure the amount of light falling on or reflecting off your subject, but if your subject is mostly lit, the technology starts to fail. A standard meter doesn't understand what you want it to do in a low-light situation with multiple light sources, so you are forced to start experimenting.

© Kevin McCollister

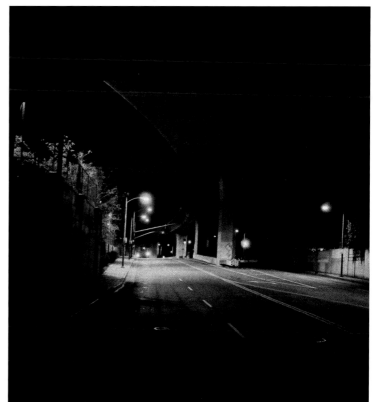

Figure 3-1:
The sunset on the LCD screen of this point-and-shoot digital camera may appear to be correct, but without looking at the histogram, there is no telling how the final image will turn out.

The main goal here is to determine which elements of your equipment you can trust. Ultimately, taking blind stabs in the dark, no pun intended, isn't the way you want to create your images, but you do need to understand the equipment you have on hand so you can evaluate the exposures you are getting, take your first few shots, and determine where to go from there.

Here are some tips and guidance for determining what information your camera has captured and how useful it will be in making your final image.

Don't Trust Your LCD

One of the major advances of digital camera systems is the fact that they provide active feedback information. What that means is as soon as you take a picture, you can see what you have captured on your LCD screen. The image is shown as a review JPEG, with your various histogram settings and data. One of the main caveats with night shooting, however, is that your LCD screen is lying to you.

The function of the LCD screen in normal shooting situations is to allow you quick access to see the structure, composition, and dynamic range of your image within a certain tolerance, but it is calibrated as a JPEG that compresses your file information and adds a bump in contrast and saturation so you can see the image and evaluate it in bright, outside conditions.

When you are shooting at night, all of those helpful characteristics of your LCD screen hinder a proper evaluation. The bumped contrast does not give you an accurate estimation of where your highlight and shadow details are falling in your overall image, so either side of your exposure could be clipped, or it could be overexposed or underexposed, and your LCD won't really be helpful in letting you know where you might be going wrong. The bump in saturation might make a clipped highlight appear to have more information than it does, or it could even draw attention to parts of your image that don't really have the same punch and information in your file as it appears to have on your screen.

Worst of all, the overall brightness of your LCD screen in relation to your undoubtedly dark surroundings will make the image on your screen pop. Your dark-adjusted eyes will see nearly any image as amazing, and you might throw away an opportunity to reshoot or bracket because you have been mislead by your technology.

Besides the pitfalls of working with your LCD, having the preview screen on for your entire shoot can drain your battery unnecessarily. In cold environments, that means greatly reduced shooting time and, ultimately, less productivity.

Histograms

What you should be working with, instead of the LCD screen, is the histogram. No matter how bright or dull the histogram appears, it is relating specific data to you and not compressing the real image. Learning how to read a histogram is vital in understanding where you need more or less exposure for your night images.

Reading a Histogram

A histogram shows you the distribution of light data across the dynamic range of your captured image. Typically, the histogram is oriented so the left side displays the dark data, or shadow details, and the right side displays the bright data, or highlight details. All of the information in between comprises the gray data, or the variation between the darkest tonalities and the lightest tonalities. All of this together creates the dynamic range. The more full the range, the more appealing your image. We aren't interested in blacks and whites nearly as much as the gray tones and the gradations that play around the scene in low-light conditions.

Because of this, you want to be sure that the data represented on the histogram fills as much of the graph as possible without clipping data on either side. Clipping is when you lose detail either because there is too much information for the pixels to handle, as with blown-out highlights, or when there is too little information to register on the sensor, such as with blocked shadows. The goal is to have an image that maximizes highlight detail without clipping vital information and contains as much black detail as possible.

As we mentioned in the previous chapter, we call this technique "shooting to the right," that is, you want the bulk of the information to be on the right side of the histogram, where the white information is registered. This is because in post-processing you can more easily expand the dark areas than increase the light areas. The brighter the recorded data, the more data there is to work with.

Clipping

Chances are, your camera will show you when you are clipping highlight data. If your camera has a clipping warning feature, you may want to turn it on. Typically, the clipping warning will overlay on top of the LCD image and blink red wherever the highlight data is clipped and blink blue wherever the shadow data is clipped. This can be very useful to let you know where you may need to adjust your image, depending on your overall vision for the scene. It is okay to clip some data, but it is also important that you make choices about clipped data rather than taking what you get and living with it. The goal is to use your equipment to help make choices about the image you want to make.

It is important to note, however, that some cameras will show only clipped highlights and not clipped shadows. In that case, pay close attention to the shadow detail and see if too much data appears to be pushed up against the left side of the histogram.

It is also important to understand that the histogram and clipping warnings show only the data that is just outside the range of your image; they do not show data that is extremely out of range. Only you know what you want and don't want in your image, so experiment with a variety of exposures, especially when you are first starting out, and take time to evaluate the histogram and clipping data with each different exposure to see what changes from image to image.

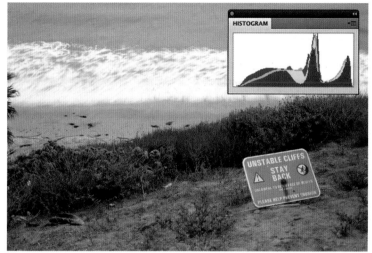

Figure 3-2:
This image was correctly exposed, with highlights to the right that aren't clipped and shadow data with room to expand.

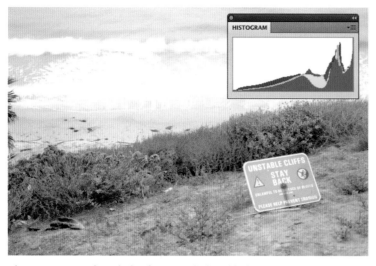

Figure 3-3: *Even though this figure can't show blinking clipped highlights, it does show what a clipped histogram looks like. Compared to figure 3-2, the histogram of this overexposure shows clipping of the data that is pushed to the right side of the graph. Although it may not seem much different from figure 3-2, detail has been lost in the highlight values, which will render as blocks of posterized white.*

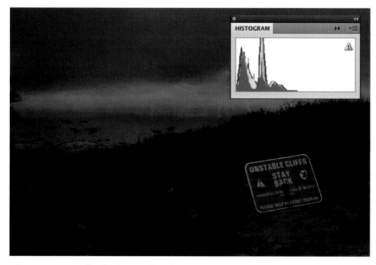

Figure 3-4: *Similarly, this is what the histogram would look like if the scene in Figure 3-2 were underexposed. Although you still can't see the blinking clip warning here, you can see how the histogram is now pushed to the left side of the graph, and the image is very dark, with lost detail in the shadows.*

Controlling Flare

As mentioned before, flare can greatly affect your images in any shooting situation, but your images are particularly vulnerable to flare in low-light conditions. It is an ironic problem. To make a photographic image, light must hit the lens, but if light hits it at the wrong angle or if the wrong light interferes with the lens, your image could be ruined.

You can use some techniques to evaluate whether or not you have flare, where it is coming from, and how far you can go to get rid of it. Your goal in dealing with flare is to prevent excess light from striking the lens. Logically, that means shielding the lens during exposure. The simplest way to do this is with a lens hood. It will reduce a great deal of flare, but that is often not enough. If you find you still have excess light hitting the lens, use a dark, nonreflective object between the offending light source and the lens. This can be tricky if you don't have a light stand or a friend with you, because you may have to stand in one place and hold the dark object next to the lens. That can be difficult if your exposure is half an hour long. But finding some way to diminish flare will ultimately be worth it to get a crisp image without the reduced contrast and telltale bursts of light that appear with flare. If you can't figure out a way to block the light that is reflecting off the lens, try repositioning your camera. If that doesn't work either, take the picture anyway, and worry about the flares later.

One way to determine if extraneous light is hitting the lens is to stand in front of it and move your hand around to see if you cast a shadow on the lens at any time. If you do, there is light hitting the lens that isn't coming from the scene, and you have identified an area where your lens hood, flag, or friend needs to be placed to reduce flare. As mentioned previously, the LCD screen won't be an accurate representation of your image, and this includes relating

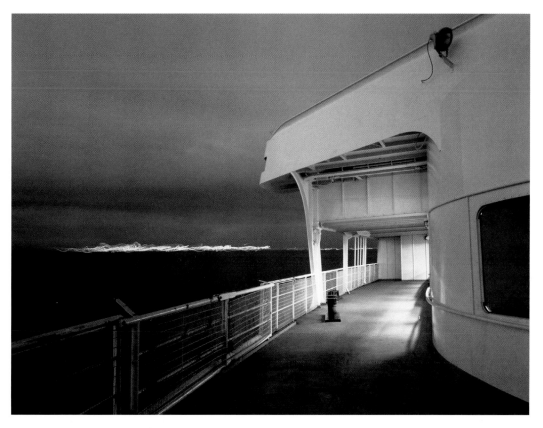

information about flare. Even if you zoom in to your LCD screen, you may not be able to detect the consequences of flare until you get your image home and onto your computer. Do what you can in the field to protect your images.

When you have gone to the trouble of setting up your camera on a sturdy tripod, composing and focusing in low light, and determining your appropriate exposures, it is a quick trick, and a smart move, to briefly check for extraneous light sources. You'll be glad you did.

Auto Focus

Auto focus (AF) is yet another great tool in modern photography that can work against you in night and low-light photography. Aside from initially finding focus, your AF feature may suit you best if you put it to sleep for night photography.

Focusing in Low Light

When you are trying to create an image, your AF sensor is trying to find an area of determinable contrast where it can reduce the blur between the components and make crisp transitions. Those crisp transitions become your critical plane of focus.

At night, there may not be an easily discernible contrast for your AF to hone in on, so it may focus in and out, in and out, ad nauseam searching for anything to grasp. Or worse, it may seem like the lens is focused when, in fact, your subject is not crisp.

As with all equipment, there are better systems and worse systems, so you might want to experiment with how accurate and reliable your AF system is in the types of low-light situations you want to capture. Sometimes there won't be enough light for you to focus with your eye, so using AF might be your only option. Knowing its

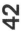

capabilities will either allow you to trust your camera or let you know when to move on.

Maintaining Focus

When you are bracketing your images, AF can severely hinder your final product. If you leave the AF feature on during the bracketing process, it may refocus before each exposure, making infinitesimal changes in the overall orientation and focus of your image, which will make perfect alignment of your bracketed exposures impossible for later compositing work. When you are working with bracketed images, it is very important to maintain exact focus and DOF, so you want to manipulate only the exposure time to get a variety of exposures. Leave your focus and aperture untouched.

To ensure that you are maintaining focus, be sure that your AF feature is disengaged before you start your bracketing procedure. Even if you use the AF function to get your first focus, change it to manual focus for actual exposures that follow.

Tripod

You should definitely use a tripod when possible so you can lower your ISO and get exactly bracketed images, but having a tripod can give you a premature sense of comfort.

In chapter 1, "Equipment," we discussed the type of tripod that will best serve you in night and low-light photography, but how you employ that tripod is as important as its construction. If even one component is loose or off balance, your efforts will be for naught.

The more advanced your tripod, the more components you can adjust, and the more brakes, knobs, and screws must be checked to make sure the tripod is as sturdy as it can be.

The first thing you will set up is the legs of the tripod. The legs are the elements that determine your perspective of the scene, sturdiness on the ground, and access to your preview screen. The leg adjustments are the coarsest refinement that you will make to settle your tripod. When you get your image as close to perfect as you can with the leg height and stability, lock down every knuckle and joint in the leg system to be sure your tripod isn't going anywhere. At this point, press on the tripod a little to see if the legs are sturdily placed. If not, adjust the legs before moving on to the next modification because they will determine the overall stability.

After the legs are ready to go, you can start fine-tuning your composition with your tripod head. Depending on the tripod, you may need to check that the head is secured in all possible directions. Some tripod heads have multiple levers to allow a variety of vertical, horizontal, and rotational adjustments. Each of these components needs to be locked down when you are happy with your composition.

Earlier, we said that if your tripod has an adjustable telescoping column, you should try to avoid using it because for every inch it goes up, the more stability you lose. But it is also important to note that even if your column is retracted all the way, it can still wiggle if you don't tighten the screws that hold it in place. Even this small movement can affect your images, so be sure there is no play in the column in any position.

When you are fairly sure you have everything tightened, clenched, and solid, try to move the tripod from the camera position and see if there is any play in the assembly. If there is, you missed something that needs to be dealt with. If not, you should be ready for long exposures or bracketing.

Cable Release

Similarly to the tripod, merely having a cable release can give you comfort, but using it incorrectly can hinder your images. To use your cable release effectively, be sure there is no tension in the line.

Think of the childhood game with the string connecting two cups that allows you to talk to someone across the yard. The string telephone didn't work if there was any slack in the line, because the principle behind the toy is that the vibration from one cup passes along the taut line into the other cup. If you treat your cable release as that string telephone, every vibration you make will translate down the length of the cable and vibrate your camera.

To prevent this, be sure the cable is slack at all times so no vibrations affect the camera.

This includes walking brusquely or sitting heavily near your tripod, so be careful what you do within range of the camera while the shutter is open.

Inclement Weather

Some of the most wonderful scenarios that you can encounter with night photography are directly related to some atmospheric conditions that disagree with electronic equipment, and your camera is not immune to these forces.

Figure 3-6:
Porch, Block Island,
Rhode Island
© Philipp Scholz
Rittermann

© Michael Penn

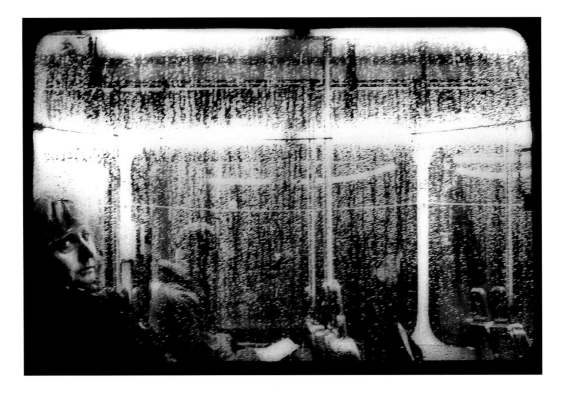

There are some things that you can do, though, to protect your camera and lenses without abandoning these beautiful opportunities.

Water
One of the most prevalent atmospheric conditions can cause the greatest damage. Water can corrode, short out, and even ruin camera components. They don't do well around any sort of humidity, and if water finds its way into your lenses, it can ruin them with permanent fogging and condensation. Taking some simple precautions in the handling and storage of your equipment can prevent many of the dangers of working around water.

Often with night photography you will be out in cold weather. When the sun goes down, fireplaces light up, and heaters turn on, you throw on an extra layer to brave the moody evening light. When you are done shooting, both you and your equipment will have acclimated to the colder temperatures. When you move

from a cold environment back into the warmth of your home, condensation will form on your equipment, just as it forms on the outside of a cold glass on a warm summer's day.

To protect your equipment from this subtle moisture, make sure that your body caps and lens caps are in place before you make the transition from cold to warm. This will help prevent condensation from forming on the vulnerable components of your equipment. It will likely still form, but because the warmth will reach the guarded elements more slowly, they will be protected from more egregious damage.

When working in more abrasively wet situations, such as rain, snow, or near a body of water, merely protecting your equipment when you come inside isn't sufficient; make sure that you take steps to protect it while you are using it.

Many cameras have weatherproof cases that you can purchase to prevent them from coming into direct contact with weather. There are also more generic, and affordable, weatherproof

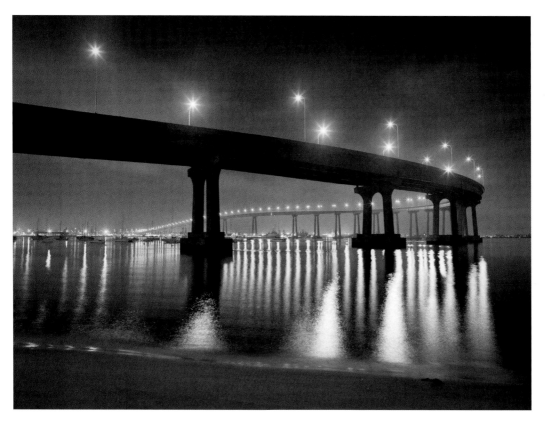

Figure 3-8:
Coronado Bay Bridge and Shoreline, Coronado, California © Philipp Scholz Rittermann

High Humidity and Salty Environments

Water in and of itself can be damaging, but when you have extremely high concentrations of water, as in a high-humidity area, those effects multiply. When you add the corrosive element of salt to that water, it can be devastating to your equipment. The corrosive elements of water and salt, especially together, may take time to affect your equipment, but when they do, entire components may stop working or become crusted with salt and lose functionality.

Yet you can also get some of the most amazing image opportunities in areas that are hardest on your equipment. Rather than foregoing the opportunity, try instead to protect your equipment and take precautions to prolong its life even when you use it in harsh conditions.

If you are in either a high-humidity or a salty environment, try to protect your equipment until the moment of exposure. Keep the water, wind, air, and other debris away from your camera, lenses, and other supplies until you are ready to shoot, and cover them immediately when you are done.

When you return home from an excursion to a particularly demanding environment, take time to wipe down your equipment to remove any residual salt or water spray with a soft, barely moist cloth. (Don't introduce more problems with a soaking wet rag that will be just as bad as the environment.) After your equipment has been gingerly cleaned, leave it out to dry before you store it, just as with the condensation problem mentioned earlier. If any moisture or salt remains in your components, it will have a lasting detrimental effect, so taking time to correct it after each potentially hazardous shoot is worth the effort.

© Michael Penn

components before you put them away. If you store your equipment with any amount of moisture present, you are leaving it open to the possibility of slow corrosion, mold damage, and creeping moisture that can find its way into nooks and crannies where water should never tread.

Cold

Beyond the complication of condensation when you move from a cold environment to a warm one, you can run into another problem with cold weather that can cut your photo expeditions short—diminished battery life.

When you are out in the cold, your batteries have to work harder to run your equipment because they lose charge due to the chilly conditions surrounding the camera. To prevent this, there are a couple of guidelines you can follow to maximize the shooting time you block out from your busy life.

Always take extra batteries on any excursion. This goes for any equipment that may need additional batteries, but it is especially important for specialized batteries that cannot be bought at all-night convenience stores, such as your DSLR batteries or small batteries in a specialized timer. It is also a good idea to bring along extra batteries for your other powered devices, such as your flashlight, just in case you find the perfect location to set up your image and don't want to be forced to leave early.

It is also a good idea to keep your batteries and equipment as warm as possible until you are ready to use them. Keep them in an interior pocket instead of letting them sit in your camera bag on the cold ground. You may also be able to get an additional spark of life out of a cold battery by warming it up again, so before you abandon an image or a location, see if you can bring dead batteries back to life for one last hurrah.

Figure 3-7:
Carrera, Bogen-
hausen, München,
Germany © Philipp
Scholz Rittermann

cases that you can purchase to serve the same function, though the access to your camera's menus and functions may be slightly hindered. If you are going out in a moisture-rich environment with your equipment, though, having one of these cases can save you thousands of dollars in damages.

In extreme weather, some sort of additional rain guard may be required, which could be as simple as a friend with an umbrella, or you could purchase more equipment for your camera, such as a rain guard. Overall, using your best judgment about protecting your equipment while shooting can help you save money and time in the long run and keep your equipment functional as long as possible.

Even with weatherproofing, when you get back into dry conditions, it is important to ensure that all water has evaporated from your

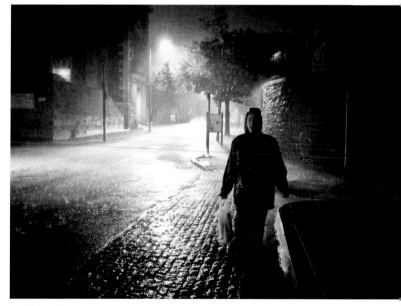

© Michael Penn

Part II: Capture

SINCE WE HAVE DISCUSSED THE BASICS of how to approach night and low-light photography, let's get to the meat of it. Now is the time to go out and start taking pictures. Or stay in and take pictures. It's time to find those situations that have low light and start to make magic. If you're the type of person who analyzes everything until you're thoroughly prepared, the previous section should have groomed you for the next step. If you're more of a fly-by-the-seat-of-your-pants type, you may have skipped the last section altogether. What matters at this point is starting the process of experimentation. Let's put your new knowledge to work and see what it takes to capture night and low-light images.

To help get you started, the first chapter of this section is entirely dedicated to the types of low-light photography you can do. From moody dusk shots to playful painting with light, this chapter will get you excited about the possibilities. And when you desire to create your own images, the next four chapters will help you go out and get those images with all the tips and tricks we have learned throughout our cumulative photographic careers. The images will inspire you and the information will guide you. Now go find some dark.

Prop Horizontal, Shipyard, San Diego, California © Philipp Scholz Rittermann

Chapter 4
What to Photograph

4.1 Finding Your Way in the Dark

Our goal with this book is to give you all of the guidance, direction, and technical information we can about night and low-light photography. We've already given you an important set of guidelines, safety tips, equipment assistance, and caveats to be aware of, yet to really get into the nuts and bolts of how these images are created we want to share some images to help you visualize the possibilities in your own backyard.

This chapter is dedicated mostly to images and the variety of environments and atmospheres that you can use to your advantage in night and low-light photography. We hope this chapter gets your imagination running and excites you to go out and create your own images, unhindered and exhilarated. What better way could we encourage and inspire you? After all, as the saying goes, a picture is worth a thousand words.

Urban Landscape

A wonderful place to start with night and low-light photography is any situation where man-made light sources are prevalent but not overpowering. These types of situations are full of interesting shadows, obtuse light directions, and multiple light sources. The atmosphere they create can be spellbinding.

Just because there is light around, however, don't forget to find the darker areas, the mysterious shadows, and the forgotten alleyways. The lights that come on for security, guidance, and night laborers can sometimes illuminate these areas and provide new venues for you to explore.

© Kevin McCollister

City Landscapes

© Michael Penn

Twenty-Four Hour Cement Pour, Oakland, California © Philipp Scholz Rittermann

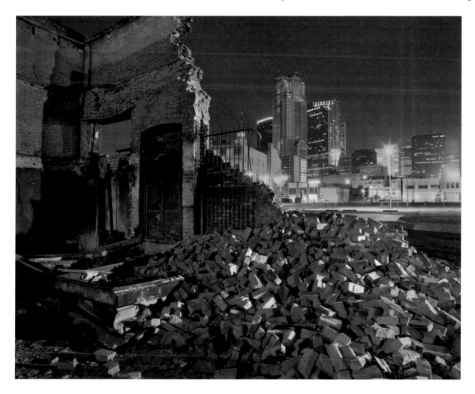

Burnt-Out Warehouse, Dallas, Texas © Philipp Scholz Rittermann

© Kevin McCollister

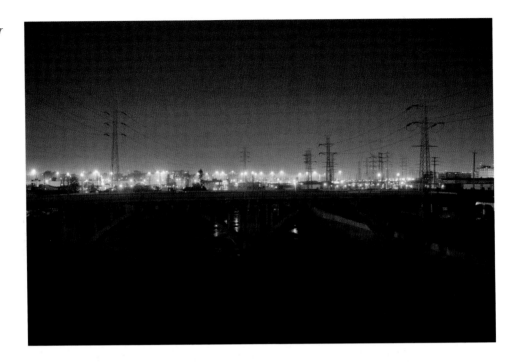

Industry

Brooklyn Bridge
with Crane,
Brooklyn, New York
© Philipp Scholz
Rittermann

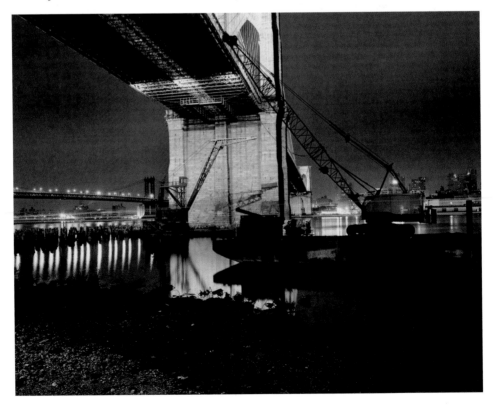

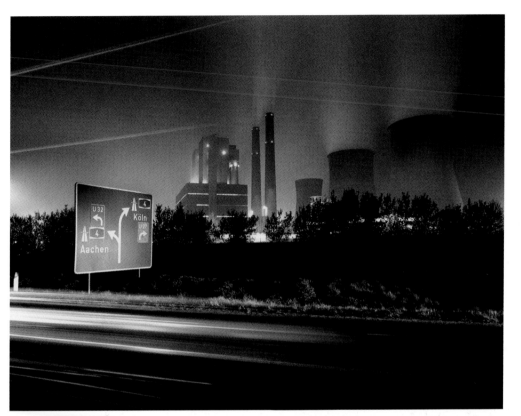

Coal-Fired Power Plant, Eschweiler, Germany © Philipp Scholz Rittermann

© Kevin McCollister

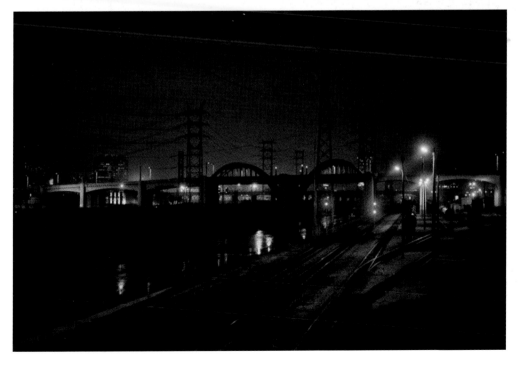

Interior of the Exxon Valdez, San Diego, California © Philipp Scholz Rittermann

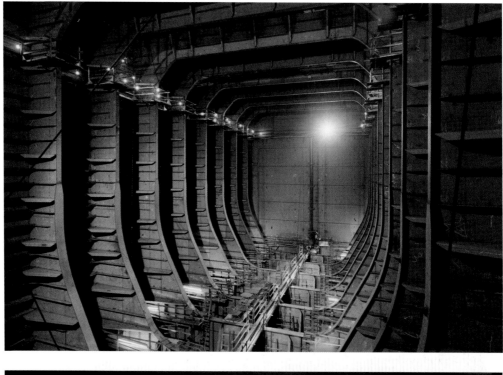

Conveyor Towers, EBV Steelworks, Kohlscheid, Germany © Philipp Scholz Rittermann

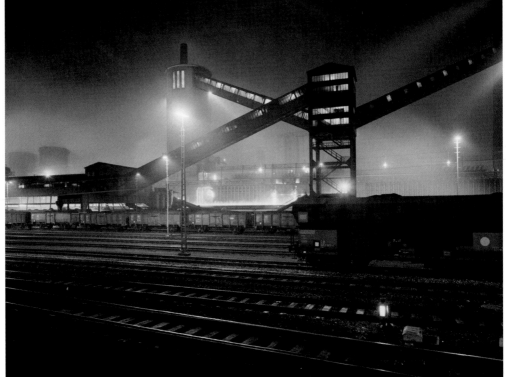

Waterfront

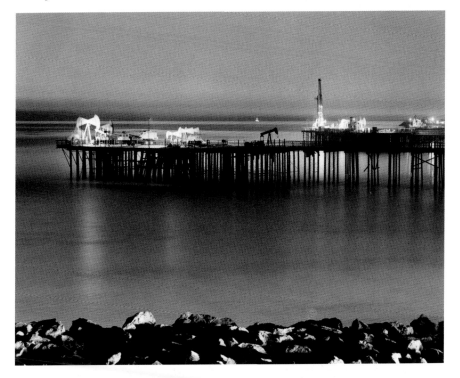

Oil Derricks on Pier,
near Santa Barbara, California
© Philipp Scholz Rittermann

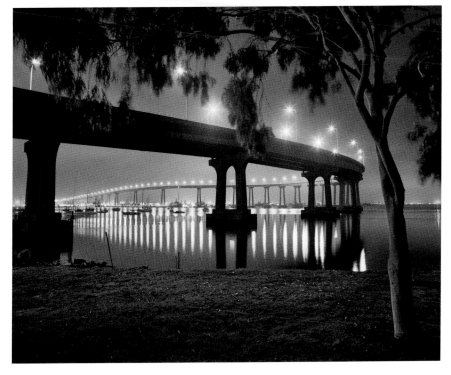

Coronado Bay Bridge and
Eucalyptus, Coronado, California
© Philipp Scholz Rittermann

Inside Cement Warehouse,
Port of San Diego, California
© Philipp Scholz Rittermann

Fishermen and Ferris Wheel,
Santa Monica, California
© Philipp Scholz Rittermann

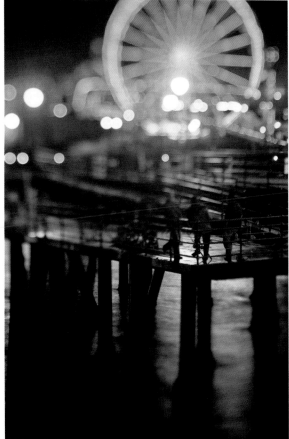

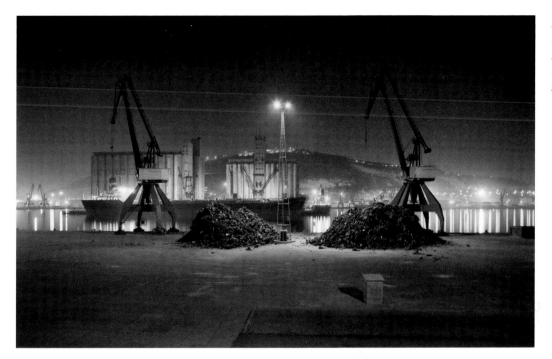

*Loading Bulldozer
at Scrap Metal Dock,
National City,
California © Philipp
Scholz Rittermann*

City Streets

© *Michael Penn*

© Michael Penn

© Kevin McCollister

© Michael Penn

© Michael Penn

© Kevin McCollister

© Michael Penn

© Michael Penn

© Kevin McCollister

© Michael Penn

© Michael Penn

Wide-Open Landscapes

A draw for any night and low-light photographer is to eventually end up in a lightless landscape. Even when our eyes can't see the gentle illumination of the moon and the stars, or the subtle atmospheric glow of a distant city as it brightens the sky, our cameras can. If there is light in the scene, the camera can record it. If you are drawn to a specific setting, set out on a night adventure to capture some truly amazing and inspirational images.

Deserts

Cardón Cactus, Yound Cirio, and Star Trails, Cataviña, Baja California, Mexico
© *Philipp Scholz Rittermann*

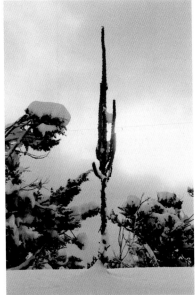

Snowy Cactus at Dawn
© *Amanda Quintenz-Fiedler*

Plains

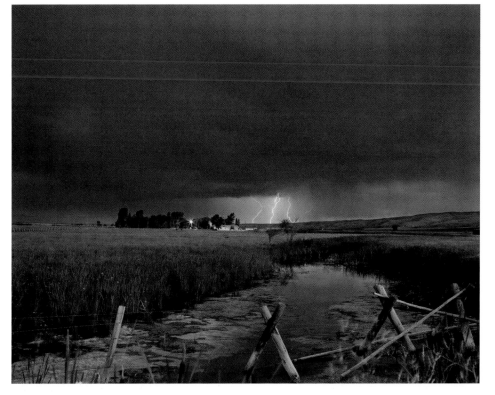

*Lightning and Farmhouse,
Western Montana
© Philipp Scholz Rittermann*

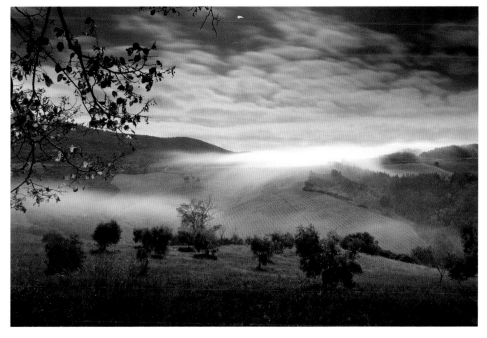

*Moonlit Fields, Radicondoli,
Tuscany, Italy © Philipp Scholz
Rittermann*

Mountains

Hoover Dam Overview, Arizona © Philipp Scholz Rittermann

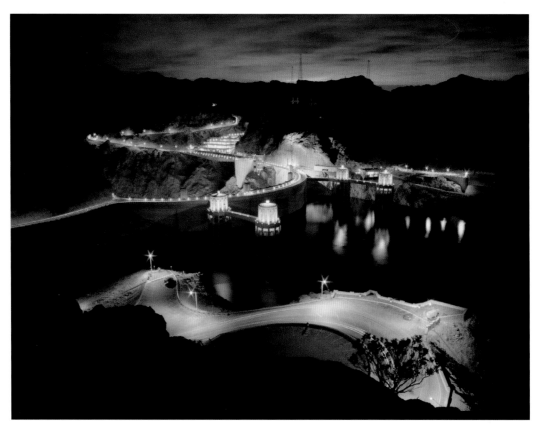

Sangre de Cristo Mountains at Dawn, Santa Fe, New Mexico © Amanda Quintenz-Fiedler

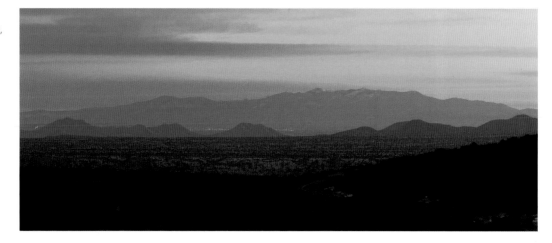

Desert Hills at
Night,
Primm, Nevada
© Philipp Scholz
Rittermann

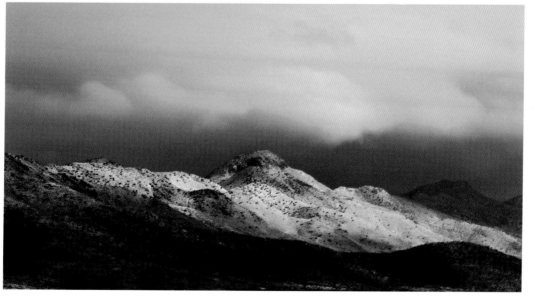

Mountains after
Hail Storm, Western
New Mexico
© Amanda
Quintenz-Fiedler

Beaches

Winter Storm, Santa Cruz, California
© Philipp Scholz Rittermann

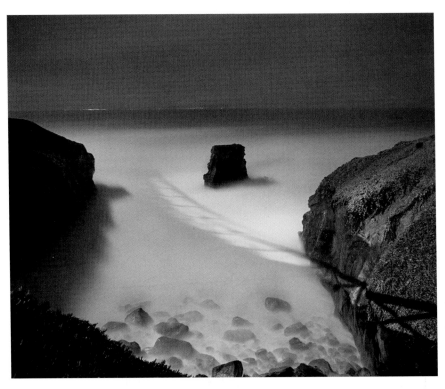

Rocky Cove at Night, Punta Cabras, Baja California, Mexico
© Philipp Scholz Rittermann

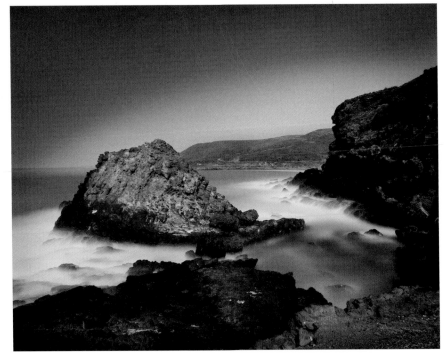

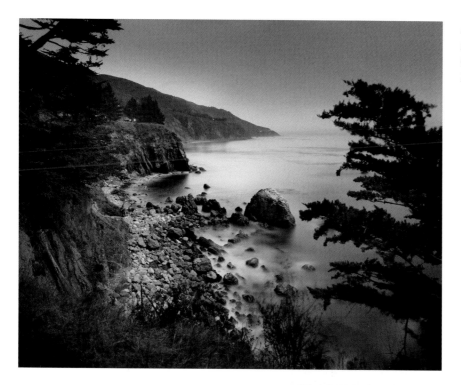

Esalen Dawn,
Big Sur, California
© Philipp Scholz
Rittermann

Atmosphere

Various atmospheric conditions can create beautiful images by diffracting light in interesting ways, obscuring information, or changing the ambiance of an overall scene. They can cause condensation on glass and reflections off pavement, and they can separate the foreground from the background. The images can be tricky to capture, but when they work, they are always worthwhile.

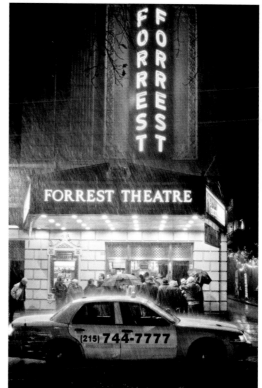

© Michael Penn

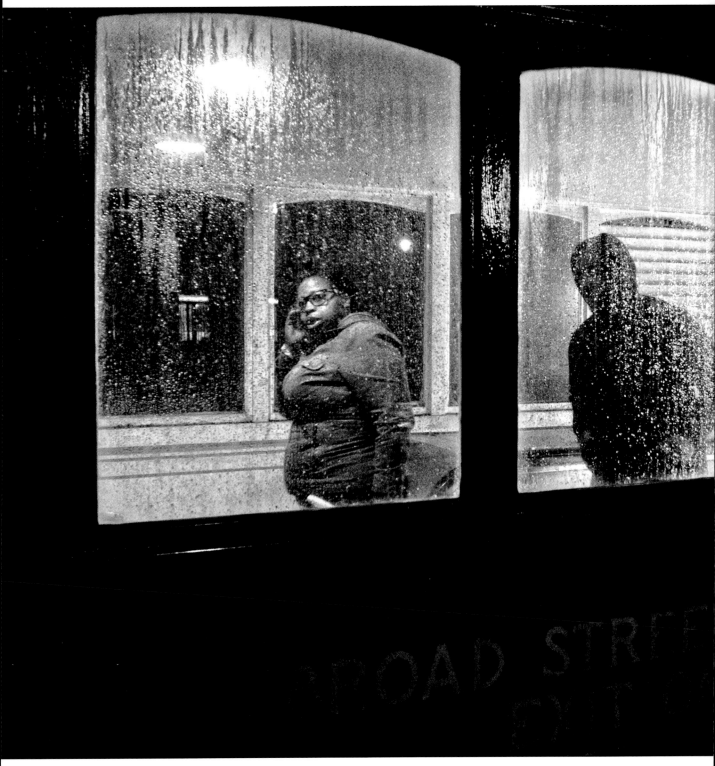

© Michael Penn

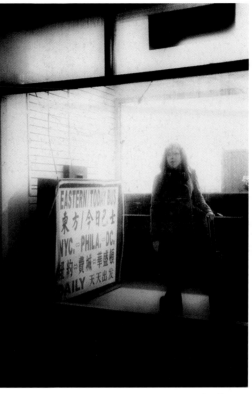

© Michael Penn

Snow-Covered Dawn © Amanda Quintenz-Fiedler

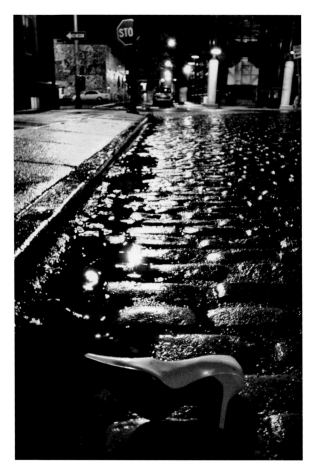

© Michael Penn

Night Movement

Motion in night photography can be a pleasure to photograph because you don't necessarily know what you're going to get. What your eye sees is instantaneous, but your camera is capable of capturing movement and active light that can show you a whole new view of the world.

Often star trails, fireworks, flashlights, and other moving light sources can create an ambiance and feel for the scene in front of you that has more visual and emotional impact than a simple capture can evoke. Open your mind to the possibilities of moving lights, and open your shutter for long exposures.

Movement in the Scene

© *Michael Penn*

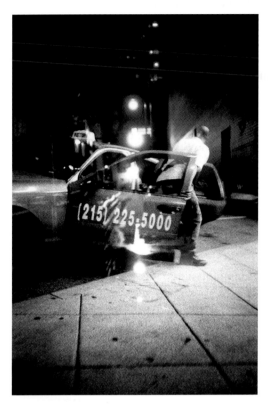

Light Drawing

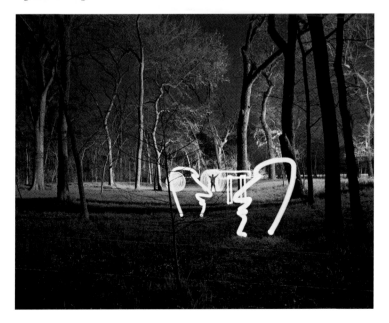

Easter Island Heads,
Botanical Gardens,
Fort Worth, Texas
© Philipp Scholz
Rittermann

Fish, La Jolla, California
© Philipp Scholz Rittermann

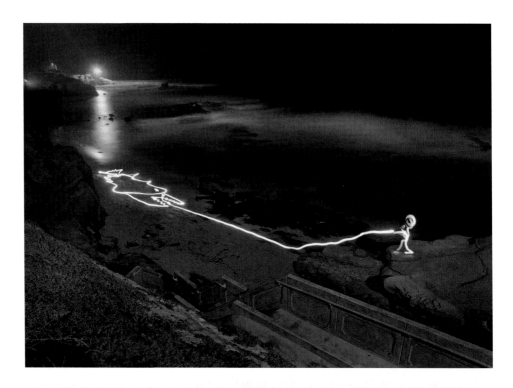

Ninety-Five-Yard Touchdown,
University of Texas, Arlington
© Philipp Scholz Rittermann

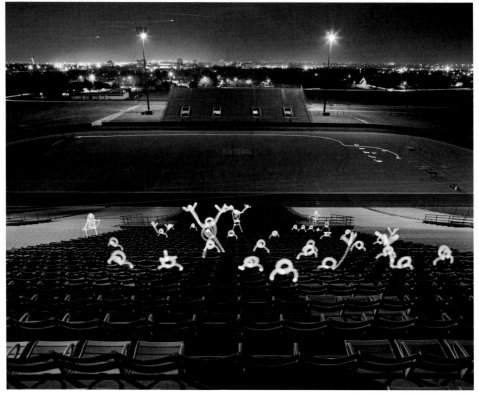

Star Trails and Meteors

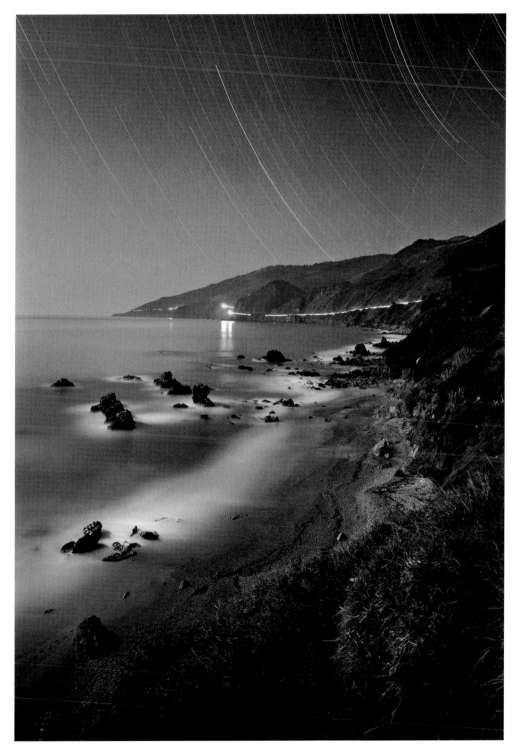

Moving Light Sources

Seven Times Forty-Five Seconds, San Diego, California © Philipp Scholz Rittermann

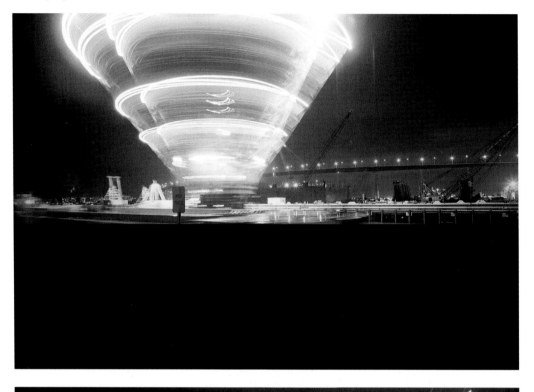

Silver Blue, Burrard Street Bridge, Vancouver, British Columbia, Canada © Philipp Scholz Rittermann

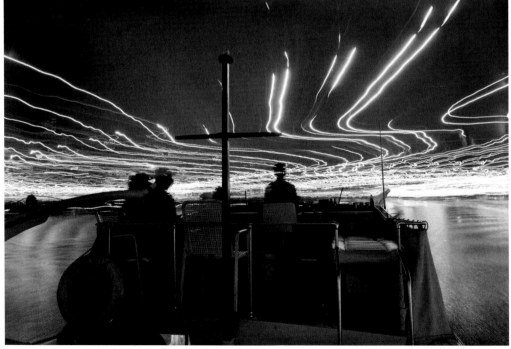

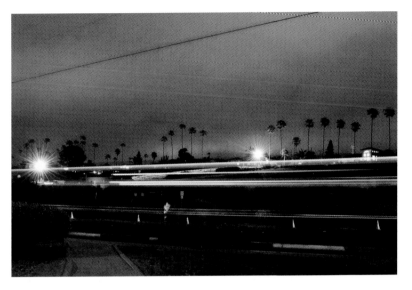

Coaster Lines
© Amanda
Quintenz-Fiedler

Combinations

Of course, any of these categories of images can be combined, as is clearly evident in the preceding pages. Never limit yourself to a specific goal. If you can find a natural environment that you illuminate with flash that has an industrial backdrop laced with fog, go for it.

Barcelona through Trees,
Barcelona, Spain © Philipp Scholz
Rittermann

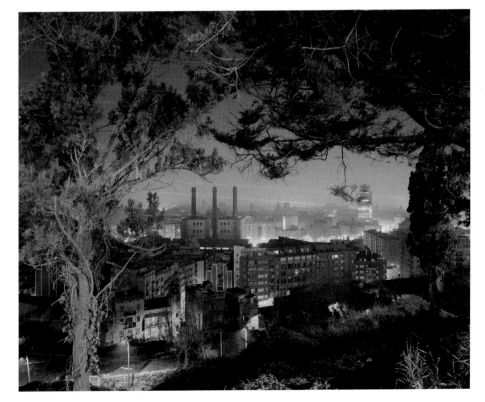

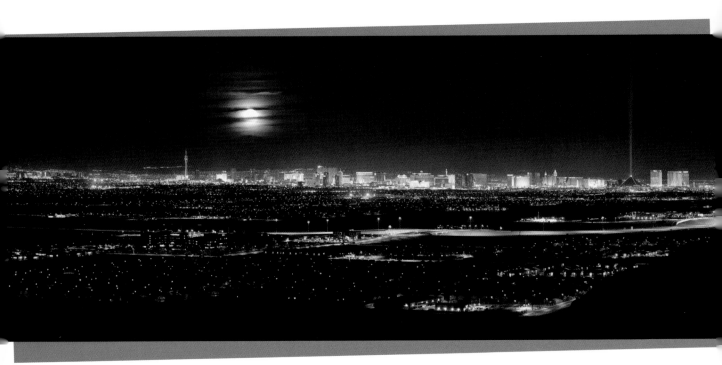

Full Moon over Las Vegas, Las Vegas, Nevada © Philipp Scholz Rittermann

Chapter 5
From Dusk 'Til Dawn

5.1 Introduction

One of the ways you can ease into shooting in low light is to naturally progress from your normal shooting situations to darker ones. What better way to start than by allowing the sunset to lead you? Your eyes will adjust naturally, you'll watch the light escaping the scene, and you can see the differences in the world around you when streetlights and house lights start to spring into your surroundings. The balance of lighting, color, atmosphere, and ambiance can create some wonderful images, and they can also serve to help guide you into the new experience of photographing in low-light situations.

When you are comfortable with that, you may notice the light getting dimmer and dimmer and the purple of dusk fading to the deep blue of night and into the blackness of the quiet hours of midnight. New opportunities arise here, with greater variance between your highlights and shadows, more contributing light sources, and altered perspective. These are the hours that will make you a veteran night shooter, with more challenges and greater rewards.

And if you stick it out through the night, eventually that deep blue returns, and fades to purple, and springs to life with the new day. Although it may seem that dusk and dawn images are the same, they can actually be quite different. The way the cool night air interacts with the warming sunlight can create fog or haze, dewdrops form on crisp, chilled leaves, and the hustle of the dusk and night have quieted as the world starts to wake.

In this chapter we will discuss all the natural environments that you can find without some of the other complications listed in later chapters, such as how to deal with specific atmospheric conditions, movement, or light painting. For now, we will allow you to roam out with the nightingales and in with the larks.

5.2 Dusk

Shooting at dusk offers several advantages—more light to see and set up your images, more comfortable surroundings, easier techniques, and ultimately a smooth transition into

Figure 5-1:

Dusk Migration at Bosque del Apache , Socorro County, New Mexico © Amanda Quintenz-Fiedler

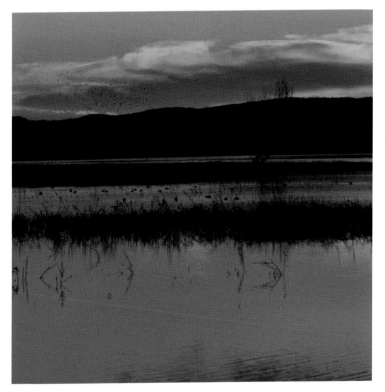

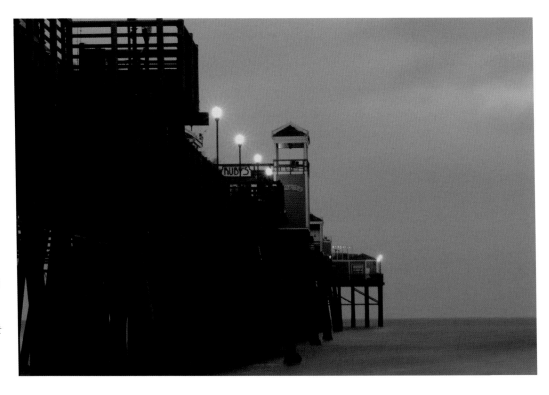

Figure 5-2:
This image was shot minutes after the sun set. The balance of the cool sky and ocean and the warmth of the lights on the pier create a pleasing complimentary look. There is still enough light to see the details in the stanchions and the sky, but if you look closely you can see that the waves have been softened by the long exposure. This image was shot at 8 seconds, f/32, ISO 100. © Amanda Quintenz-Fiedler.

low-light photography. The main drawback is that dusk shooting offers an incredibly small window of time, so you will need to be ready to start shooting, rather than heading out the door, when the light fades. So when we say dusk shooting, you should start the journey of finding your location before sunset to be sure you can capture the moody dusk light.

Start When You Can See

For a lot of reasons, it makes sense to start when you can see. You can comfortably and safely get to the location of your choice. You can head out while you are aware of your surroundings and can still see without the aid of a flashlight. This shooting situation will most closely emulate what you may have done in daylight and can help you learn the differences between standard and low-light shooting.

In dusk light, you have a good chance of being able to capture a scene in a single exposure.

If you aren't sure what you want your subject to be, you can explore, and you might even be able take some handheld shots before the light fades. You should also take this opportunity to experiment with bracketing—you might learn something, and you will be sure to get a useable image.

Meter and Bracket

When you start out with dusk light, your meter can still be reliable. At first, this can be a great tool to discover when your meter ceases to be effective as the light fades. When you are comfortable with that, you will know when to switch over from metering your exposures to bracketing your exposures. Until you are certain, though, it is a good idea to double up your exposures with a metered single shot of your scene and then a good series of bracketed images to cover your bases.

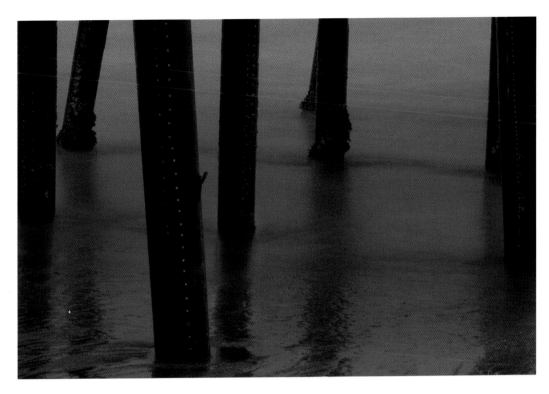

Figure 5-3:
When I created this image, the light under the pier looked black. I could see some twinkling orange reflections from the lights on the top of the pier (see Figure 5-2), but with my naked eye there was no way to tell just how much light, and color, were really affecting the scene. The camera, on the other hand, could see it all. This image was shot at 30 seconds, f/32, ISO 100. © Amanda Quintenz-Fiedler.

Because we don't plan to use these images together—we will cover that process later in this chapter—you can bracket your aperture, shutter speed, ISO, or all of these settings. Use dusk as a time to determine what sort of DOF you like and how the motion in your scene blurs at different exposure times.

Magic Hour

The time right after the sun dips beneath the horizon for the day, and for about 30 minutes to an hour afterwards, is known to photographers as magic hour. The light is soft purple and still bright enough to reveal details and allow you to take some handheld or faster shots, but it is clearly not standard lighting.

Some of the best architectural images are shot during this time, when the last remnants of sunlight are balanced with a background of dusk light. These warm tones accented by cool tones are inherently complementary. This can be especially effective when the artificial lights of the building are turned on to further accentuate the architecture and the details of the building and avoid a sea of black.

One major disadvantage is that magic hour doesn't last very long. It seems like it would last an hour, but the light can shift faster or slower depending on the latitude and the season, so don't expect to have time to get out there and set up when sunset is over. To get the best magic hour shots, be prepared and set up well before the sun goes down so you can take advantage of the diminishing light. Even then, you may get only a couple of shots before you lose the fading light.

Color We Can't See

In low light, our eyes lose the ability to differentiate colors in favor of general tonalities (because of how the rods and cones in our eyes work), but that doesn't mean the color is

Figure 5-4:
In this image, a bonfire is illuminating the sky and surrounding crowd, and it provides a little bit of smoke to add atmosphere to the image.
Easter Fire, Pohle, Germany © Philipp Scholz Rittermann.

We suggest that you start working at dusk and continue into the night to get a variety of images of the same general subject. Each of these different lighting conditions act as wonderful stepping stones from the light you are familiar with to the unfamiliar darkness.

Atmosphere at Dusk

Atmospheric conditions at dusk can be particularly appealing with the interplay of fading light on fog, rain, or another unexpected occurrence. Don't let a little weather stop you from venturing out! Taking the precautions that we mentioned in chapter 3 to protect you and your equipment from harm, and the resulting images can be well worth the effort.

actually gone from the scene. The camera can still see, and capture, different colors and how they interact with the scene.

And so it is in the light of dusk. It offers a beautiful environment that, if captured correctly, can have an overall color palette similar to daylight conditions. The differences are that grasses and trees will be softer because of slight movement during long exposures, static items are rendered more sharply in comparison to the moving elements, and the overall scene will appear more dreamlike but still somehow familiar.

Again, we have to worry about a short time frame. Dusk fades even faster than magic hour, and you can have trouble pinning down the correct exposure before the light is gone. However, in northerly latitudes during the summer, there can be hours of "permadusk," where the light stays basically the same and reaches true night after a much longer period of time. But closer to the equator, or toward the poles during winter, dusk is much shorter—if you can call the brief glimpse of winter's fading sun *dusk*. So let's assume that you are in a more generalized location and you have a time limit for your exposures.

5.3 Night

Night is the ultimate playground. When you are shooting at night, you are fortunate to have more stable lighting, uniquely altered scenes, and hours of predictable conditions. You can experiment, bracket, and evaluate your images as you take them to determine what you might want to change or do differently. Although this type of shooting might be new to you, when you are comfortable with the techniques, you can be out creating images while the majority of the neighbors are asleep.

Pocket Your Meter

One of the main differences between standard shooting and night and low-light photography is that your meter, whether handheld or in-camera, is no longer reliable. It isn't that the meter can't find a light reading of the scene, it's that you are now working with a variety of light sources that will most likely be in the image and compete for attention, exposure, and their bit of the available dynamic range on the physical

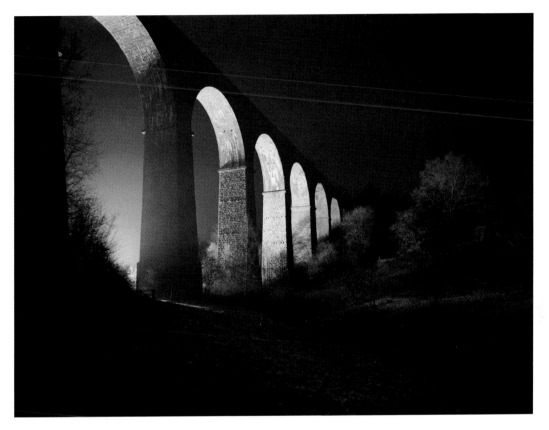

Figure 5-5:
Railway Bridge,
near Heidelberg,
Germany © Philipp
Scholz Rittermann

sensor. Your meter can't understand all this information, so it can't give you a reliable reading.

That being said, feel free to start with your meter and see what you get. In some situations, it might work well for a starting point. In others, it will be readily evident that the meter is not capable of handling the complex lighting situations we find at night.

Now is the time when you should start evaluating the histogram, like we mentioned in chapter 3. Look to see when you are getting information in the shadows and highlights and when you are losing all information to glare, or when there is too much information that results in muddy shadows and no differentiation in the highlights. Experiment with exposure times to get a large range of stops to choose from in post-processing—five stops at least—so you can be sure to have enough detail in the shadows for interest, and enough detail in the highlights to

tone glare down into recognizable, contributing photographic elements.

In the darkest scenarios, your in-camera meter will be useless. We suggest the following approach: Start your exposure sequence with a minute or two of exposure at f/5.6 (usually about two stops down from a wide-open aperture) and wait to see the result. Again, study your histogram. If you find that the image is still underexposed—most of the image information is pressed up against the left side of the histogram—increase your exposure time. If you know that your image sensor can handle higher ISO settings without gaining too much noise, you can raise your ISO to compensate for the underexposure. You can also open up your aperture, but remember that it will change your DOF.

In particularly dark environments, all sensors may gain noise. In these situations, it may be worth your time to try an experiment of

Figure 5-6:

Prop Diagonal, Shipyard, San Diego, California © Philipp Scholz Rittermann

bracketing your exposures with ISO settings instead of extremely long exposures times. To determine how your camera handles noise, you can compare two equivalent exposures where you push the ISO the same number of stops that you decrease the exposure time. For instance, an exposure of 8 minutes at ISO 100 can be compared to an image of the same scene at an exposure time of 30 seconds at ISO 1600. Depending on your camera's sensor and its ability to control noise, you may find that one or the other of these settings is more reliable at capturing images with reduced noise but reasonable exposure times. You may also find that the noise seems to be about the same for each combination, which gives you the flexibility to choose a higher ISO or a longer exposure, depending on your goals.

In the end, each camera handles these situations differently, so it is a good idea to run an easy test or two to find out what your equipment is really capable of producing. Of course, if you get new equipment, you will need to test it instead of relying on your knowledge of a previous system.

Light Stability

In most circumstances, the light you will find at night, even in an urban or industrial location, will be stable for hours on end. After the last traces of dusk have faded, you have until the earth spins back around to face the sun before

Figure 5-7:
Railway Overpass, Leinhausen, Hannover, Germany
© Philipp Scholz Rittermann

being concerned about changing light. Because of this, you have the luxury of taking your time.

Luxury of Time

When you are no longer chasing the fleeting light of dusk or trying to balance the purple of the sky with the artificial lights cropping up in windows, you can relax. Use the stable light to find the images that mean the most to you.

Since you don't need to rush, really look at your environment and possible subjects to find what strikes your fancy. Try to let go of the hustle and bustle of the day and take this moment as a meditative experience. Breathe, observe, and follow your heart. When you have time to focus on the little details, the shadows, and the

enigmas of the night, you are free to find some truly amazing images.

Mostly Stable, Most of the Time

If you are in an industrial location with standard work or safety lights that stay on all night, that environment won't be altered too much. An exception is the brightest element in a typically dark landscape—the moon. If the moon is full, the images you create with bracketing will vary, although the exposure times may be consistent, because the moon could be in a different place in each image; the shadows cast by your subjects could move, too. It depends on how long your exposure times are. When you combine the images in post-processing you can get some wonderful results, but you should be

© Michael Penn

Exceptions to the Rule

Of course, there are night scenarios where the light is completely unstable. These can be wonderful moments that are full of interest, but you will have to approach them differently. For instance, on a perfectly dark night—say, in the early part of July—you might find fireworks flooding the sky with light, shapes, and colors. Or if you venture out to take pictures of a steel mill, you might find that when they pour the slag out, the billowing clouds of steam reflect a great deal of light and can alter your exposure.

As with everything, evaluate your specific situation and make adjustments as needed. Don't be afraid of something unfamiliar—that's where innovation usually finds its path.

Capturing Images for Expansion

If you want to increase your dynamic range beyond what your sensor is capable of, you need to bracket your images with the intention of expanding them in post-production. The expansion techniques are covered in chapter 10, but you can use that process only if you capture the images correctly in the first place. Follow these guidelines to ensure you have perfectly registered (aligned), bracketed exposures over at least a five-stop range to create expanded dynamic range images in post-production.

Camera Settings

Start this process in the light—at home, in your car, or with a flashlight—before you set up the camera:

aware of these potential changes when you shoot in a relatively bright landscape under a high, full, unobstructed moon.

A waxing or waning moon, on the other hand, won't pose as much of a problem and is therefore a less critical consideration. It is important to be aware of where your light sources are coming from and how you can avoid complications.

1. Set your camera to capture images in RAW format. This will ensure that you record the greatest amount of information in every exposure, and it will give you the greatest flexibility in post-production.
2. Select a low ISO setting to minimize noise. Use your camera's native ISO whenever possible.

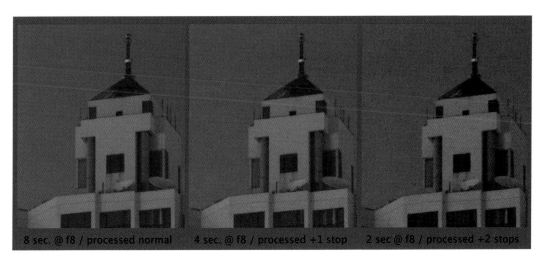

8 sec. @ f8 / processed normal 4 sec. @ f8 / processed +1 stop 2 sec @ f8 / processed +2 stops

3. Turn on your camera's noise reduction system if it has one. Use a moderate setting if you have a choice. Avoid using a setting that will prevent the camera from capturing successive exposures, because the processor is busy running a noise reduction algorithm. You need to capture several images without waiting for the in-camera processor.

4. Turn off your camera's AF function.

Camera Setup

Now take your camera to the scene and find the perfect location to spend some time. Remember, the photographic process can be arduous, so don't choose a spot that you can stay in for only a limited amount of time. Make sure you can set up camp and see the process through to the end. It will be worth it.

When you have found a good spot, follow these steps:

1. Set up your tripod on sturdy ground and, if necessary, use additional weight to ensure it doesn't move around.

2. Attach your cable release or electronic remote to your camera so you don't have to touch the camera after it is set up.

3. Set your focus manually. If you can't see well enough in the dark to focus manually, use the AF function, but you must turn it off again before you take a picture to prevent the camera from trying to refocus before every shot. If your camera has it, use the digital zoom-in feature in live view to help you achieve focus. (Note: If you are using a zoom lens, be sure to pick the focal length first to prevent the focus from drifting when you adjust the zoom. When you zoom in on a detail to focus it and zoom out again to compose your image, it does not mean your focal plane will be the same! Pick the focal length, then focus the lens.)

Determine your exposure for sufficient highlight, midtone, and shadow detail. Noise is most prevalent in smooth midtone and shadow areas. It is better to overexpose and underdevelop midtones and shadows, rather than trying to lighten them. Compare the three 100 percent crops in the following figure, and notice the marked increase in noise from right to left. The images have been processed so they have approximately the same tones. That requires increasing amounts of compensation, which causes increased amounts of noise.

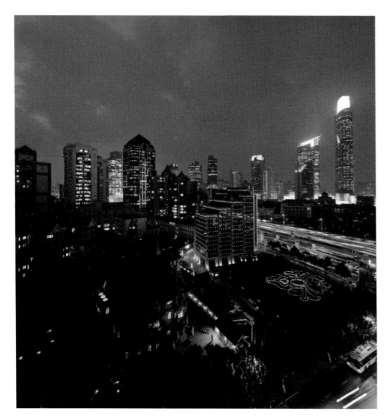

Figure 5-9:
In this image of downtown Shanghai, the colors and light filling the sky never really change at night. You can therefore create an image with a different type of appeal than a similar skyline with a black night sky as a backdrop. Dusk Skyline, French Concession, Shanghai, China © Philipp Scholz Rittermann.

Image Capture

Now you're ready to capture your images. Recall from chapter 3 how to evaluate your histogram to determine the appropriate range of exposures. There is no hard-and-fast rule, other than covering your bases. But after you figure out your base exposure, you can bracket to ensure you have information to use in every aspect of your final image:

1. Make a series of bracketed exposures using a cable release or an electronic remote to ensure that you won't need to touch your camera during bracketing.
2. Bracket with different exposure times (e.g., 10 seconds, 30 seconds, 1 minute). Try to bracket at least five stops:
 a) A stop of light is equal to twice (or half) the amount of light hitting the sensor as the previous stop. With bracketed exposure times, that means twice (or half) the amount of time from one exposure to the next.
 b) If you shoot an image with a 1-minute exposure and it looks like a good base image, you will need to take four more exposures to end up with a bracket of five stops. Double the base exposure to 2 minutes, and double it again to 4 minutes. Then halve the base exposure to 30 seconds, and halve it again to 15 seconds.
3. Don't change the aperture because the DOF will change, and it requires you to handle the camera. Both of these factors will cause the exposures to be misaligned.

Elusive Dark

In urban areas, you may find that you can't get a rich black sky. The atmosphere may always be illuminated with city light bouncing off the urban haze. These situations won't ever get fully dark because cities never sleep. After the sun goes down, streetlights, billboards, neon signs, and cars cumulatively illuminate the environment.

These urban environments create their own sort of permadusk. Rather than scoffing at the state of the world, take it as an opportunity to use this faux dusk as a backdrop for your urban images. You may be particularly happy with the results.

Night for Day

Hollywood invented the concept of shooting day for night—placing red filters over lenses and underexposing the frames to emulate moonlit scenarios—because the film was not capable of adequately capturing the scene at night.

Why not alter that to night for day photography? If you take an image at night and expose it long enough, you can get an image that appears

to be shot in the day, with some notable exceptions. Some edges might be soft, with elements moving slightly during the long exposure. Or if you look closely into the brightened sky, you can see hints of star trails. What works so well here is that you get an ambiguous time frame. Distant lights on the horizon can seem like a sunrise or sunset against a deeper blue sky than you see in the day. But those lights are distant cities, and that blue is the great expanse of night sky.

All of these elements create a mood that you simply cannot find during the day. Depending on the mood you want to inflect in the image, you can increase or decrease the exposure to create images that are more questions than answers. These kinds of images are prized because images with no puzzles to solve don't hold our interest. They engage the mind longer because we intentionally obfuscate when the image was taken. That ambiguity makes for wonderful, challenging images.

Figure 5-10: *Believe it or not, this image was shot at 9:00 p.m., well after the sun had set. There are some indications that something isn't right, in terms of daylight exposure, which adds to the interest of the image. For instance, the colors are slightly off. Rather than normal blue shadows, these have a purple hue, not because the image was modified, but because the normal blue has been shifted by the light of a nearby city illuminating the low cloud cover. And the light on the branch is coming from a low angle, which is impossible in daylight, because the sun casts shadows downward. The light is coming from passing cars on a roadway just beneath this hillside. Although the stump is crisply focused, the leaves on the nearby shrub are soft, not because they are out of the focal plane (even though it is hard to tell), but because a slight breeze was moving them. This image was shot at 4 seconds, f/2.8, ISO 3200. Underlit Stump © Amanda Quintenz-Fiedler.*

Disadvantages

Of course, there are disadvantages to shooting at night as well. As we discussed in earlier chapters, you may be wandering around very dark surroundings. This can compromise your safety both in the sense that you can stumble and potentially harm yourself, or you may be exposed to unsavory individuals that seem more prevalent at night.

Photographically, you might find you have an incredibly bright subject with a difficult and very dark background, making your array of bracketed exposures seem unwieldy.

Yet innovation and creativity cannot be stifled because of a few obstacles. You can take measures to protect yourself and your equipment, and you can embrace the situations that seem photographically untenable. The most important thing is to try to photograph what interests you. You may fail, of course, but you also may succeed. If you don't try at all, you won't have the opportunity to get those images you are picturing in your head, so getting out there, safely and with patience, is the first step.

5.4 Dawn

Although it may seem like dawn light is the same as dusk light, it is actually very different. From an obvious standpoint, the direction of light will be different and ultimately result in a different look on certain subjects, but it is also different in other ways. Dawn is the beginning. For the most part, cars haven't been bustling about and filling the air with exhaust, the colder night air condenses into dew on your surroundings, and lights start turning off as colors start coming back into the sky.

Yet there are some similarities to dusk shooting that should be considered. The light changes very quickly. But now, instead of chasing fading light to get that different perspective, you are running ahead of the standard, familiar light. Images that you see and want to capture might be gone in the blink of an eye, and it's not as easy to set up your equipment in the predawn hours as in the evening light.

We find that it is easier to work while chasing the light—moving from dusk into night—than it is to be chased by the light—moving from night into dawn. But there can be some wonderful atmospheric conditions that are more prevalent in the dawn because of the change from colder air to warmer air. Plus you might find that you are even more alone in the dawn hours than in the night hours, so the added meditation of watching the sun rise can be a reward of its own.

With dawn shooting, if you make it all the way through the night and into a new day, find out what types of interesting moments you might get due to morning fog, empty streets, and dew-covered parking meters, and make images that are pertinent to dawn as its own time of day, rather than the little sister of dusk.

© Michael Penn

General Fog Blanket

Fog entirely alters the landscape. As you move through a scene, elements will disappear that are normally there and leave you with only your immediate surroundings that have themselves faded into the mist. Walking a few steps in any direction changes your entire perspective, and can make you sharply aware of your surroundings in a way you weren't before.

When you shoot around artificial light sources in fog, you get a unique type of light. Streetlights, for example, are still bright enough to fill the scene with light, but they no longer look like glare bombs; rather, they provide softened, diffused illumination that creates halos of light as far as the fog will let the light flow. In these types of situations, you can position yourself to backlight or illuminate your subjects with an even, ethereal light that is fairly evenly represented, creating a silhouette or a softly lit subject that is taken out of context.

Low-Moving Fog

Low-moving fog can creep around the ground while maintaining sharper detail and contrast in the higher areas of the landscape. It generally has a tendency to move more independently, creating areas of thinner and thicker fog, which leads to interesting fluid changes from one image to the next.

These images can reveal improbable flows of white wisps throughout the image while maintaining a normal night landscape in fog-free areas. It is a perspective and a look you can get only with low-moving fog. You should take advantage of it whenever you see these conditions forming.

Generally, low-moving fog can be found in damper climates in hollows or low-lying areas, but be observant. When the atmospheric conditions are right, low-moving fog can appear in nearly any part of the world where the climate gets just cold enough to condense the moisture in the air.

something in particular that you always wanted to capture, but stopped because the natural background of the subject is distracting, fog can help to differentiate your subject and diffuse or completely obfuscate the unwanted background. Fog can separate your subjects, create an eerie mood, or even provide unprecedented motion capture in the most unlikely places.

Chapter 6
Atmospheric Conditions

6.1 Introduction

Atmospheric conditions can make for interesting images at any time of day, but at night can add to the already enigmatic feel of the scenes you are creating. Atmospheric conditions transform the world and provide an ever-changing canvas. If the atmospheric conditions change, and you return to an area you have photographed in the past, we guarantee it will be different and you will notice things you completely ignored before.

In this chapter we'll give you some advice and tips on how to shoot atmospheric conditions and what type of elements to look for; we'll also encourage you to keep your eyes open for changing conditions and to take advantage of them.

Fog

One of the best things about fog is that it has a tendency to scatter light into areas that might not otherwise be visible and simultaneously obscure your subject's surroundings. If there is

Figure 6-1:
In this image we have smoke instead of fog. It works in much the same way and is equally un-predictable. Although you should of course always be safe, keep your mind open to the possibilities.
© Michael Penn

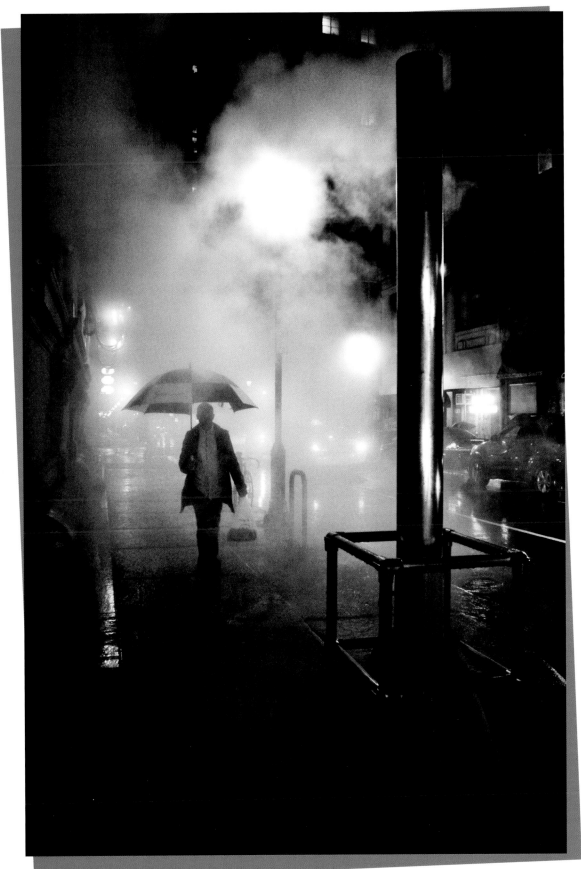

© Michael Penn

Fog and Moonlight

Moonlight and fog are old friends and make for wonderful images. Similar to artificial lights, moonlight coming through fog will diffuse and scatter throughout the scene, but it will also come from a different direction and can often be seen as a specific globe of light in an otherwise lightless scene.

Depending on the nature of the fog, you can sometimes catch a glimpse of the moon more clearly through the fog and establish a particular mood, akin to the moors of Sir Arthur Conan Doyle. These types of images can trick the brain to seek out the dark shadows for peering eyes and lingering threats.

Shooting in the Fog

Although most of the shooting information we've discussed will apply to capturing images in the fog, there are times when the blanket of fog isn't as reliable. In cases of moving or thin fog, or at dawn when the heat of the sun might start to clear the fog away, you may want to be more nimble and mimic the ebb and flow of the fog you are trying to photograph.

In these situations, you should skip bracketing. We know! We've been hounding you about bracketing, but in this particular situation, when you need to keep on your toes to capture the moments that are happening too fast to bracket accurately, you'll be better off finding a way to stay fluid with the scene. That doesn't mean you should abandon your tripod and skip using long exposure times, but try to capture the correct image the first time, when the fog and the scene are perfect, and don't try to flesh out the final image with details that will likely change before you get the chance to complete a full range of bracketed exposures.

Our number one recommendation for foggy conditions is to get out there and shoot. You might come back with some of the best images you'll ever get at night.

© Michael Penn

Rain

Rain may seem like an atmospheric condition that isn't very unique, especially if you live in a particularly rainy environment, but keep in mind that rain, like fog, changes your natural environment and creates some interesting new natural effects. Anything that alters the scene is worth exploring and considering, and rain can actually be an extraordinarily transformative element.

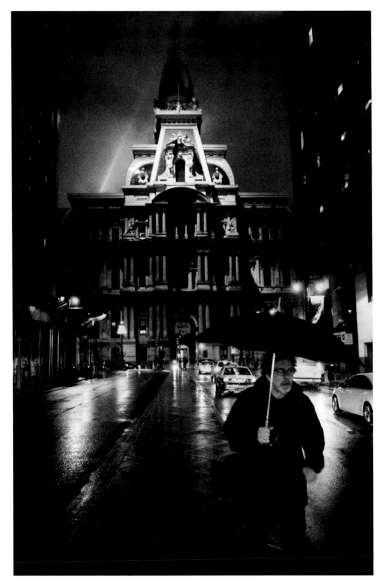

© Michael Penn

Using Rain

Rain is clearly different from fog, and taking an image of a rainy scene can cause a mixture of diffused and dispersed light that can be magical. Tiny pinpoints of light can add a bit of twinkle throughout your scene, and in a longer exposure create little streaks of light or an overall haze. Inherently, rain also comes with clouds, which can sometimes be moody, stormy clouds that enhance your scene. The resulting effect of

capturing rain can be similar to fog, but you will be able to see more of your landscape, even all of it, with just a hint of something coming between the camera and the environment.

Rain will also alter the surrounding environment, creating droplets on glass and turning some surfaces into mirrors. In a rainy situation, don't just look for the slanted streaking rain in front of the subject, but look around, behind, and through the rain to see if there are other interesting perspectives that have been altered by the weather.

Wet Pavement

One thing rain does beautifully is give new life to standard parts of your scene, particularly elements like pavement. Wet pavement creates mirrors, ranging from pinpoint puddles to whole swatches of reflection. These pavement mirrors can reflect portions of cityscapes that otherwise aren't there and allow you to see things in a whole new way.

Any reflective surface has two modes, reflection and absorption. If, due to the angle between you and a puddle, you can see a reflection of something, it will be upside down in your image. If your angle to the puddle doesn't reflect anything, except for the night sky, the puddle will look like a black hole. One problem with this is that pavement, even when it's dark, still has enough texture and surface to accept and bounce a bit of light back into your scene, but a black hole reflection sucks the light out of the scene, causing much greater contrast.

Your pavement mirrors might also reflect pinpoints of light, creating even more potential glare.

Shooting in the Rain

We probably don't need to remind you, but be sure to protect your equipment in the rain. You want to prevent moisture from seeping into your camera or lens elements and corroding the vital internal components. So do your best to

© Kevin McCollister

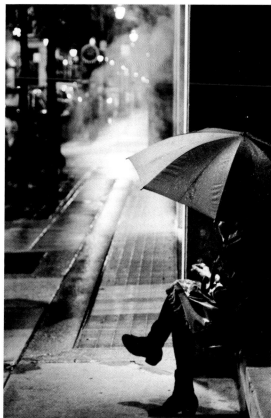

© Michael Penn

make sure you are minimizing the exposure of your equipment to water.

When your equipment is protected, you can approach shooting in the rain in much the same way as an ordinary scene. You can capture discrete moments if the subjects within your scene are scurrying around and you want them to be recognizable, or you can use long exposures to blur the effects of rain and the surroundings, focusing instead on solid items that aren't affected by the rain. When you are working with wet pavement, you may need to capture a wide bracket to be sure you can control the real scene, the reflected scene, and all of the potential glare and pinpoint reflections that will come with the wet environment.

Consider the difference between shooting a reflection during the rain versus after the rain.

During the rain, the reflected areas might be slightly fuzzy because the rain hitting the puddle will cause ripples that change the perspective of the scene right before your eyes. Waiting until the rain stops can allow you to capture a perfectly crisp rendition of your scene reflected in the pavement pools while maintaining a great deal of the mood of the original storm.

Consider taking images both during and after the rain. Perhaps you can use them together, or just determine which ones you prefer.

Rain and Fog

Sometimes you may be lucky enough to have lingering fog and a light rain at the same time. This is yet another situation where the environment will be changed by atmospheric

Figure 6-2:
Pavilion, Hofgarten,
München, Germany
© Philipp Scholz
Rittermann

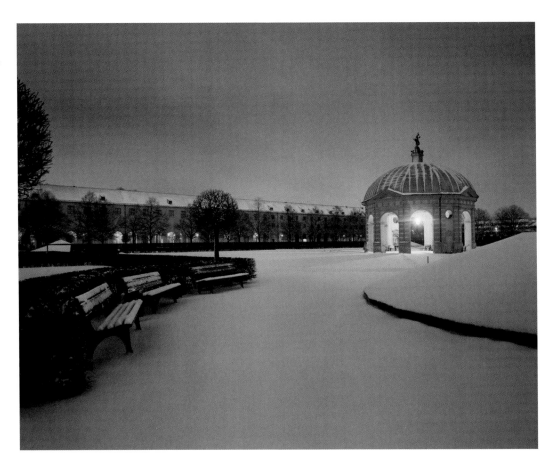

conditions, so it is worthwhile to go out and explore this situation, even if you already have rain and fog shots of the area.

Snow

Snow is vastly different than both rain and fog. It travels more slowly, blankets the ground in white, and can create the feel of a hush over a sleeping city. When photographing snow at night, you will find that your exposure times might be quite short. The white of the snow covering the landscape provides a diffuse reflector that bounces light back into the scene. If the snow is settled and the clouds have passed, the scene can be quite bright.

If you're photographing an urban environment, the snow transforms the space. The way the snow catches on buildings, streets, bridges, and every aspect of the city creates soft edges. The snow acts as a sort of baffle, knocking the harsh edges and shadows down and providing a calm, even, unifying look to the photograph. Photographing snow on a landscape catches the silence of the city at night.

If you're photographing in driving snow, you can get an entirely different look. The conditions are a mixture of harsh and tranquil, where the driving snow brutally scrapes the scene and the fallen snow blankets it in white.

Shooting in the Snow
Just because the snow can seem quiet and tranquil, don't forget that it is ultimately water! Of course, driving snow will be more damaging to your equipment than resting snow or lightly

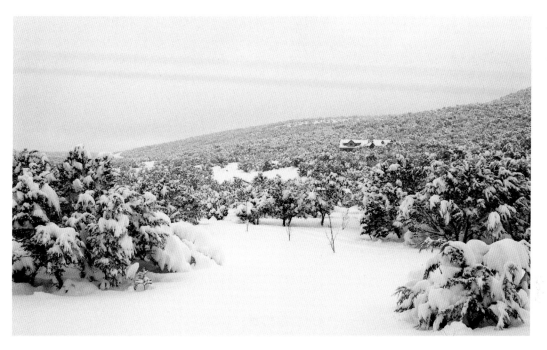

Figure 6-3:
Snow-Covered
House in the Woods
© Amanda
Quintenz-Fiedler

falling snow; regardless, take precautions to protect your equipment from the effects of water.

When shooting in snow, you should also prepare for colder temperatures since snow is possible only in freezing conditions. Be sure to dress appropriately and bring extra batteries. Store your batteries as close to your body, or other warm source, as possible while you aren't using them. It also can't hurt to have a thermos of hot cocoa or coffee to keep you warm.

Because the snow might allow shorter exposure times, you can experiment with very small apertures or maybe use fewer brackets to get an accurate range of exposures. Snow images shot at night might be more forgiving with exposure times, even if they aren't as forgiving for exposed noses and fingers.

Low Cloud Ceiling

A low cloud ceiling can be a wonderful aid in night photography, especially if you're working in an urban environment where there is some artificial light that can reflect off the clouds and illuminate the scene in an unusual way. It can also separate buildings or other tall objects from the background of a perfectly dark sky, giving contrast to the subject.

Depending on the environment you're working in, a low cloud ceiling may even pick up different colored light sources, creating an implausible canopy in the sky that could be particularly interesting if rendered in color.

Moonlight

Moonlight may not seem like an atmospheric condition, but you can approach the same moonlit scene at different phases of the moon or different times of the year and come away with very different images. Shooting moonlight images can be a natural starting point for photographers who are new to night shooting. These types of scenes should be considered for their versatility and their predictability.

Basics of Shooting in the Moonlight

Moonlight is nothing more than reflected sunlight. Because of this, you can set your white balance to the daylight setting and rest assured, it will be accurate. In a dark enough environment—such as a natural landscape far out of reach of the ambient lights of a city—moonlight can actually function like sunlight, with a few differences.

Night for day images that you create with moonlight will still reveal objects' shapes and shadows, but the edges of both might be softened with a longer exposure. Or a solid, unmoving object might have an unusually soft shadow as the moon moves through a long exposure time. Shorter exposures at higher ISOs can also simulate the sun, but the appeal of moonlit landscapes is still different from standard landscape shooting.

If you photograph a moonlit night with scudding, moving clouds crossing in front of the moon, you end up with softened contours on the moon and direction and movement to the sky.

With a moon that is not full, your exposures can stretch for hours, but with a full moon you might have enough light for a relatively short exposure that appears to stop the motion of the moon in the sky. Experiment with different looks for each type of exposure and find what works best for you. The moon will rise again tomorrow if you wish to try something different.

Moon Trails

If you want to record a moon trail across the sky, you are going to be rooted to one location and perspective for a long time. Be sure to set up your tripod and camera carefully so you don't risk ruining your images due to slight movements of the camera during the hours that you will be photographing.

If you want to record a moon trail over a two-hour period, start with a waning moon that rises well after sunset to be sure you won't get unwanted illumination from the dusk light or overbearing exposure from a full moon. To get a rising moon that anchors somewhere in the landscape, start your exposure before the moon enters the scene, or before the moon enters the frame and leaves the frame. In this way, you can create either a moonrise or a moonset, but you won't have a hanging, disembodied trail of light that isn't rooted to your image.

After you've determined your composition, decide on your exposure. For instance, you can

Figure 6-4:

Icicles by Moonlight
© Amanda
Quintenz-Fiedler

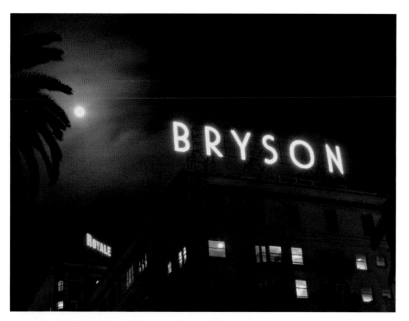

© Kevin McCollister

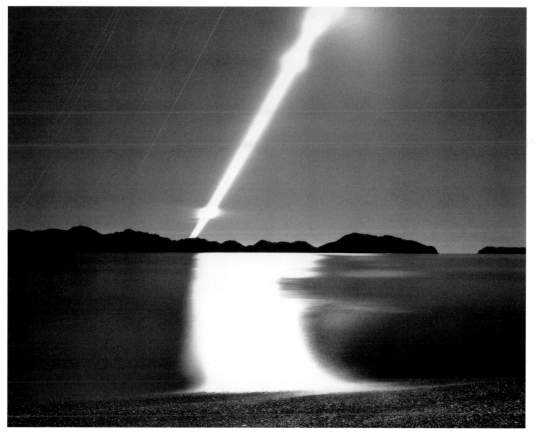

Figure 6-5:
Lunar Ascent, Bahía de Los Angeles, Baja California, Mexico © Philipp Scholz Rittermann

Figure 6-6:
Solar Eclipse,
May 20, 2012
© Amanda
Quintenz-Fiedler

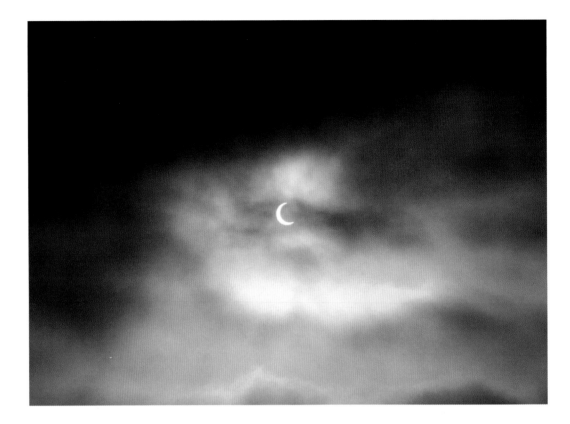

take 60 exposures at 1 minute each and get an hour-long moon trail when you composite the images together.

With your noise reduction disabled, either set your timer to take 1 minute exposures consecutively for the entire exposure time, or be aware of your exposures so you can take consecutive exposures for the duration of the trail. Repeat this exposure from before when the moon enters the frame until after it has left, either from horizon to sky or sky to horizon, based on your preference of moonrise or moonset.

Your resulting image will be a continuous trail of stars and moon—the firmament above us—as seen from the earth spinning far below. More information on how to composite these images can be found in Part III of this book.

Again, with the moon as a subject, as with all atmospheric conditions, every time you go out into the world to photograph, you will return with something a little different. So don't hesitate to approach the same situations again and again with only seemingly slight differences in conditions or lighting. You never know what you're going to find on a given excursion.

Other Conditions

Be aware of other less frequent atmospheric conditions that you might be able to take advantage of. Forest fires, from a safe distance, or the occasional solar eclipse might make for some beautiful and unexpected images.

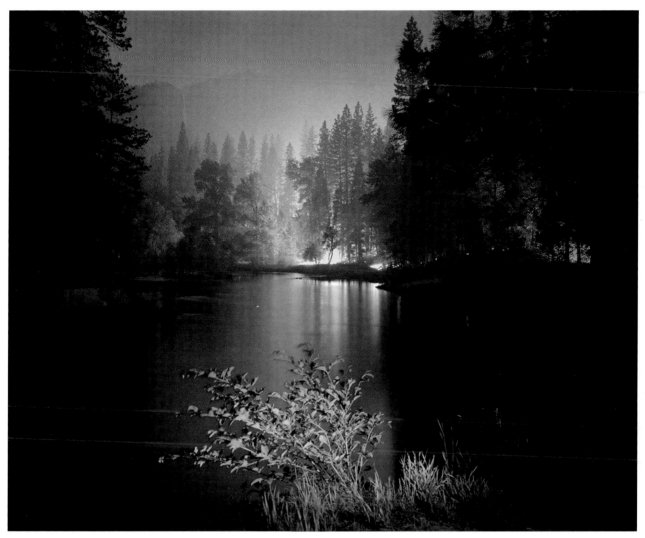

Figure 6-7: *Prescribed Burn, Yosemite National Park, California © Philipp Scholz Rittermann*

Night Fishing © Amanda Quintenz-Fiedler

Chapter 7
Movement

7.1 Introduction

One of the main reasons we work with long exposures at night is because it changes the way we see the world. Not just in the way things are illuminated, but in the way they are captured on the image sensor. Things we cannot perceive with our eyes are suddenly transformed into ethereal shapes or wisps of subjects and surfaces. A sea at night can turn into an opalescent scene. Clouds moving through the sky turn into omnipresent ghosts watching over everything. The movement of water tumbling on a beach or foliage swaying in the breeze turn into ethereal elements that aren't there during the day. As night photographers, we want to capitalize on these effects.

Why We Use Long Exposures

Movement and how we render it is one of the main tools we use to create atmosphere in a night photograph. To blur movement, everything at night is already working to your advantage. You are already going to be working with low light, you can leave your camera at its native ISO setting, you can stop your lens down to your desired aperture, and everything that is moving is by default going to be blurred. This makes blurring movement in an image easier to achieve at night than with stopped motion.

That being said, some of the most interesting effects that we can generate are actually a balance of sharply rendered elements of the scene and blurred elements. For instance, think of the difference between frozen water crashing onto the beach in a broad daylight image versus the soft, liquid look of that same scene in low light with motion. It is important to note here that we are achieving the sharply rendered and smoothly blurred elements of the image, not through DOF, but through the natural movement of certain portions of the scene, such as people in a market or tall pine trees in the wind.

As night photographers, we need to balance the two elements in whatever way makes sense for our scene. Sometimes the long exposure itself will allow the edges of certain elements—such as the sharp, abrasive leaves of a palm tree—to soften slightly without losing the overall sense of focus and clarity within the image. Other times we need to take more specific action to render elements of our images more clearly, such as balancing our overall image with an off-camera strobe, or making different choices with aperture and exposure time to get the right mix of recognizable subjects and blurred motion. In this chapter, we will cover all sorts of methods to capture motion in your images at night.

7.2 Blurring Movement

Perhaps the easiest place to start with movement is to take advantage of the conditions you find at night and try to create the best possible RAW file. By that, we mean that you can use your native ISO, a stopped-down aperture for a long DOF, and whatever exposure time will give

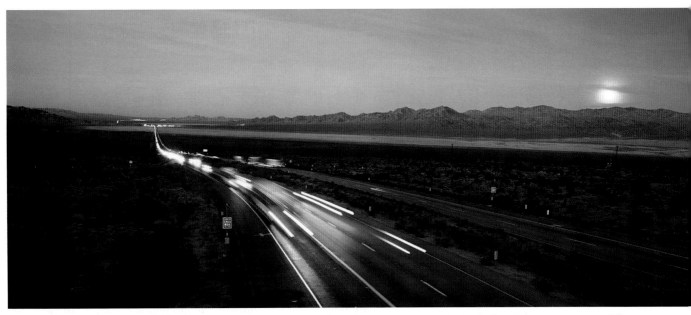

Figure 7-1: *An image like this one, of a freeway in low light, creates anonymity with the individual vehicles while giving a sense of the larger experience. Interstate 15 at Dusk, near Primm, Nevada © Philipp Scholz Rittermann*

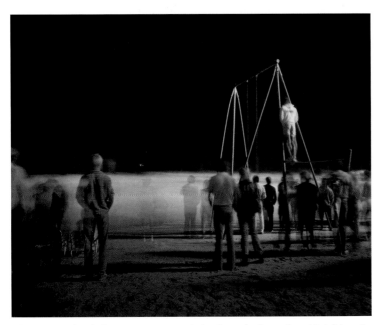

Figure 7-2: *The slight movements made by the onlookers of a midnight surf contest create an interesting and nearly stationary perspective, while the ocean in the background becomes completely blurred and a wash of white. Midnight Surf Contest, San Diego, California © Philipp Scholz Rittermann*

you the correct histogram, which, of course, will depend on how much light is in your scene to begin with.

Think, for instance, of the classic freeway at night image. Instead of getting bogged down with the stopped motion of individual cars, makes, models, and license plates, you get a sense that the freeways themselves are arteries. There is one giant stream of white headed in one direction and one giant stream of red in the other. The metaphor of the image becomes clear and visually much more appealing than the same image with discrete vehicles frozen in time. This also allows the infrastructure of the freeway to become clear—the architecture, the placements, the sturdy and solid foundation of the arterial system we use day in and day out in our lives. An image like this switches the focus from being an individual with personal automotive taste to being part of a moving, living system.

In a similar way, you can find something that we normally perceive as discrete components

and give it an entirely new meaning with blur and indistinguishable characters. Take, for instance, this image of a midnight surf contest. Instead of seeing the surfer stopped in action at the top of his peak, we can get a sense of the experience of surfing with a more fluid representation of movement and action.

Ultimately, you are already set up for capturing blurred motion when you shoot at night, so your main goal with blur is finding a subject that will be interesting to render with motion. This may take a bit of searching, and you may find it right away, but be sure to utilize this type of capture in your night photography. If you don't, you aren't taking advantage of one of the most intriguing ways that night photography can manipulate perception.

7.3 Distinguishing Movement

In some situations, movement in your scene can obscure what it is you are trying to show. Think, for instance, of a tree blowing in a hearty wind. If you leave your shutter open too long, you may lose all of the tree's definition. Yet if you take that same tree with a shorter exposure time, you will still be able to distinguish that it is, in fact, a tree. In most situations with bustling people, you might find your images more appealing if you can recognize the shapes and actions of individuals rather than blurring them out completely. Yet in this situation, you might still find a balance between the subject's movement and rendering truly discernible features. The identities of these people are probably not as important as the ambiance of the scene, but to get that atmosphere, the viewer needs to at least be able to determine that the colorful blurs in the scene are actually people in motion.

If you have a scene at night with a subject that has movement you would like to render in a recognizable manner, you have to make some compromises. Rather than using the

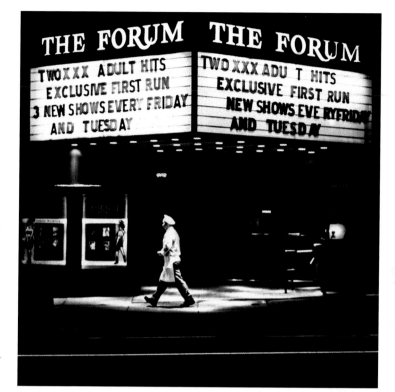

ideal settings we have talked about, you will be forced to use shorter exposure times, which will force you to use higher ISO settings and wider apertures. Yet we can still find a way to maximize these settings to get the best possible image without sacrificing all of your techniques.

If this type of image is your cup of tea, you might want to investigate equipment that will help you maximize your shooting experience in more complex conditions like these. Look into getting the fastest lenses you can, which means the widest possible aperture (such as f/1.4), and crisp, clear glass. You also might want to invest in a camera that has excellent noise control at higher ISOs, but it will be more expensive. If this is what you really want to shoot, it may be worth the cost up front to save you agony and trepidation later with files that are hard to work with and missed opportunities.

Figure 7-3:
In an image such as this, you can set the camera up for a moment that you can anticipate. Even if the man in the image isn't there to begin with, the light under the marquee is bright enough and distinguishes the space beneath it well enough that you can expect to get a good shot. With a little bit of patience, you can snap the shot when someone walks through. © Michael Penn

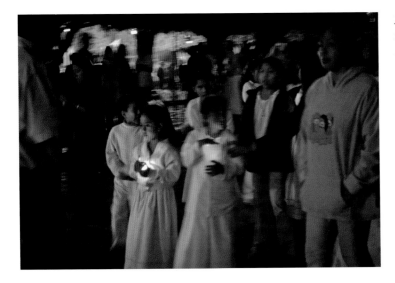

Figure 7-4: *In this example, it is important to recognize that these are people walking in a candlelit procession. The exposure is not so long that only a sense of light and motion comes across. To accomplish this, a balance was struck between a wide-open aperture, a high ISO, and a relatively short exposure time. Otherwise, we would not be able to see enough of the scene to relate to the moment, which, in this case, is the entire reason to take the picture.* Candlelit Procession, San Miguel de Allende, Guanajuato, Mexico © Philipp Scholz Rittermann

7.4 Blurry and Sharp Motion

When we look at images, we naturally try to find the areas of highest contrast, brightest tonality, and sharpest focus. In normal shooting situations, you can direct your viewers by controlling the DOF, but in low light conditions, you can create a similar effect by having the area around your subject moving while the subject stays stationary. In some circumstances, you can catch a lucky break, but these results are not necessarily repeatable.

And sometimes, you just want to have it all. You want that atmospheric, liquid appeal along with frozen motion. You can't get this by just changing the exposure time or aperture; you will need to take a hand in manipulating the scene.

For a single shot with blurred and frozen motion, you will need a strobe—not the little built-in flash that pops up from your camera body and gives you that police crime photo look, but a real, professional, off-camera strobe. If you place a strobe on your camera for this type of image, you will diminish some of the best qualities of night photography with washed-out, boring

light. If, however, you take that strobe off your camera, you can create a new level of interesting light that freezes motion amidst your blurred and enigmatic scene.

Dragging the Shutter

This combination of blurred movement and flashed subject is called dragging the shutter. What you are actually doing is creating that same type of dreamy blur that we have seen in other examples and freezing a moment of the frame, not with exposure time, but with concise illumination of the subject with the overpowering and extremely brief action of the strobe.

To do this convincingly, be sure to flash your subject at the end of the exposure using a feature on your camera called *rear curtain sync*. What this does is wait until the shutter is about to close to activate your strobe, so the last thing the image sensor sees is the bright capture of the subject. This results in an image that appears as though your subject sped through the frame like Flash Gordon was captured in midrun through your image. If you instead sync your flash to the front end of the image, it will

Figure 7-5: *This was a lucky shot. In the sunset light after the wedding ceremony, the bride turned suddenly and stood nearly perfectly still while I walked up to her and cars passed behind her. With some quick thinking and a 1/15 second exposure, I captured this image where the motion of the rest of the scene helps define the bride as the main subject.*

Figure 7-6: *In an image like this one, the blurring of some of the motion captures the energy and fun of the scene, and the off-camera flash from behind and to the right of the dancer freezes the motion and captures the bride covering her face in mock embarrassment.*

Figure 7-7: *This image may not be appealing no matter what we do, but it is particularly distracting that the lights appear to precede the truck. This happened because front curtain sync flash was enabled.*

Figure 7-8: *Here, the image is a bit more appealing. The lights trail the truck because the rear curtain sync flash was enabled. (The light that appears to be cutting through the truck is the blurred drag from the safety light on the right headlight, so technically this is still trailing light.)*

seem as though your image is moving in re-verse, because the motion lines we expect to see with this type of image will visually precede the subject, rather than follow it.

Flash Control

To get the best possible image with your flash, think about the aesthetics of the light source you are introducing to the scene. Remember, with digital capture you can see your images after you take them, so use your LCD screen to review the composition and light direction to help you determine if your off-camera strobe has been placed in a visually interesting place to not only stop the motion of your subject in the appropriate location, but also to add interest to your final image.

Flash Position
We have already mentioned that off-camera flash is imperative. But after you get it off the camera, think about aiming it into the scene. What direction should the light be coming from for the best use of added illumination? Side-lighting, backlighting, and bouncing the strobe create the best effects for enhancing your moving subject.

With sidelighting, think about placing the strobe in such a position that it will illuminate enough of the subject's front to see who or what is moving through the scene while also provid-ing some sort of directional light on the subject. Technically, sidelighting can be about 45 to 90 degrees off the camera axis, so play with the location of your strobe in relation to the camera and the subject.

With backlighting, you will want to accentu-ate the silhouette of your subject, rather than any discernible details, while simultaneously freezing motion. This can be an excellent way to separate your subject from the background and the atmosphere of movement from the crisp-ness of the strobe. Again, you cannot achieve

this unusual and visually appealing look in any other lighting conditions, so take advantage of it when you can.

Finally, with bounce lighting, you use some-thing else in the scene—a wall, the underside of a bridge, an umbrella—to use the strobe in a softer way. The light that bounces into your final frame won't have that same harsh quality that a full-frontal strobe has, with its deep shad-ows and highly visible texture. Instead, the light from the strobe will become more of an ambi-ent light source and fill the frame with a more diffuse light source that will ultimately stop motion, but it will do so with softer shadows, less light direction, and less texture.

Control Your Flash
Although using a strobe seems like a great idea, you can easily overpower your entire image if you aren't careful. Remember, our goal is to cre-ate night and low-light images, not overblown strobe images. You want to be sure the strobe doesn't ruin everything that you have set up in the rest of the scene, so familiarize yourself with the strobe settings and experiment with your scene to find the best balance of strobe illumi-nation and ambient lighting.

To do this, learn how to aim your flash, which is partly about the physical direction the light will be traveling and partly about how wide the beam of light will be. Higher-end strobes allow you to focus your light from wide-angle to tele-photo coverage. If you think about stage light-ing, a wide-angle setting will cover the whole stage in light, and a telephoto setting acts more like a spotlight. Generally, you want to use a telephoto (or spotlight) setting to focus the light on your subject without letting the strobe light obliterate the rest of the atmosphere in the scene.

This also means you need to contain the light in the scene. Remember that we are always concerned about flare, and introducing a new light source means you are introducing a new

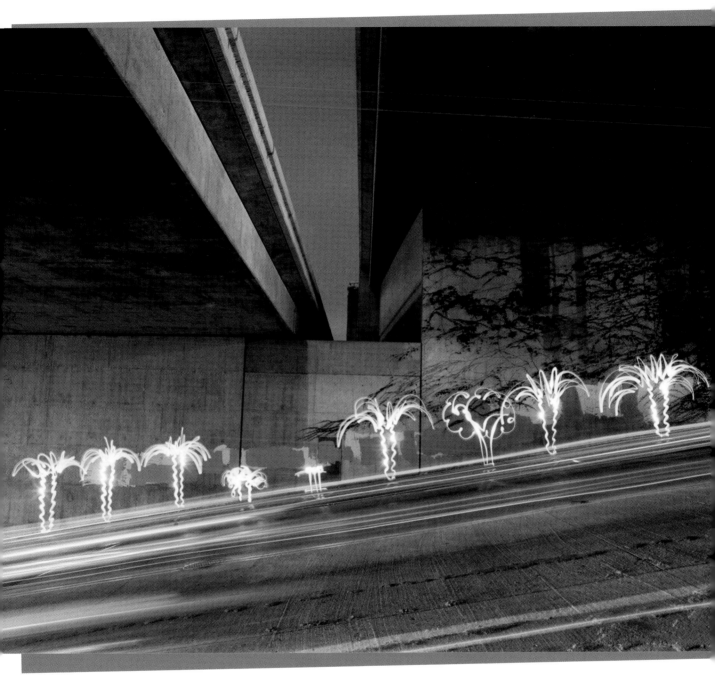

Sassafras Underpass, San Diego, California © Philipp Scholz Rittermann

Figure 7-13:
Lew Sterrett Justice Center, Dallas, Texas © Philipp Scholz Rittermann

potential flare source. Be sure that you take precautions to protect your lens from stray light, and direct and control your flash so you illuminate the scene correctly.

Finally, control the amount of light that comes out of the strobe. If you leave the strobe at its highest setting—1:1 or, in some cases, Automatic—your strobe will determine the illumination of the scene. With a higher-end strobe unit, you can control the amount of light that comes from the strobe. Instead of blasting the entire scene with a 1:1 setting, try using a 1:4 or a 1:16 setting. The strobe will affect less of the scene, and it will be balanced with the ambient light that you were probably attracted to in the first place.

Multiplying Your Subject

An extension of working with a strobe at night is using an extremely long exposure time and using your strobe to paint with light in your image. You can create a new scene with multiple versions of the same subject in one frame, rather than trying to multiply your subject in post-production.

For this to work, find a suitably dark location where you can leave the shutter open for a long enough period of time to interact with your scene by taking the strobe with you and illuminating one subject at a time with controlled

bursts of light. You can change the position of your subject—such as yourself—over and over, and illuminate it to create twins, triplets, or any other engaging combination. You can argue with yourself, describe the movement of a dancer through a scene, or create a story filled with life and variety using only a handful of characters.

For example, if you have a strobe that can emit pulses of light every 10th of a second, and it takes a dancer 3 seconds to complete a movement, in a single frame you can have 30 versions of the dancer moving. It captures not only the beauty of any one moment of the dance, but also the feel of the entire dance over time, not to mention the complexity of the physical movements required to complete the task.

Night and low-light photography allows us to see what we cannot otherwise see for ourselves. We can extend that logic to evaluating movements that our eyes aren't fast enough to comprehend. You could evaluate how a tricky stunt is performed, or review your golf swing, or watch a diver coming off of a board. As with everything else we have done so far, we are utilizing our night and low-light photography to reveal something about the world that we would otherwise not be able to perceive. Embrace that and determine what is out there that you need to discover and share.

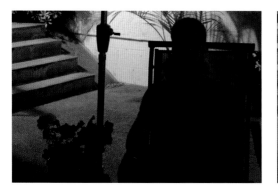

Figure 7-9: *To visualize what controlling your flash can do for an image, look at this scene. Without modification, the main subject is backlit by the porch light, and his features are not distinguishable.*

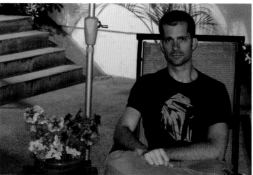

Figure 7-10: *In this version of the scene, the on-camera flash was fired, which washes out the foreground and removes some of the interest of the low-light scene.*

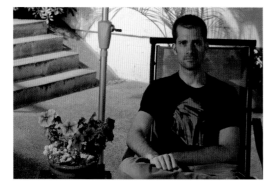

Figure 7-11: *In this version, an off-camera strobe was used. The strobe wasn't modified. Notice that the light direction and overall modification of the scene is much better in this version than the previous one, but the light of the strobe is considerably more blue than the scene, which creates an odd result.*

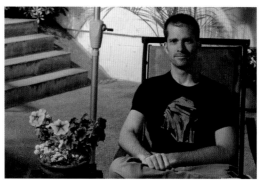

Figure 7-12: *In this final version, the off-camera strobe was modified with a Roscolux gel that approximated the color of the porch light in the scene. Although this lighting is impossible to achieve with the existing elements in the scene, the similar color balance and varied lighting direction on the subject make for a much more pleasing, and believable, final product. This technique is especially useful for illuminating subjects at sunset where the sunset itself is the backdrop.*

Chapter 8
Light Painting

8.1 Introduction

So far in this text we have discussed how to capture the enigmatic ambiance of night and low-light situations as they exist. We discussed the variety of ways to ensure we get a large dynamic range, how to see into the shadows without being blinded by the highlights, and how to let the low-lit world craft its own story with unique lighting and wispy movement. What we haven't discussed is how to alter these landscapes with directed efforts. We haven't discussed how we can use the dark to literally paint with light. In this chapter, we will take image creation to the next level and use our imaginations to take matters into our own hands. So pick up your Maglite and let's get started.

8.2 Clean Graffiti

Because we are working in low-light situations, we have the opportunity to add our own flare to the image, not just by adding a flash or bringing a work light on location with us, but by using light as the subject and manipulating it during exposure. Think, for instance, of the way you used to draw in the night sky on the Fourth of July with a sparkler. Maybe your goal was to write something fast enough that it would stay imprinted on your retinas long enough to be legible. With photography, you can create and capture those moments so they last. And after you get used to it, you'll be able to create whole scenes, spell whatever you want, and doodle in

midair. Think of this process as clean graffiti. It allows you to make a silent, ephemeral mark on the world that becomes indelible only when photographically processed.

Your Paintbrushes

Just as a tagger needs spray paint and stencils, it's important to choose appropriate tools for your masterpiece. There are a variety of things you can use to create your light paintings. The only real criterion is that the tool must create light. You can use anything you might have laying around the house, or you can go hunting for a new and interesting light source. Just keep in mind that the brighter the light source, the more it will render on the camera sensor, which can be a good thing or a bad thing, depending on your desired effect.

Renaissance masters were not limited to a single brush or color. Different effects need different tools—a large and wide brush for sweeping backgrounds, a small, refined point for eyelashes. Although you won't have as many brushes in your tool belt, you should have a variety of tools for different effects. Here are some ideas to get you started, but you are limited only by what you can imagine and illuminate.

Fine Point
Take, for instance, an LED light source. A simple LED flashlight can be powerful, but it is also nicely directional. This means that you can use it as a point source to write in the dark or draw stick figures or sketch out a landscape. If used

Figure 8-1:

Stalled Development, near Fort Worth, Texas
© *Philipp Scholz Rittermann*

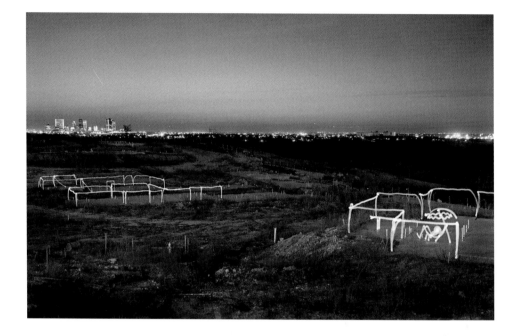

Figure 8-2:

Airport Parking, San Diego, California
© *Philipp Scholz Rittermann*

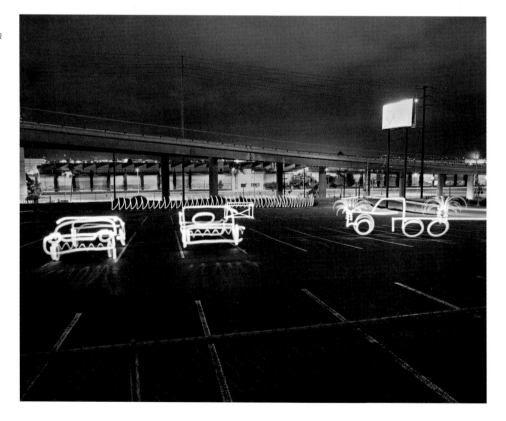

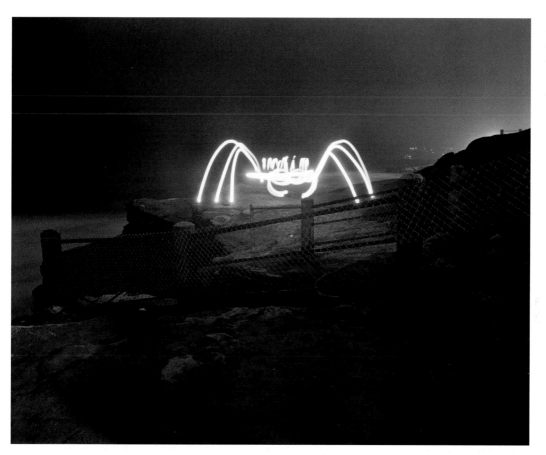

Figure 8-3:
Spider, Point Loma, San Diego, California © Philipp Scholz Rittermann

correctly, LED tools can create precise details. A single-LED keychain light that is activated by maintaining pressure on a button is a great tool for specific creations, but it's not so good from a great distance or in a larger space, because the light is small and not very powerful. In contrast, an LED flashlight has several of these lights bundled together, which makes the light stronger and a little less precise. When you use this kind of a source, you can work with relative precision from a slightly greater distance, or in a larger space you can create the effect of writing or drawing.

Midrange
A midrange light source, similar to a portable work light, can be used for somewhat specific illumination. This kind of light can be used for additional illumination in an area that you want to modify, and it can be turned on and off throughout a long exposure to add light to specific areas of the frame. It can also be moved across the frame during exposure, more like painting with smaller light sources, but you would most likely need an extension cord or a heavy-duty battery. Larger flashlights that are intended to cast a broad beam of light are also midrange light sources. They can make specific shapes, though the lines will be much larger because they also cast a certain amount of light on the surrounding scene. You have to be careful what is being illuminated besides your canvas of air because the camera might pick it up. Any midrange source will be less controllable, but it can be helpful in illuminating a larger area while maintaining some definition.

Broad Strokes

The broadest light that we generally use in night and low-light photography is a flash. We started this chapter by talking about being more specific, but if you pre-visualize your image and see that you need large strokes of light and color, an off-camera flash unit, complete with batteries and designed to pack a huge punch, can be used to provide a little more oomph to your final image. This can be helpful if you want to decorate an existing scene, such as a monument or interesting architecture, but it's important to be able to see the initial scene to make additions. Using a light source such as a flash unit provides the broad stroke needed to ensure that the background of your scene is illuminated enough, but it does so evenly enough that it doesn't seem inappropriate in the final image. The broader the light source, the more evenly lit the subject. After all, the purpose of the flash is to give lots of even light for a photographic exposure.

Be careful with the flash, though. If you use a flash unit to color or lighten your scene, be aware of the falloff of the flash unit. Although it may cast a wonderful color or light on one area of the scene, it will also cast shadows and dim outlines of color and light around the subject. If those areas of the scene are in your frame, you have the potential to contaminate your overall image.

Specialty Tools

You can also take time to create a more specific light source. For instance, you could create a wire frame in a specific shape and decorate it with Christmas lights, or use toy light sabers with flashing lights to re-create your favorite duel, or take your great aunt's beaded lamp to a beach and set up a tiny sitting room on the sand. Think about using intermittent light sources, like the flashing lights on the wings of a plane or a beacon. Use your smartphone to create blocks of light in different patterns. After all, there's an app for that.

You can use anything that creates light for your paintings. Just remember that you will always need a power source, and battery-operated tools are more convenient than cords. But these are your creations, so if you want to make that sitting room on the sand, you may need to invest in a power adapter for your car cigarette lighter or a small generator.

Your Palette

Not only do you need to think about the size of the light sources you want to use, but also think about the color. When you are painting at night, you have the opportunity to introduce any color scheme into your image.

Figure 8-4: *Primary Dragonflies*
© Amanda Quintenz-Fiedler

Global Color Adjustments

First things first: You can set the overall mood of your image by choosing a white balance that will enhance its overall look. The standard is daylight balanced, which will render tungsten lights as amber, fluorescent lights as green, and any colored light true to the original. But if you want to set a different mood, you can change your white balance to the tungsten setting and turn white lights blue, which gives a more bluish look to the whole image. You can take a couple of initial exposures to determine your overall starting place before you set up the rest of your light painting. This can be helpful in determining just how much time you are going to have for your whole light painting experience.

Color Your Brushes

After you determine the overall color of the scene, you can modify your light source tools in a variety of ways. The easiest modification is to use colored gels that are designed to modify photographic light. One of our favorite tools is a sample pack of gels from Roscolux that you can pick up for just a few dollars. The pack has hundreds of colors and diffusion samples that are the perfect size to fit over a small flashlight head or a portable flash unit. You can put the pack on a chain that can be opened so you can take one sample out, attach it to your tool with tape, and replace it later. You can also buy a larger piece of any color for use with your larger tools. If you like the results on a small scale, chances are it will work wonderfully on a large scale as well. No matter how you choose to color your light, having a variety of color options can add dimension and interest to your light paintings.

8.3 The Basics of Light Painting

Creating light paintings takes a great deal of experimentation and repetition. It isn't for everyone, but if you're interested, the most important advice is to keep trying! Start small and see how it goes before you try to re-create the Sistine Chapel in light. Start with a word or a stick figure, or even just add interesting illumination to something that is already in the scene. It will take time to build your understanding of how to use the new tools in your image making, so be patient and persistent.

Darkness

To make art from light, start with a canvas void of light. The darker the environment, the easier it will be for you to control the outcome. If your scene is nearly pitch black, you can choose every element that is illuminated. If your scene is too bright, the weaker light sources won't have the power to register, but your presence, as the artist, will be captured on the sensor along with your creation. You must have a dark enough scene for the light painting to be visible. However, be careful not to put yourself in a situation of such darkness that you can't see where you are stepping. That pitch-black darkness won't work unless you move when the shutter is open.

If you want to do more than paint with a flash, try to find an ideal scene where you can paint at will without running out of dark tones. You don't want your intricate light experiments to be overwhelmed by ambient light, so try to find a scene where ambient light won't bounce back into the frame. If there is a large white wall behind your camera, you run the risk of accidentally illuminating the subjects in front of your camera as your individual light sources are used. Remember, the only way your light painting will show up in the frame is if there is something dark in the background.

That being said, after you get the hang of

Figure 8-5:

If you see a light source in your frame that might be interesting, take advantage of it to add additional elements to your photograph. In this image, the giant circle in the sky was created by the flashing lights of a police helicopter, circling overhead. That can't be controlled, but if you can recognize what is happening around you, you can use it in your image.
Police Helicopter on Mission Beach, San Diego, California © Philipp Scholz Rittermann

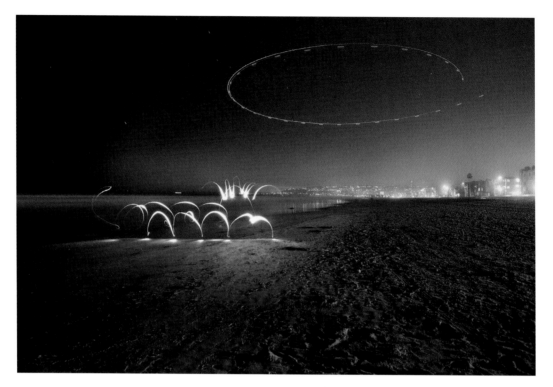

light painting, an image like the one in figure 8-1 will give you enough darkness to create your scene and provide some context because of ambient illumination in the background. In this case, having a great enough separation between the two sets of light sources allows for ambient lighting and manipulation of light for painting.

Time

We've talked a lot about the benefits of long exposures in low-light situations. In this case, you must have a long exposure to allow you to work within your frame. The more time you have, the more you can do. Your time frame is a constraint that you have to work within, so do what you can to lengthen that time as much as you can. Find the balance between scene brightness and exposure time that will allow you to move within the frame and light paint while preventing the overall image from becoming so bright that the details of your light painting are lost.

In practice, an exposure time of at least a few minutes allows you to move within your frame and intervene in the natural scene. In that amount of time, you can add your drawings to the darkness and move between one area and the next without your own form rendering on the sensor. Yet a few minutes is also a short enough time frame that you can evaluate your final image on your LCD screen and see if you were successful. This allows you to get enough frequent feedback that you can keep trying until you achieve the results you want or adapt your technique if something isn't working correctly.

Positioning

It's important to shift your thinking now from standard art creation to light painting. When you are working with light, you have to be behind the light source or you'll be in the image. In other words, if you are writing your name, you have to write it backwards and in front of

you while facing the camera. If you try to write it the usual way, it will be backwards in the image (though you can, of course, flip the final image if that works better for you). And if you are between the light and the camera, you will appear as a silhouette; the light writing won't be the only subject. Even if you are illuminating the backdrop—that monument we mentioned earlier, for example—be sure that whatever is being illuminated is not interrupted by your presence. To get that background illumination, aim the flash unit to your side instead of directly behind you.

You also need to be aware of the edges of your frame. You don't want to create a poem in light and see only the first stanza. However you do it, be sure that you are manipulating an area of the scene that will be captured by the sensor.

Be sure to keep your final design in mind, and remember what parts of the frame you've already illuminated and what parts remain blank. In an ideal light painting, you would have a good understanding and control over not only your light and lines, but the negative space as well. You don't want to go over the same space over and over, and you don't want to leave huge areas of your image empty.

Whatever tools you are using, ask yourself these questions before you start the light painting process:

- Where are you in relation to the camera?
- Where are the edges of your frame?
- Have you gone over that area before, or does it need something more?

If you can answer all of these questions and have the patience to find the right location and bring the right tools, you can learn to create wonderful, impossible lightscapes by painting with light. It can be a wonderful tool for self-expression or just plain fun, but it is certainly something you cannot do unless you are in a night or low-light situation.

Figure 8-6: *In an image like this one, the overall scene seems fairly bright, but the scene was dark enough that I was able to use a 30 second exposure and walk in front of the camera to pop the flash several times on each side of the tiki head. The end result is an illuminated foreground and background, where the subject was illuminated with warm and cool tones—warm tones to match the ambient light, and cool tones to separate the head from the background and create visual interest. With the 30-second time frame, I was able to move enough within the scene to get the desired result and not register my presence in the image, and also not blow out the highlights in the background. Swami's Painted Tiki © Amanda Quintenz-Fiedler*

Part III: After Capture

NOW THAT YOUR IMAGES ARE CAPTURED on your card, the second half of the process begins. What many people seem to forget is that the job isn't done when the shutter is released. The post-production process is just as important in realizing your final vision as the initial capture.

Admittedly, post-production can range from a minute of tweaking in Adobe Lightroom to hours of compositing and stitching together dozens of images to get your final result. The amount of effort you choose to put into post-production is a personal choice. Of course, the amount of effort you put into taking the images may dictate a certain amount of post-production work to get the most out of your images. If you went to the effort to capture those tricky and demanding HDR images, you're going to want to take some time to put them together. If you're more of a shoot-from-the-hip photographer, your final image massaging may boost a little color or remove the color altogether with a black-and-white conversion.

No matter what your intentions or goals for the post-production process, these next chapters will guide you from the basics of image workflow through the most complicated night and low-light photographic process we could think of. Ideally, you will use these chapters as a guide to create your own workflow and you'll then advance beyond the pages of this book. But until then, it never hurts to have a jumping off point.

Oceanside Pier after Dark © *Amanda Quintenz-Fiedler*

Chapter 9
Basic File Processing

9.1 Introduction

Every digital image requires some processing before it can be considered complete. This processing can be as simple as resizing and sharpening, or it can involve more complex modifications to an image to achieve a desired look. Night and low-light photographic images are no different. We need to consider our final output and maximize our image for what we want to see based on what is available in the captured image.

Later in this book there are complex approaches to creating images, but to get started, we will talk about some basic file management techniques that should be applied to every image. For this process, we are not dealing with images that we specifically captured to expand the dynamic range. For that process, see chapter 10.

9.2 Image Extraction

If your images were captured correctly, when you first bring them into your computer, they will be RAW files. How you do this is really up to you, but it is recommended that you use at least these five basic tenets when extracting files from your camera:

1. Rename your files to have unique filenames. There are batch renaming functions in both Adobe Bridge and Adobe Lightroom that make this process easier. Using the capture date as part of your naming convention can make creating unique names easier and allow you to quickly find groups of images from the same shoot.

2. Back up your RAW files. It is always a good idea to back up all of your files; however, if you at least have your RAW data, you can recreate any image that might get lost.

3. Catalog and keyword your images when you download them. If you create keywords as part of your workflow, try to do this every time you download images. This will save you from having to slog through hundreds of old images to apply keywords.

4. Limit your keywords to general information that can be applied to a batch of images, with perhaps a few important people or places called out specifically.

5. When you are certain your images are copied onto your computer and backed up, reformat your memory card. This will prevent you from wondering if you have already downloaded the images and will free up much-needed space for your next escapade into the night.

After you have your images off your camera, you can start processing them to bring out their majesty.

9.3 Processing Your RAW Files

When we process our files, we have a couple of software choices that make our lives easier. Adobe Photoshop has a bundled program called Camera Raw that allows you to manipulate your RAW images using the native data of the photograph. Adobe Lightroom can also handle these adjustments and catalog your images at the same time, so which program you use is up to you. For this chapter, we'll use Camera Raw because it's already included with Adobe Photoshop.

When you open your images in Camera Raw, you can do so with a single image or in bulk. We are going to select a group of images from Adobe Bridge and open them together in Camera Raw for processing. See figure 9-1.

Notice in this image that we have clipped data both in the highlights and in the shadows, which we can expect in one shot of a scene with this much of a dynamic range. Since we didn't bracket these images, we are going to process them to maximize the information in the image.

Let's start by bringing as much of the information as possible into the histogram by adjusting the exposure, recovery, fill light, and blacks sliders. Keep an eye on the histogram as you do this to see where you minimize the clipping of the highlight and shadow detail. See figure 9-2.

Although this image isn't perfect, we've opened up the shadows while maintaining detail in the highlights and revealed some of the nice color that was present in the dusk sky.

After you brighten the image some, you can make a determination about the overall white balance of the image. For this image, the stark contrast between the bright amber of the sodium lights and the deep blue of dusk could stand to be accentuated a little more, so you can change the white balance to remove a bit of the warmth from the image and bring out the cooler tones. To do this, grab the white balance temperature slider and pull it toward the left until the overall tonality more closely matches what you envisioned.

At this point, you can also use Camera Raw to adjust the contrast, clarity, vibrance, or saturation on a global level, or you can opt to control those areas with more precision in Adobe Photoshop. Let's go ahead and increase the contrast on this image just a little to accentuate the starlight effect on the streetlamps.

If you haven't decided between one shot in a series of similar shots, you can use a Camera Raw function called Synchronize to apply all of the changes you just made to one image to the whole group:

1. Make sure that your modified image is selected, then press Cmnd/Ctrl+A to select all images that are currently open in Camera Raw. You can also Shift+click just a selection, or Cmnd/Ctrl+click individual images if you don't want to apply the changes to every opened image.
2. After all the desired images are selected, press the Synchronize button at the top of the filmstrip to open a dialog box. Here, you can click on and click off any of the settings that you want to change. If you want to apply every change across all images, leave all the items selected. Otherwise, you can pick and choose which items to apply and which to skip. See figure 9-3.
3. After you click OK, you can watch as the thumbnail images in the filmstrip change with the new modifications.

Now we can move on and work with our images more specifically in Adobe Photoshop, but to do that we need to tell Camera Raw how we want the native data in the RAW file to be processed.

At the bottom of the Camera Raw window there is an odd strip of information.

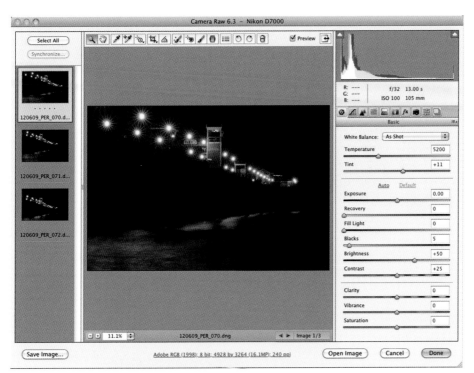

Figure 9-1: *The Camera Raw dialog box with three images in the filmstrip*

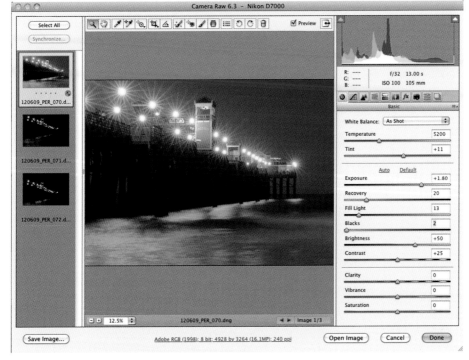

Figure 9-2: *Adjustments made with sliders in Camera Raw*

Figure 9-3: *The Synchronize dialog box allows you to pick and choose which changes from the lead image you are going to apply to the other selected images*

Adobe RGB (1998): 8 bit; 4928 by 3264 (16.1MP): 240 ppi

Figure 9-4: *Workflow Option information at the bottom of the Camera Raw window*

Figure 9-5: *Workflow Options dialog box*

This information tells you the color space, bit depth, image size, and pixels per inch (ppi) of your image. To change this information, you just have to click it to pull up the dialog box that allows you to change your Workflow Options.

Within this box you can assign a color space, change the bit depth of your file, adjust the size and resolution, and even choose to sharpen the image when you open it. You can adjust these options as you see fit based on your knowledge, workflow, expected output, and quality of input. But here are some guidelines that will get you started.

Space

Unless you have a specific reason to use a different color space, Adobe RGB (1998), which is the default color space for the Workflow Options, is an excellent color space to work in. It isn't so small that you are going to truncate your data, and it isn't so large that you are going to be dismayed when your final print posterizes because

large portions of it are out of gamut between the color space and the printer space. So let's leave that one alone.

Depth

The bit depth that you want to work with is up to you, but be aware that the more bits you have, the larger the files will be. Of course the files are larger because there is more information, but choose wisely before jumping into a larger bit depth without reason. Also be aware of your computing power. There are some programs that can't handle files larger than 8 bits, so know your system before you commit to something you may not be able to use. Adobe Photoshop can handle anything that Camera Raw offers, so don't worry about that. For most applications, a depth of 8 bits is plenty. If, however, you are planning to print 4 foot tall, 8 foot wide high dynamic range panoramas, you might want to go with a bigger bit depth.

Size

This one is trickier than it should be. You can use the largest file size that Camera Raw will interpolate for you, but that makes for a large file. On the one hand, you won't need that kind of file size, and it is interpolated data, so it isn't necessarily accurate in terms of the details and information that you're going to be working with.

On the other hand, if you know you want to print an 8x10 for your wall and choose the file size that matches those constraints, but then you have the opportunity to show the image in a gallery that wants a minimum of 11x14, you have thrown away valuable data and will need to rework the whole file at a larger size, which is twice the work and headache and doesn't guarantee that you'll get the same results.

We recommend using the Goldilocks principle. Don't use a file so large that you eat up all of your computer's available memory on one

file, but don't use a file so small that you limit the possibilities for your image in the future. Our rule of thumb is to use the largest file size we anticipate using without reducing it to less than the native data size. You can tell which file size is the native data because it won't have a minus or a plus symbol next to it in the drop-down menu.

Figure 9-6: *In the Workflow Options dialog box, the Size drop-down menu allows you to choose the output that Camera Raw will give you. Native data is selected here in blue and is denoted by the lack of a minus or plus symbol next to the dimensions.*

Resolution

The default resolution of 240 ppi will print without the individual dots being visibly discernible to the average human eye. To account for those whose eyes are above average, we recommend changing this to 300 ppi. Plus, it's a nice round number.

After you've chosen all of your options, select OK. Notice that the data at the bottom of your Camera Raw window now matches the settings you just changed. If anything is wrong, go back in and change it before proceeding.

The next step is to open your chosen image. If you select the Open Image button on the bottom right corner of the Camera Raw screen, the image will open directly into Adobe Photoshop with the criteria you just defined.

If you were instead to press Done, Camera Raw would save the data that you changed as a sidecar file linked to your RAW file, but it would

not open the image in Adobe Photoshop. This allows your RAW file to remain unmodified while maintaining the data of the adjustments made. The next time you open your RAW file in Camera Raw, all of those adjustments will still be in place. If you open your image, that data will also be saved as a sidecar file.

If you decide to press Cancel, no changes will be saved, and you will have to start again.

9.4 Processing Your Individual Files

Now that you're in Adobe Photoshop, you can make specific changes to your image that are meant to be applied to this image only. Here are some guidelines for a basic image processing workflow:

1. Review your image and determine if you want to crop it. Think about how the image flows, where the viewer's eye is led, what the points of interest are, and if they have directionality and space to breathe. If there is something distracting in your image, you can crop it out.
2. Create a duplicate layer of your background. This allows you to return to your starting point if you get off track. To do this, press Cmnd/Ctrl+J with your background layer highlighted.
3. It is a good idea to name each of your layers to keep things clear. Name the new layer "Retouch."
4. Use this opportunity to retouch any issues in your image, such as dust, noise, stray information, or elements that you wish weren't in the frame. If you want to review your image at actual pixel size, select Opt/Alt+Cmnd /Ctrl+ 0.
5. Review your image for tonality. Are there areas that you wish were darker or lighter? What does the overall relationship of the colors look like? You can create a curves

adjustment layer on top of your image to fine-tune the overall distribution of shadows, midtones, and highlights.

6. When you have made any additional global changes in Adobe Photoshop, look for areas that need specific, local adjustments. There could be areas that you want to accentuate with color or contrast, or just areas that you want to bring out to make the image as a whole more appealing.
7. At this point, save your image! This is the largest file you will work with for this process, and we can assume you've put everything into it that you wanted. Save it as a layered TIFF or PSD file so you can return to the individual layers and modify them in the future if you want to.

9.5 Output

When you decide what output you want to create, reopen your saved file and name it something else! You don't want to resize or modify this image and lose all the work you have done. If you don't rename your file, be sure *not* to save it when you are done with these next steps because saving it will overwrite the image data:

1. When you know what your output will be, resize your file accordingly. You should always resize your image to the final output before sharpening to ensure that you are applying the appropriate amount of sharpening to enhance the image.
2. Create a merged layer on top of all your layers by pressing Shift+Opt/Alt+Cmnd/Ctrl+E.
3. Name this layer Sharpen. See figure 9-7 on the previous page.
4. Apply the sharpening technique of your choice. If you don't have one, you can use any of the sharpen filters available in Adobe Photoshop, or you can reference the selective Smart Sharpening process in chapter 11.

5. Generate the output of your image!

6. If there are any issues with your image at this point, review the output (if you can) and make adjustments as necessary. Even though the digital file isn't going to change, your output devices aren't the same. A perfect print on one machine may need some manipulation on a different machine.

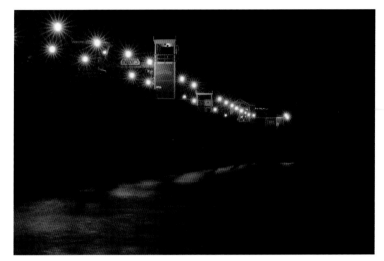

Figure 9-8: *Before basic modifications*

Figure 9-7: *Even with only basic processing, you should have a layered file that looks something like this at the end of your process*

With night and low-light photography, your starting image can have a world of information that you may not see on first inspection. But don't fret! With the powerful tools that are available to you, you can create something truly wonderful from your images if you stick with the process and keep trying.

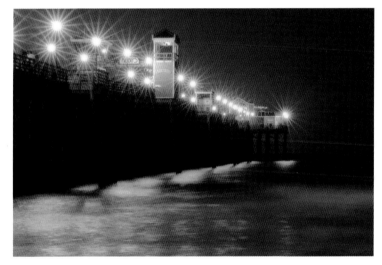

Figure 9-9: *After basic modifications*

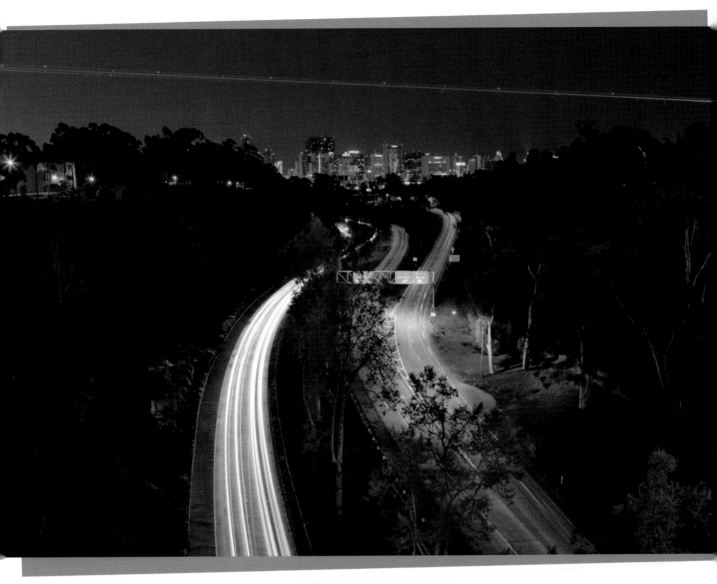

Downtown Skyline Seen from Cabrillo Bridge, San Diego, California © Philipp Scholz Rittermann

Chapter 10
Increasing Dynamic Range

10.1 Introduction

When we are working with night and low-light photography, limited dynamic range is a fact of life, whether you capture images on film or with a digital sensor. This is because these scenes inherently have a higher dynamic range. That is, the difference between the highlight details and the shadow details is much greater than an average scene because we are working with extremely bright areas (such as electric light sources) and extremely dark areas (such as deep shadows in a dark alley at night). This phenomenon is one of the things that is so appealing about night photography, but makes the work of the photographer that much more challenging.

When film runs out of dynamic range, it gradually lets go of detail and, one could say, more elegantly than a digital sensor. A digital sensor records information in red, green, and blue channels rather than pure information. Often these channels run out of dynamic range at a different point due to a variety of factors in the scene. This can create ragged or abrupt transitions from detail to no detail, causing highlights to look burned out and surrounded with odd swaths of posterized color that looks unnatural.

To expand a digital camera's dynamic range, we need to make multiple exposures of a scene to ensure that we have captured all the highlight, midtone, and shadow detail we want for the final image. This works well when photographing scenes with no moving components, such as landscapes or architecture. We discussed the merits of this process in detail in chapter 5, but let's take time to outline a step-by-step process, start to finish, for expanding the dynamic range of your images.

10.2 Capturing Images for Expansion

In order to use this technique, be sure you have captured your series of images precisely using the guidelines explained in chapter 5. If you completed those steps correctly, the process described here should be straightforward and rewarding. If you aren't certain if your images meet the necessary requirements, you may want to reshoot them rather than struggling through this process. If the images aren't aligned and exposed correctly, you may not get the results you want.

10.3 Importing Images for Expansion

Remember, this technique works only if your camera was absolutely stationary for all exposures, you used a cable release or a wireless remote, your AF was off, and your exposures were bracketed using more or less time, without changing the aperture. In this technique we will use nondestructive adjustment layers to create a final composite image, while keeping the original pixel information intact. To do this, we need to process our images carefully to ensure we have the necessary components for the task at hand.

Figure 10-1:

The Synchronize function in Adobe Camera Raw allows you to choose which elements you want to sync between images and which ones you don't, such as exposure or recovery. Adobe Lightroom has a similar functionality.

1. Begin by selecting your bracketed RAW images in Adobe Bridge.
2. Select your main exposure (the one that will contribute most of the tonal information) and two others: one with sufficient highlight detail, and another with sufficient shadow detail. Open them in Adobe Camera Raw.
3. Make all the necessary global adjustments to your main exposure (the one with all of the midtone information):
 a) Adjust the color balance, hue, exposure (white point), shadows (black point), brightness, contrast, saturation, chromatic aberrations, lens corrections, vignetting, noise reduction, and so forth to your liking.
 b) Pay special attention to the edges of bright light sources to avoid an unnatural appearance when applying Recovery and Clarity. When you adjust these settings, go easy, zoom in to 100%, and check to see what you are doing. (Blown-out highlights in the main exposure will be augmented with information from the underexposed frame, so don't be too concerned by this.)
4. Evaluate your exposures individually and consider what each of them will contribute to the final images:
 a) Your main exposure's midtones should have the overall look and feel of what you want, even if it lacks some shadow or highlight information.
 b) Your underexposed frame should be optimized for highlight information; you can disregard the midtones and shadows.

c) Conversely, the overexposure should be optimized for the way the shadows look; the midtones and highlights are not important.

5. When you are satisfied that all global adjustments have been applied to the main exposure, select the other two images with Shift+click, synchronize them to the main exposure, and click Done. An exception to this is when you choose to apply different contrast or brightness to the other exposures. In this case, uncheck the items you do not wish to synchronize to the settings of the main exposure. See figure 10-1.

10.4 Layering Images

Now is when the subjective work begins. This is Philipp Scholz Rittermann's method of creating the ideally expanded dynamic range image. There are products available that will create a high dynamic range (HDR) image for you with the click of a button, such as the Merge to HDR Pro functionality in Adobe Photoshop CS5 and CS6, or plug-in software such as Nik Software's HDR Efex Pro. The method described here is a way of creating a much more controlled, personal HDR image that meets your vision exactly.

Layering Your Images

To work with this method, you need a single image with multiple layers that you can modify independently in Adobe Photoshop:

1. If you are using Adobe Photoshop Extended CS4, CS5, or CS6, select the three images in Adobe Bridge. Go to Tools > Photoshop > Load Files into Photoshop Layers. Bridge will open all three images in Photoshop as a single document containing all three exposures in separate layers. See figure 10-2.

2. Alternately, open all three images in Photoshop, then layer them on top of each other by using the Move tool (V on the keyboard). Drag and drop the highlight and shadow images onto the main image while holding down the Shift key to automatically position them correctly.

Figure 10-2:
Using Adobe Photoshop to create a layered file

3. You should now have an image with three layers:

 a) If you used the Load Files into Photoshop Layers command, you will have a document with three layers, each named with the RAW file name or number.

 b) If you used the alternate manual method, your layer stack will read from bottom to top: Background, Layer 1, Layer 2. Double-click the background, and click OK to make it into a layer.

4. Whichever method you used, arrange the layers (by clicking and dragging) so the main exposure is between the underexposure (on the top) and the overexposure (on the bottom). If this seems weird, bear with us because it will soon make sense.

Figure 10-3: Layers palette in Adobe Photoshop

Adding Highlight Information to Your Main Exposure

This process will allow you to change your base image with specific adjustments in highlight and shadow detail. Although you can go back and forth with your modifications due to the nature of this image process, we will start with adding highlight information:

1. Make the underexposed (top) layer active by clicking it.

2. Add a hide-all (black) layer mask to the top layer by Opt/Alt+clicking on the Add Layer Mask button (third icon from the left at the bottom of the Layers palette). This will hide the top layer, and you will see the midtone exposure.

3. Add a reveal-all (white) mask to your main exposure by clicking the middle layer once and clicking the Add a Layer Mask button, without holding down the Alt/Opt key. (To change a mask from white to black, or vice versa, click it once, then press Cmnd/Ctrl+I to invert it. To delete a mask, drag it to the Trash icon in your Layers palette.) Your layer stack should now look like the figure 10-4.

4. Make your main exposure layer active by clicking it once (see figure 10-3; make sure there is a double outline around the thumbnail image).

5. Go to the menu bar, and under Select, choose Color Range.

6. At the bottom of the new dialog box, click the Selection button; under the selection preview, choose None.

7. With the first eyedropper, click one of your highlights in the image. Then, using the second eyedropper (the one with the plus symbol), click and drag across all the highlight areas that you want to select:

 a) Be careful not to include any tones you do not wish to affect.

 b) Look at the small preview window in the Color Range dialog box.

 c) Use the Fuzziness slider at the top to make the correct selection, and click OK when you are satisfied that the highlight areas you wish to add information to are all selected. They will show white against black.

Figure 10-4: *After you have created your color range selection, it should look something like this, with your highlight areas appearing as white, as seen here.*

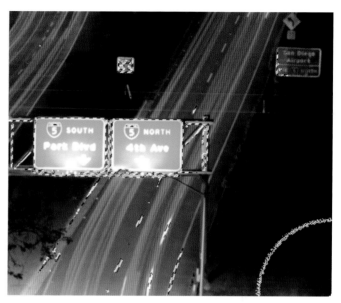

Figure 10-5: *The black-and-white dotted line shown here would be moving in an active selection, but you can see the basic elements that have been selected in this particular image.*

8. Now you should see a selection superimposed onto your main exposure layer:
 a) Be aware that these selections are represented by a sharp line of what looks like crawling ants, but in reality there is a feathered edge when the tonal transition from highlights to midtones or shadows is gradual.
 b) When the transitions from light to dark are hard, the selections are more precise.
 c) If you accidentally click anywhere in your image, the selection will disappear. You can recover it by stepping back in your history.
9. Click on the layer mask of your top (underexposed) layer, and make sure you see a double edge around the black Mask icon. The crawling ants selection should still be active.

10. Press the B key to select the brush tool, select white paint, set your brush opacity to 5–10 % feathered, and begin painting in the selected highlight areas of your image that you want to bring more detail into.
11. Click and drag the mouse over an area to brush in some detail, then let go. Repeat until you begin to see some of the information from the underexposed layer showing through, but be careful not to overdo it because too much information in a highlight area will not look believable and may create strange dark halos around the light source.
12. Zoom in to a comfortable magnification so you can see what you are doing.
13. The brush size can be larger than the area you want to reveal. The crawling ants selection will keep it from revealing anything outside the selected area.
14. If adjacent areas you don't wish to affect are selected by crawling ants (such as the streaks of car headlights in the previous

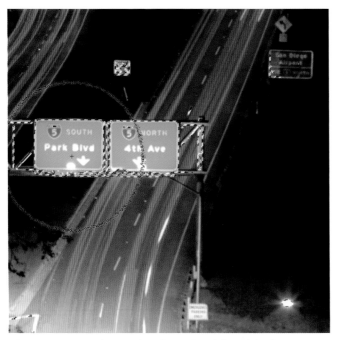

Figure 10-6: *Note the greatly enhanced visibility of the freeway signs*

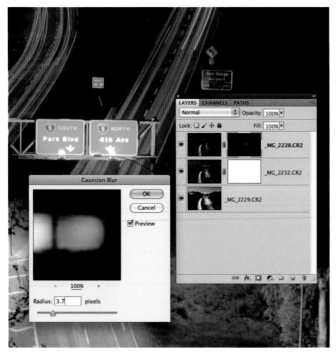

Figure 10-7: *This figure demonstrates the smoothing effect that the Gaussian Blur filter has on the layer mask for the underexposed layer. Notice that this mask also has varied densities before the blur was applied. These densities were achieved with the gradual, low-opacity brush application mentioned earlier.*

illustration), you can deselect them by using the lasso tool while holding down the Opt /Alt key.

15. Compare figure 10-5 with figure 10-6, and notice how much more detail there is in the freeway signs.

16. Use many strokes at low opacity to achieve the best results. When you are satisfied, press Cmnd/Ctrl+D to deactivate the crawling ants selection.

17. Look at the density of the new highlight information you have added to the image. If you have overdone it, don't panic. You can easily correct it by painting the area with black paint to hide the surplus information. Do this just as gradually as you did with the white paint, using low opacity, 3–5 % black paint, and a feathered brush.

18. Look at your transitions critically. Zoom in to see how the edges of the new information blend in. In your Layers palette, click the eyeball of the underexposed layer to turn it on and then off to see what information has been added and whether the transitions are acceptable.

19. There may still be some hard transitions that you can soften:
 a) Make sure the Layer Mask icon is active by clicking it once.
 b) Deselect any crawling ants (Cmnd /Ctrl+D).
 c) Go to Filter > Blur > Gaussian Blur. Adjust the radius, using the preview feature to click the blurring effect off and on. Pay special attention to hard edges because that is where inadequate transitions are most noticeable. See figure 10-7.

20. Fine-tune your mask:
 a) To see what a mask looks like, press Opt /Alt and click the Mask icon. You will see a black-and-white image of the mask you just created.

b) To modify the mask, you can paint on it with your brush using white paint to reveal more, or black paint to reveal less, of the underexposed layer.

c) As before, a feathered brush at low opacity and multiple strokes usually works best.

d) To go back to the normal view, click the eyeball for that adjustment layer.

21. If there is too much detail in the highlights, you can reduce the overall opacity of the underexposed layer until it looks right to you (top right of Layers palette).

Adding Shadow Information to Your Main Exposure

In this part of the process we will add shadow detail. Remember, though, at any time you can go back to your highlight detail masks and adjust them. This is the beauty of using layer masks!

1. To add shadow detail to your image, activate your midtone exposure layer by clicking it.

2. Deselect any crawling ants selection that may still be active (Cmnd/Ctrl+D). Generally, a precise selection isn't necessary to paint in shadow information, but if you prefer, you can create one by using the technique outlined for revealing highlight detail, with the exception that you will be using a white mask and black paint.

3. Make sure the new mask is selected by clicking it once (you don't want to paint on your pixels by mistake).

4. Press the B key to select the brush tool. Make sure you have a feathered, low-opacity (5–10 %) brush and black paint, then brush in your shadow areas.

5. Slowly, you will begin to reveal the shadow information of the overexposed layer that is beneath the midtone exposure.

6. To check your progress, hold down the Shift key, and click the main exposure layer mask

on and off repeatedly to see how much shadow detail is being revealed.

7. Fine-tuning works the same as it does for your highlight layer mask, except you will use white paint to gradually undo areas where you have revealed too much shadow detail.

Final Adjustments

The main work has been accomplished in the previous sections, but there is always room for some final adjustments. To get the image to look exactly the way you want, here are some finishing touches:

1. Now that you have added all shadow and highlight information, zoom out to fit the entire image on your desktop.

2. Evaluate it and decide if there are any areas that need further tweaking.

3. In this case, we found that even though there was enough detail in some of the highlights, they needed a contrast boost on the left side of the freeway and under the streetlight on the right. The same went for the shadows, which had plenty of detail but were a bit flat.

4. We added two curves adjustment layers named Highlight Contrast + and Shadow Contrast ++ (because it was more extreme).

5. You can call them whatever you like, as long as they make sense to you. Figure 10-8 shows what the curve shapes look like that target the specific tones we are trying to influence.

6. The last step is to add hide-all (black) layer masks to each of the new adjustment layers by pressing Opt/Alt+click on the Add Layer Mask button (third icon from the left at the bottom of the Layers palette) and revealing the effect of each curve locally by painting on the mask with white paint.

7. You can see the layer masks in figure 10-9, which shows that a small portion of the highlights and a large swath of the shadow areas were boosted.

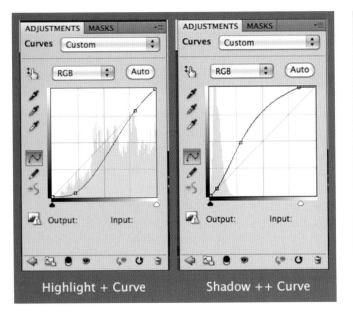

Figure 10-8: *Create and modify your own curves or other adjustment layers as you see fit. This stage is completely subjective, but because you have created layers for every step so far, you can adjust all or none of your final image with localized, specific controls.*

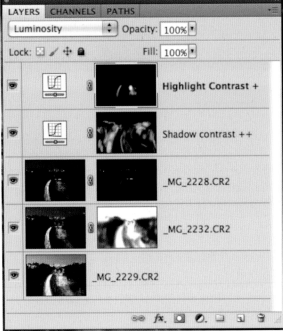

Figure 10-9: *Notice that the curves adjustment layers apply to the entire image as a whole, rather than just the under- or overexposed images. Because of this, the final modifications to the image are applied to all visible areas of the final image and give you an additional level of control over your vision.*

Results

The process described in this chapter is achievable. But if you are thinking, "I'll just use Photomatix, it works great," and you are 100 percent happy with the results you get from it, then use it. In fact, the Nik Software HDR Efex Pro tool is a wonderful plug-in that gives you a lot of flexibility and choice over how your final image is rendered.

If, however, you have often been left wanting, wishing you had better control over individual areas of your image, or if you found that the image lacked midtone contrast punch or you couldn't control the weird artifacts around some highlights, then this technique is for you. There are some great programs out there, but they can't achieve the nuanced results that are possible with the technique we explored here. It's a semiautomatic approach to image processing that allows maximum control over the final result, while getting Photoshop to do all the tedious, heavy lifting.

At the end of the day, results are what matter. With this technique, you can make an already dramatic image like this:

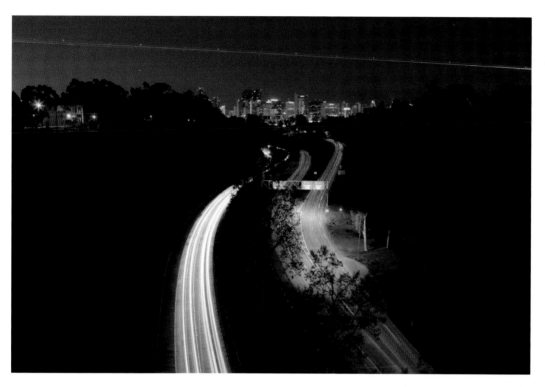

Figure 10-10:
The original night freeway image

look like this:

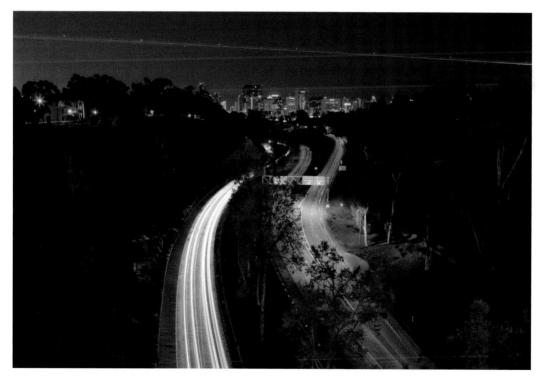

Figure 10-11:
The final result with layering process

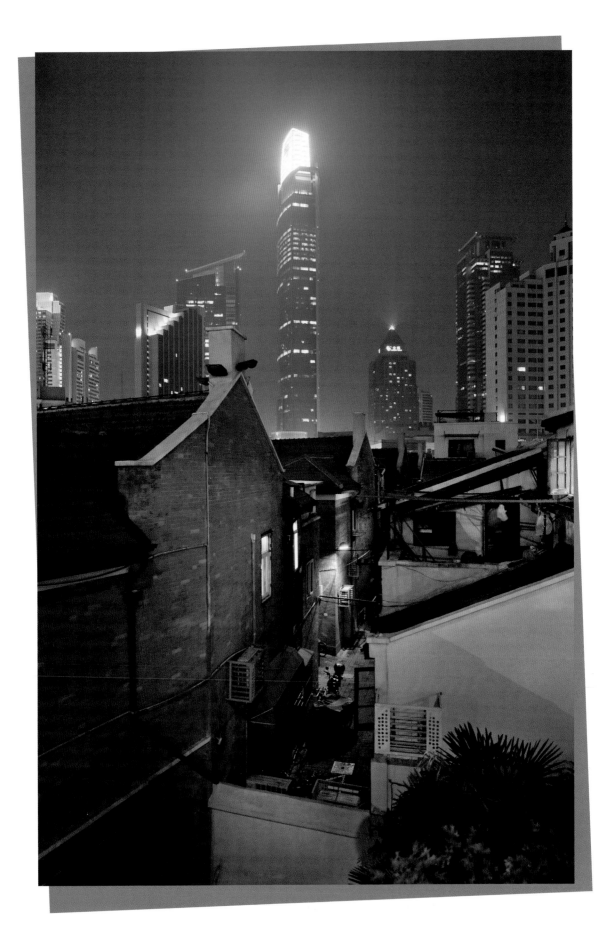

Figure 11-7:
Loading your Smart Sharp Mask

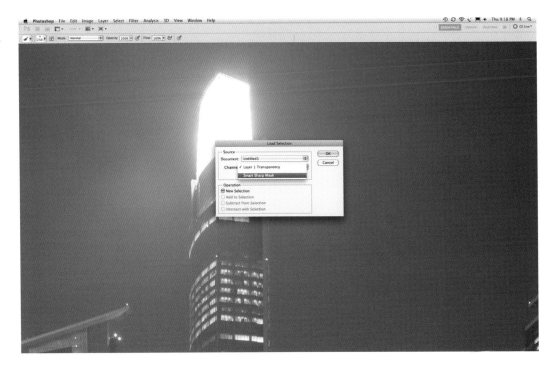

Figure 11-8: *Smart Sharp Mask applied to Summary Layer in final layers dialog*

6. Zoom in to a sharpened area of your image to admire your handiwork. Click the eyeball of the Summary Layer on and off to see the effect.

7. Check the low detail areas to make sure they have not been sharpened. If something was unintentionally sharpened, select the mask and use a brush with black paint to hide the sharpening.

At this point, because you have created a selective, specified sharpening mask, you can create specific changes to the look of your final image. Adobe Photoshop has done most of the heavy lifting, but you remain in charge of the final look without having to give control to the software.

11.4 Smart Sharpening

Now that we have created a detailed channel mask, we can go about sharpening our image:

1. Select your Summary Layer. Zoom in 100 % by pressing Cmnd/Ctrl+0.
2. In the main menu bar, go to Filter > Sharpen > Smart Sharpen.
3. The Smart Sharpen dialog box asks you to select a type of blur to remove (lens, Gaussian, or motion). You can choose whichever one you want, but for the purposes here, choose Gaussian.
4. Check the More Accurate box.
5. Adjust the amount and radius to your liking, while paying close attention to areas in which you want to increase detail. The settings will vary depending on many factors, including inherent file sharpness, file size, and how much sharpening is needed for a given form of output. Experiment with a high amount (100–200 %) and a low radius (0.2–0.6), and vice versa. Take your time.

When you achieve the desired effect, click OK. Avoid oversharpening. See figure 11-6.

6. Rename your Summary Layer to reflect the sharpening formula. For example, we would name this layer SmartSharp 100/.7.

11.5 Applying the Mask

To apply the mask, follow these three steps:

1. With your sharpened and renamed Summary Layer active, go to Select > Load Selection in the main menu bar.
2. Under Channel choose the layer mask you created earlier: Smart Sharp Mask.
3. Click OK. See figure 11-7.
4. A crawling ants selection should now be visible, providing a crude outline of your line drawing.
5. Add a layer mask (bottom of the Layers palette, third icon from the left). Your Layer stack should now look like figure 11-8.

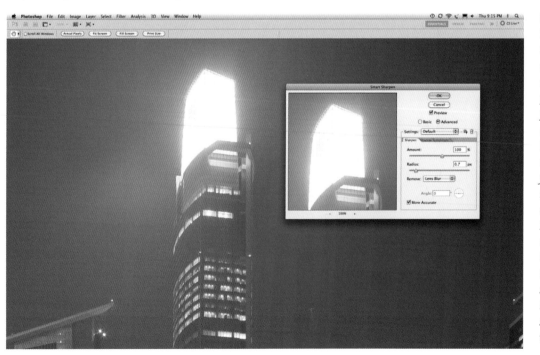

Figure 11-6:
This step is subjective based on your criteria. We recommend that you experiment not only your first time, but on a case-by-case basis. Each image may require a different type of sharpening with different criteria. Because this technique is about controlling the specificity of your sharpening, it can't be applied in the same way each time.

Figure 11-4:

The goal with this technique is to create black-and white line art of your image with very few gray tones. This will help with the selective sharpening of your image. Notice how steep the curve is. The steeper the curve, the more you reduce the gray information between the black-and-white tones.

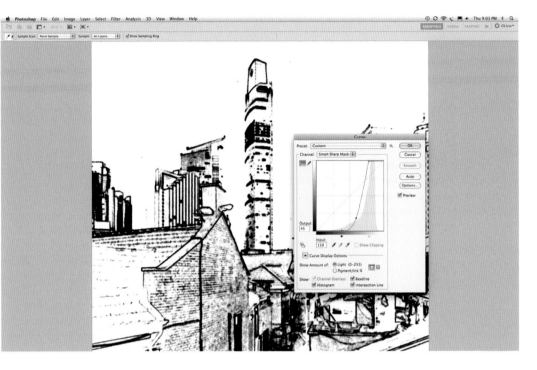

Figure 11-5:

Your inverted line art should look something like this

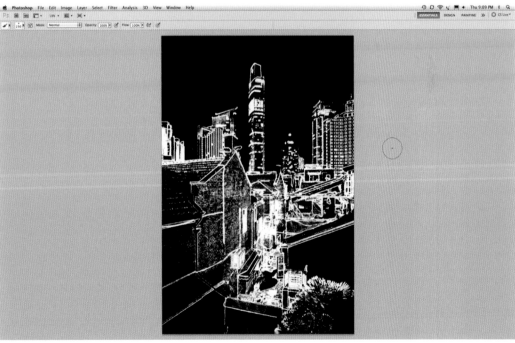

14. Click the RGB channel to reveal your original image and return to your Layers palette.

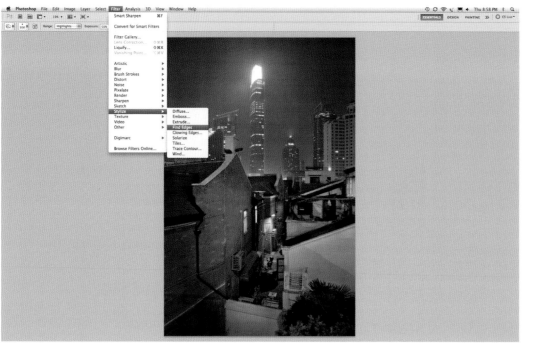

Figure 11-3:
With your Smart Sharp Mask channel selected, follow this path to create your line drawing.

8. In the main menu bar, go to Filter > Blur > Gaussian Blur. Apply a level of blur that will retain the shape of your line drawing while creating a smooth transition to the areas that will not be sharpened.

9. Make sure your Smart Sharp Mask is still active.

10. Press Cmnd/Ctrl+M to open a curve dialog. Adjust your black-and-white points to clean up your line drawing by making it darker and making the light gray areas white:

 a) Move the black point to the right and the white point to the left until you see a line drawing of the main contours of your image.

 b) The white areas will not be sharpened; the dark areas will be sharpened.

 c) The curve adjustment is extremely steep, but don't worry because we really do want only black-and-white tones, with nothing in between. See figure 11-4.

11. If necessary, apply another tone curve to strengthen your lines and clean up the white areas.

 Note: You can experiment with steps 8–10. You may find that changing the sequence of blurring and tone correction will benefit some images. The goal is to get Adobe Photoshop to make the best selection of your edges, without spending a lot of time manually tracing contours you want sharpened.

12. Inspect the line drawing. If you see any gray or black in areas you want to leave unsharpened, simply use a brush with white paint at 100 % to remove it. Conversely, if there are areas you wish to sharpen, use black paint.

13. The last step in the creation of your mask is to invert it. Press Cmnd/Ctrl+I. You should now see a white line drawing on a black mask.

Creating a Summary Layer

To apply sharpening across the entire image without losing the flexibility of having separate layers, create a summary layer that shows all of your changes in one merged layer on top of your existing layers:

1. Make sure all of your contributing layers are visible by turning on the eyeball next to the layer title in the layers dialog box.
2. With the topmost layer selected, press Cmnd /Ctrl+Opt/Alt+Shift+E.
3. This will create a new layer that contains merged information from all your visible layers on top of your stack. Name this layer Summary Layer to avoid confusion.

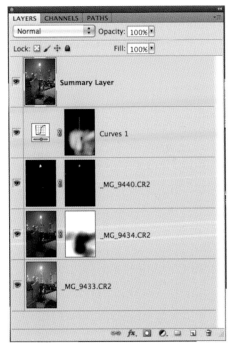

Figure 11-1: *The layers in your dialog box should look something like this after you have created the summary layer.*

Next, create an edge mask:

1. Click the Channels tab and select all of your channels.
2. Press Cmnd/Ctrl+C to copy the contents.
3. Create a new channel by clicking the second icon from the right at the bottom of your Channels palette. The new channel will automatically be named Alpha 1.
4. Rename Alpha 1 to Smart Sharp Mask.
5. Press Cmnd/Ctrl+V to paste the contents. You should see a grayscale version of your image.
6. Press Cmnd/Ctrl+D to deselect it.

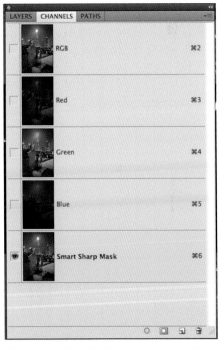

Figure 11-2: *You should have five channels in your Channels dialog box when this step is completed: RGB, Red, Green, Blue, and your new Smart Sharp Mask layer.*

7. In the main menu bar, go to Filter > Stylize > Find Edges. This will convert your grayscale image into a line drawing. (If the contours are faint, run the filter a second time.)

Chapter 11
Selective Smart Sharpening

11.1 Introduction

All digital images captured with a Bayer pattern array, or similar filter array, require some sharpening. Due to the nature of digital capture, discrete details aren't captured in a single pixel site, but are interpolated over several contributing sites. There is also an anti-aliasing filter in front of the imaging sensor, which is intended to reduce the incidence of moiré. In addition, any resizing, distortion correction, horizon leveling, or other global image changes can contribute to perceptual blurring of the original image data.

To correct for that perceptual shift and the limitations of digital capture, images need to be sharpened in post-processing to result in the best possible final image. This chapter deals with the task of sharpening your images selectively, as we did in the previous chapter by selectively expanding the dynamic range of your image. Again, there are more immediate techniques that you can use to sharpen your images on a global scale. There is an entire filter folder in Adobe Photoshop dedicated to just that function, not to mention Adobe Lightroom capabilities and an array of plug-in filters from third-party companies. The process described in this chapter, however, gives you greater individual control and should be used if you want to ensure a more precise and subtle application of sharpening.

To use this technique, we will use the Smart Sharpen function in Adobe Photoshop, but you can use any filter you prefer. Smart Sharpening

is capable of revealing amazing levels of detail; however, despite its intelligence, it is not selective enough. It can improve apparent sharpness in detailed parts of an image, but often at the expense of creating sharpening artifacts in low-detail areas or out-of-focus areas, such as sky, clouds, smooth expanses of skin, or other areas that don't need sharpening. With this method, you can control which areas of the image are sharpened and which are not.

11.2 Proper Workflow Process

Before you begin this process, it's important that you complete all global and local image adjustments. In every case, sharpening should be the last step in your workflow before image output. In fact, it's a good idea to resize your final image for output size before applying sharpening so that you're sharpening the image most closely representing your final product. Of course, you don't want to lose data from a larger image, so this step can be applied to a new file that has been resized for your final output.

11.3 Create an Edge Mask

To demonstrate this technique, we'll use a completed image, shown at the head of this chapter, that has already been through the expanded dynamic range process outlined in chapter 10. It is the result of three combined exposures that is now ready to be sharpened.

Plaza 66 Skyscraper, Shanghai, China © Philipp Scholz Rittermann

Nostalgic US Grant Hotel © Amanda Quintenz-Fiedler

Chapter 12
Black-and-White, Color, or Somewhere in Between?

12.1 Introduction

One of the greatest flexibilities of digital photography is that we don't have to determine exactly the final outcome of our image before we photograph it. We don't have to choose a specific color temperature, we don't have to select our favorite film stock, and we don't need to decide if the image will end up being black-and-white, color, or a mixture of the two. In the film days, you got the best results by choosing that beforehand, and of course with film you can't go from black-and-white to color; even though you can print a black-and-white image from color film, it isn't the best workflow.

With digital photography, you can play around in post-production with fewer constraints. You still need to worry about proper exposure, and it is still a good idea to determine your white balance ahead of time, but the final image can have some flexibility. In this chapter we will look at various iterations and techniques you can use to convert one image to a variety of different images with different appeals.

Figure 12-1 is our starting image, a night shot of the US Grant Hotel in historic downtown San Diego, California.

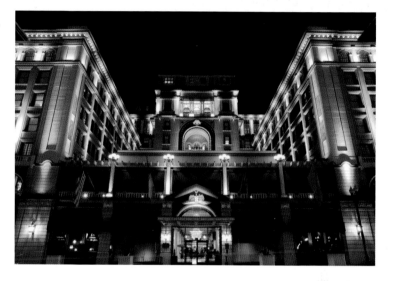

12.2 Black-and-White

There are a variety of wonderful techniques that you can use to make a digital image black-and-white. In fact, there are entire books dedicated to just that process. Here, we are going to look at a few of the most popular techniques.

Adobe Lightroom

Adobe Lightroom has a few wonderful mechanisms to turn a color image to black-and-white. Although there are single-button options that make the job easy, you can explore them on your own. This method gives you more control, but Adobe Lightroom makes it so easy it can hardly be considered an advanced method. That doesn't mean the result won't be excellent.

Figure 12-1:
This original image was a single shot. Basic file management has been applied, but no further work has been done. This is our starting point.

Figure 12-2:
This is the automatic black-and-white conversion from the HSL > Color > B&W tool in Adobe Lightroom

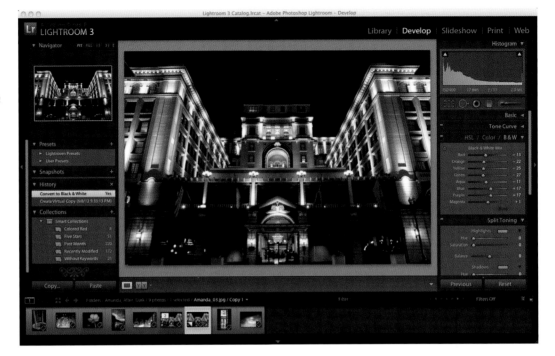

1. With your image selected in Adobe Lightroom, proceed to the Development Module.
2. Scroll down to the HSL > Color > B&W menu, and click on the B&W menu header. This will provide your image with an automatic black-and-white conversion based on Adobe Lightroom's algorithms.
3. You can export this image as your final image, if you love it, but this tool has a lot more flexibility.
4. Within HSL > Color > B&W is a tool that provides more specificity. It is called the Target Adjustment tool, and can be accessed by pressing the double circle button at the top of the menu. When it is selected, notice that two arrows—one above and one below the double circle—appear to indicate that it is active.

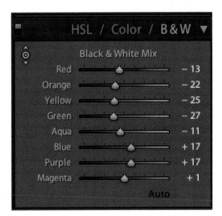

Figure 12-3: *Notice the two arrows that appear around the double circle on the Target Adjustment tool to let you know it is active*

5. What is nice about this tool is it allows you to change specific hues throughout the image to make adjustments based on what you want to accentuate or diminish. I know what you're thinking. There are no hues in a black-and-white image other than the gray scale. You're right, but when you start with a color

image, this tool looks at the base information and makes specific adjustments.

6. If you forget what the original tones are, there is an easy way to go back and forth between your starting image and your black-and-white conversion. Simply press the \ key to switch between the before and after views.

7. For example, in figure 12-4, look at what happens when we use the Target Adjustment tool to increase the blues and decrease the yellows. To increase the blues, we hover the tool over blue in the original image, click, and drag up. To decrease the yellows, we hover the tool over yellow in the original image, click, and drag down. It's that simple, and it makes a huge impact on the image.

8. Now look figure 12-5, and at the difference when we reverse the previous two options—increasing the yellow and decreasing the blue. You can see how this flexibility allows you to make global image modifications in a specific way to get the look you desire.

9. With this tool, you can easily create a variety of looks. Play around and find a look that you like for each image, or stick with a preset or the automatic conversion if you prefer. There is no right answer.

Adobe Photoshop

Adobe Photoshop has some tools that allow you to make instant conversions, but you will have more luck using the tools that allow you to control the image more specifically. Again, there are several methods you can choose from to achieve a variety of results. Here are two good methods.

Channel Conversion

In this method, you have only three choices, but it is a quick way to pick a visually appealing conversion without too much experimentation:

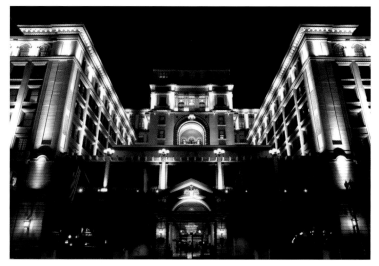

Figure 12-4: *In this version, the blues were brightened, giving dramatic appeal to the lighting on the building.*

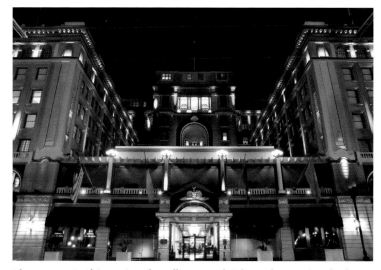

Figure 12-5: *In this version, the yellows were brightened, accenting the front of the building and the awnings and deemphasizing the decorative lighting.*

1. Open your image in Adobe Photoshop and click on the Channels tab in the Layers box. (This is if you have the basic window setup for CS5. If not, you can find Channels under Windows > Channels.)

2. In the Channels tab, you will see four channels: RGB, Red, Green, and Blue. The RGB channel is the composite of all the information in your image, so it is in color. The other three channels are black-and-white representations of the specific map of each channel color throughout the image. The areas where there is a high instance of that color appear white, and the areas where there is a low instance appear black.

3. In this method, your three choices are the Red, Green, and Blue Channel information. You can't manipulate them like you could with the Adobe Lightroom method, but this is a quick and dirty way to get the best of three choices. See figure 12-6.

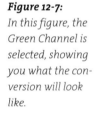

Figure 12-6: *Notice the different appearances of the image in the Red, Green, and Blue Channel thumbnails, and notice how the RGB Channel is the original image.*

4. To previsualize your conversion, just click on one Channel at a time and see how it changes your image.

5. To apply the Channel information to the whole image, pick your favorite and select the information in the Channel by pressing Cmnd/Ctrl+A, Cmnd/Ctrl+C. This will select and copy all information in that Channel. The marching ants will show you that the information is selected. See figure 12-7.

Figure 12-7:
In this figure, the Green Channel is selected, showing you what the conversion will look like.

6. Reselect the Composite Channel. It is important that you select the composite Channel, not just turn on the eyeball. Make sure that all four Channels are highlighted blue before proceeding.

 Note: It is a common mistake to turn on the eyeball of the Composite Channel without selecting it. If you do this, when you paste the copied information back into the image, you will be pasting it over the selected Channel, which will have no affect on the overall image and won't function as a conversion (refer to figure 12-6 on the previous page). So be sure to select the Composite Channel!

7. Return to the Layers tab and press Cmnd /Ctrl+V to paste the copied information as a new layer on top of your background. You have achieved a black-and-white conversion of your image.

8. Name this layer with the color you have chosen to keep things straight. For this instance, we used the Green Channel, so we gave it that name.

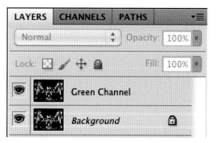

Figure 12-8: *When you return to the Layers Palette, the new pasted information will appear converted in the thumbnail view. We named this layer according to the conversion technique we used.*

9. For our image, to follow are the three options.

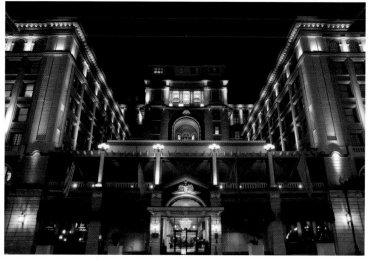

Figure 12-9: *Red Channel black-and-white conversion*

Figure 12-10: *Green Channel black-and-white conversion*

Figure 12-11: *Blue Channel black-and-white conversion*

Black-and-White Adjustment Layer

For more control in Adobe Photoshop, you can use the Black-and-White Adjustment tool. It has similar functionality to the Adobe Lightroom tool, with some important differences:

Figure 12-12: *Shortcut from the Adjustments Tab to create a Black-and-White Adjustment layer*

1. To access this Black-and-White Adjustment tool, select the Black-and-White Adjustment Layer shortcut in the Adjustments box. (This will create a separate adjustment layer so you will not lose any of your base image information in this conversion.) See figure 12-12.
2. You should see a Black-and-White Adjustment Layer dialog box with a Default Preset selected for your conversion.
3. You'll notice that you have different hue choices, as you did with Adobe Lightroom, but in this option there is no Target Adjustment tool, so you have to adjust these manually based on what you remember of the image. There is a quick preview function that you can turn on and off to review the colors in the base image.

4. What is really helpful about this tool, though, is that there are several presets that mimic black-and-white contrast filters from the film era. These are wonderful quick starts; you can select the one that gets you closest to the look you are going for and make custom adjustments after you've selected your favorite preset. See figure 12-13.
5. There are too many choices to print here, but you can see the vast differences you can achieve with these presets without much work. You also have the option of creating and saving a custom preset. See Figures 12-14 and 12-15 on the next page for examples.

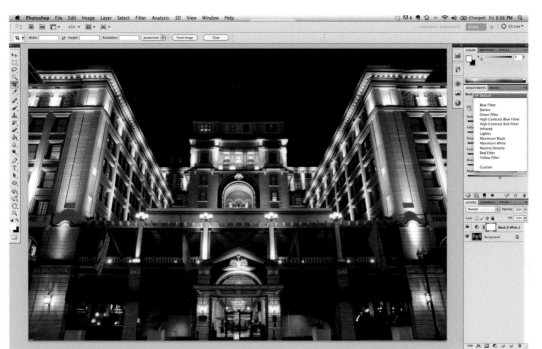

Figure 12-13:
In this example, the Default preset is selected, but you can see the list of other presets in the upper right corner and the option to create a custom preset. Any customizations you make can be saved as a custom preset.

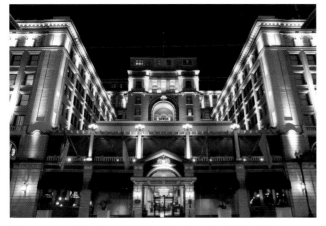

Figure 12-14: *Black-and-White Adjustment with the Maximum White preset and no other adjustments*

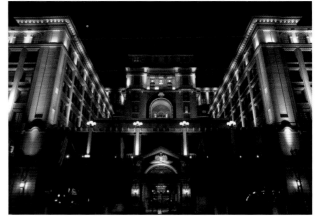

Figure 12-15: *Black-and-White Adjustment with the Maximum Black preset and no other adjustments*

Nik Software Silver Efex Pro 2

In addition to the possibilities with Adobe Lightroom and Adobe Photoshop, there are some great plug-ins that specialize in black-and-white conversions. Obviously this is an additional expense to your software library, but in some cases the options are well worth the purchase price.

One of the best is a plug-in by Nik Software called Silver Efex Pro 2. This plug-in provides you with options not only for one-click solutions,

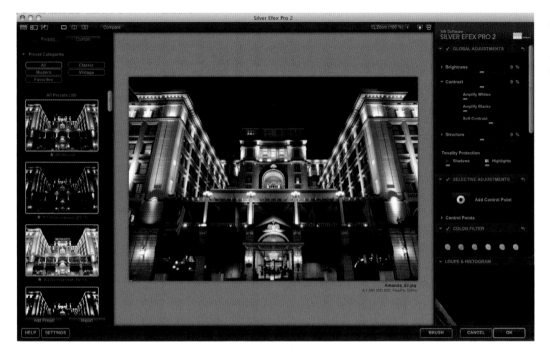

Figure 12-16:
The Nik Software Silver Efex Pro 2 dialog box

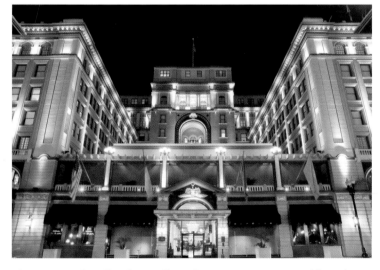

Figure 12-17: *The Nik Software Silver Efex Pro 2 002 Overexposed (EV +1) filter applied to the image*

but also the flexibility to start with one preset and adjust your image based on your desired outcome.

To use Silver Efex Pro 2, you need to have the plug-in available in Adobe Photoshop or Lightroom. Open your image and simply click on Silver Efex Pro 2. When the plug-in is open, you have a variety of options to choose from as presets. You can also add a color filter; amplify whites or blacks individually; or adjust contrast, brightness, structure, and shadows or highlights globally. Nik Software also has a function called Control Points that allows you to locally adjust areas of your image, starting with selecting a base point and modifying it, and then applying it to all other areas in the image that meet the original Control Point criteria. The algorithms that Nik Software have created are phenomenal, and they can give you some of the most beautiful black-and-white versions of your image. See figure 12-16.

Figure 12-17 is an unmodified version of the 002 Overexposed (EV +1) preset, but the possibilities are endless.

12.3 Color

There are plenty of reasons to make a color final image instead of a black-and-white one. If you choose to pursue a color image, your initial RAW file management will be the same as in chapter 9, but you can do a couple of things to enhance certain colors in your image to make more of a statement. In this section, it's all about the color.

Adobe Lightroom

Adobe Lightroom can be as flexible with modifying the color in your images as it is with customizing your black-and-white conversions. This can be done using the same tools. The HSL > Color > B&W tool can enhance or diminish any color scheme throughout your image in the same way it changes the overall appearance of the black-and-white conversion in B&W mode. Remember, though, these are global changes, so you don't have much flexibility with one area over another.

1. Open your image in the Adobe Lightroom Develop module and scroll down to the HSL > Color > B&W tool.
2. With the Target Adjustment tool selected, raise or lower the hue, saturation, or luminance of a set of image criteria by clicking the tool and dragging it up or down. See figure 12-18.
3. Of course, you still have all the basic modifications available to you in Adobe Lightroom; this just gives you control over a subset of information. It isn't exactly local, but it is more specific than a truly global modification.

Adobe Photoshop

There are so many capabilities in Adobe Photoshop that it's impossible to incorporate all of them here. To change the color in your image

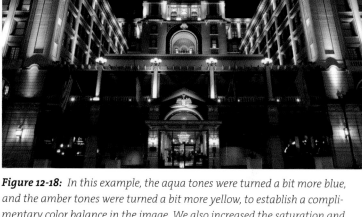

Figure 12-18: In this example, the aqua tones were turned a bit more blue, and the amber tones were turned a bit more yellow, to establish a complimentary color balance in the image. We also increased the saturation and luminance of the blues and decreased the saturation and luminance of the yellows to bring out the details in the hotel.

you could use a curves adjustment layer, a hue/saturation layer, a selective color adjustment layer, or individualized local adjustments with brushes, stamps, layer masks, or an entire host of other possibilities. So instead of discussing a specific set of tools, let's discuss a good workflow:

1. When you make adjustments to an image in Adobe Photoshop, start with the largest file size you will ever use. In general, we suggest using the native data size so you can scale down if necessary, but not lose too much data if you need to scale up. By contrast, if you were to start with a small file and decide later to scale up, you will have lost a good deal of your details because a smaller file can't hold on to them. No matter how good an interpolation algorithm is, it can't create lost detail.
2. As soon as you open your file, create a duplicate layer of the background so you will

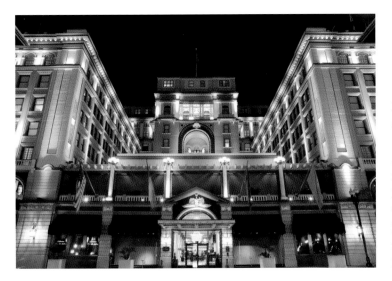

Figure 12-19:
In this example we used a filter called Contrast Color Range to enhance the inherent contrast between the blues and yellows without losing detail or blowing out the highlights.

always have your native data to go back to if something goes horribly wrong. You can do this with the shortcut Cmnd/Ctrl+J.

3. For every other adjustment you make, use a separate layer. This will make your files much larger, but it also allows you to return to any function that you have performed and tweak it. If you modify only one layer, you can't go backwards after you close and reopen the file. So to maintain control over your image, use layers.

4. To really get the appropriate functionality out of step 3, you should save your files as layered TIFF or PSD. Both of these formats allow you to save layered information in lossless formats. This is good for keeping your work accessible to future changes.

5. Resize your image before you sharpen it for your final product. If you sharpen your image at 16x20 and then resize it to 8x10, the sharpening won't have the same effect. It is always a good idea to resize before you sharpen or print any image.

6. Don't be afraid to experiment. The nice thing about layers is they allow you to redo a step, try a new method, or flip back and forth between a black-and-white conversion and the original color image to see what you like best.

But that doesn't mean the experimentation has to start and stop with your post-production. The best way to become a better photographer is to get out there and photograph.

Nik Software Color Efex Pro 3.0 Complete and Viveza 2

As previously mentioned, there are a lot of plug-ins out there that do amazing things. It just so happens that Nik Software has two other tools that are great for color modifications. Color Efex Pro 3.0 Complete and Viveza 2 allow different approaches to modifying color images. Both tools are user friendly and have a ton of capabilities, so we recommend playing around with them. In this section we will demonstrate a brief adjustment to our base image using both of these plug-ins, but, again, the possibilities are limitless. There is only one downside to this software. After you complete a specific function, it can't be accessed again in the same way as with an Adjustment Layer, so be sure you like the result before you accept it. Any filters you use will be placed in your image as a new layer, though, so you do have the option of going back and starting over if you need to.

Color Efex Pro 3.0 Complete

When you open Color Efex Pro 3.0 Complete you have many different options, each of which must be handled individually. Unlike Silver Efex Pro 2, Color Efex Pro 3.0 Complete has a menu of overall filters that you can apply, and each of them will open a separate adjustment window.

There are several view options within the software that allow you to track your progress, and a loupe in the bottom right corner allows you to see an enlarged area of your image and how the filter will affect it. As you play around with the filters, you'll see that multiple filters can be used on one image to create a unique look. See figure 12-19.

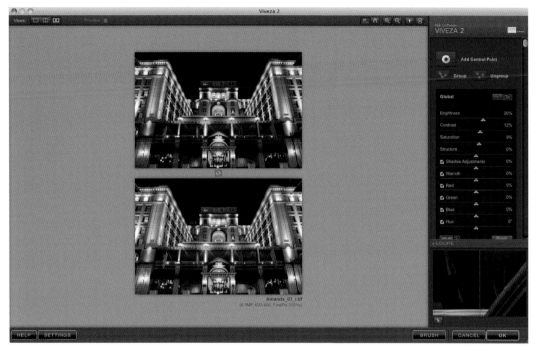

Figure 12-20:
The Viveza 2
working window

Viveza 2

Viveza 2 functions more like Silver Efex Pro 2 in the sense that you can make multiple adjustments to the image at one time and not have to select multiple filters to get to the final product. It also has the functionality of Control Points, which allow you to modify the image more specifically:

1. When you enter Viveza 2, you can make the same types of global changes we've seen in Adobe Lightroom and Adobe Photoshop, though of course they will be different because the algorithms are not the same. But the functionality and ease of use and understanding will get you started.
2. The plug-in opens a new window with a variety of preview options. In this option, the old image is on top, and the modified image is below. See figure 12-20.
3. Make a variety of global changes first to enhance your overall image.
4. When you like the global look, use the Control Point function to go into specific areas to bring out details, control highlights and shadows, or modify something more specific that you couldn't do with the global approach.
5. The more Control Points you add, the more control you have over the final image.
6. When you are done, simply click OK, and Viveza 2 will apply your changes in a new layer on top of your background layer.

Figure 12-21: *Viveza 2 will create a new layer on top of your background with your modifications. This is not an adjustment layer, so you cannot go back into these Viveza 2 modifications.*

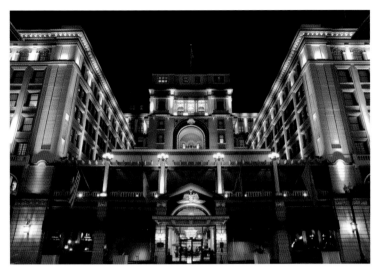

Figure 12-22: *In this example we first adjusted the overall brightness, contrast, and saturation, and then we used Control Points on the aqua areas to make them a little more blue, reduce the aqua brightness to get the highlights back, and add structure to clarify some of the blue areas.*

12.4 Somewhere in Between

Another capability of digital photography is that you don't necessarily have to choose between presenting your image in color or in black-and-white. You can find something in between. There are a variety of reasons to do this—you can accentuate a certain color, give an overall ambiance to the image, or make an image look antique or space age. All of this can be done with a specific approach to how you introduce color to your image, or how you don't.

Adobe Lightroom

As we have already discussed at length in this chapter, Adobe Lightroom is helpful for making broad, global adjustments to your image. The technique described here is no different. Because of that, we won't adjust specific areas of the image—we'll leave that to Adobe Photoshop. Instead, we'll play around with the ultimate look of the image in a reduced color palette:

1. We'll open our image in the Develop Module in Adobe Lightroom and scroll down to the Split Toning tool.
2. In this particular image, we already have two strong colors, so we will use them to create a new look that is somewhere between color and monochrome.
3. To get started, we need to change the image to black-and-white. Do this by clicking on the B&W header in the tool above Split Toning.
4. Next, we need to select our highlight color. In general, warm tones work well as highlight colors, so we will choose a hue that is as close to the yellow tones as possible. Click on the colored box next to the word *Highlight* and select the starting color that is closest to your desired tone, then fine-tune it with the color palette provided. (To pick a color, you can go back and forth between your black-and-white image and the base image by pressing the \ key.) See figure 12-23.
5. Now we need to select a shadow color. We will use the blue of the base image to create it. Click on the colored box next to the word *Shadow* and select the starting color that is closest to your desired tone, then fine-tune it with the color palette provided. See figure 12-24.
6. Although this image is different than the original, and the tonalities in many places have actually been switched, it is a fun two-color version of the image that references the antique and historical value of the US Grant Hotel and also pays homage to the actual tones in the base image. See figure 12-25.

Figure 12-23:
We selected the highlight tonality by eye to match the base image amber tones as closely as possible.

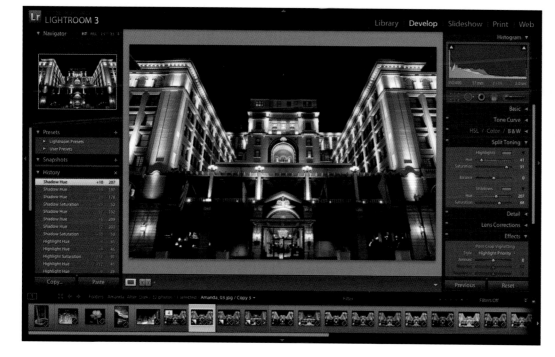

Figure 12-24:
We also selected the shadow tonality by eye to match the base image aqua tones as closely as possible.

Figure 12-25:
In the final version of this image, the two-toned look gives an antique feel to the photograph.

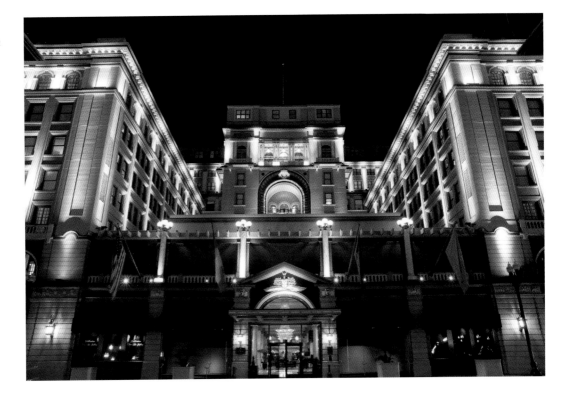

Adobe Photoshop

Adobe Photoshop is where we can really play around with what color we want to reveal and what color we want to conceal in our final image. We are going to use the flexibility and precision of layers to start with our two favorite images—one color and one black-and-white—and layer them to create a final image that is a perfect hybrid between color and black-and-white:

1. Open your favorite black-and-white and favorite color versions of the same image in Adobe Photoshop.
2. With the black-and-white image selected, drag the background layer of that image into the color image, hold down the Shift key, and release the layer. This will create a new layer in your color image that contains your black-and-white image. Though it should be obvious, we are going to name them Color and B&W.

Figure 12-26: *The two images are joined into a single image with two layers.*

3. Turn off the eyeball for the B&W layer.
4. In the Selection menu, choose Color Range.
5. Select the color you want to accentuate. In this case, we choose the blue tones. Drag the fuzziness slider up until most of those tones are selected without contaminating the selection with other colors. See figure 12-27.

Figure 12-27: *A midrange blue was chosen and the fuzziness was adjusted until most of the tones are highlighted in the Color Range selection box.*

6. Select OK.
7. Turn the B&W layer eyeball on, select the layer, and create a layer mask on the B&W layer.

8. Press Cmnd/Ctrl+I to invert the mask and reveal the dominant color. See figure 12-28.
9. Now drag the Opacity slider on the B&W layer down slowly until a little bit of the secondary colors come into the image. (You can do this by clicking on the word *Opacity* in the layers dialog box and dragging to the left. Drag to the right to increase the opacity.)

Figure 12-29: *Adjusting the opacity of the B&W layer will allow more of the color of the base image to come through in the final image.*

Figure 12-28:
With the Color Range selection mask inverted, the selected blue tones are the only color on the black-and-white image.

Figure 12-30: *With this image, the final opacity of the B&W layer was set at 60%.*

10. The resulting image should have some bright tones and some subdued tones that fall somewhere between a full color image and a black-and-white image.

The overall point of this chapter is that you shouldn't feel trapped by how you captured your image, but rather you are free to explore a number of different ways to realize your vision. Mix and match the techniques listed here and play around with other plug-ins and new advances. Any one of the black-and-white conversion methods and color adjustments described in this chapter could be used as the starting point for this type of hybrid image. The only limitation is your imagination.

Food Vendor and LED Trees, Grand Canal Park, Weishan, Jining, Shandong Province, China
© Philipp Scholz Rittermann

Chapter 13

Panoramic HDR Imaging at Night

13.1 Introduction

Throughout this text we have built on the basic tenets of exposure, control, predictability, and repetition. Creating crisp images that mimic your original vision for the scene involves a precise application of all the techniques we have brought to the table. If you have tried all of these techniques as we hope, you undoubtedly experienced the difficulty in maintaining perfect stability for your multiple images and saw the effects of one slight bump of the tripod. In other words, you probably had to start at square one, at least a couple of times, to get one clean set of images to put together.

When you are successful with this technique, you can create beautiful, detailed images with a wide range of tonalities in either black-and-white or color. You can reveal the tiny intricacies of the deepest shadows and control the brilliance of highlights without losing the surrounding interest of the scene. It takes a great deal of control, patience, and experience to execute these images consistently, not to mention countless hours of night and low-light trekking.

As complex as this process is, however, you can always add another level to create a new challenge. Philipp Scholz Rittermann is no stranger to these challenges, and after a career of photographing all sorts of night and low-light work around the globe, it struck him that it might be interesting to photograph certain scenes as panoramas at night.

13.2 Panoramic Photography

First let's talk about panoramic photography. As we have already discussed, in digital photography you are not limited to the confines of a single capture in creating your final image. We have shown this with our expanded dynamic range images, but there is a photographic tool in Adobe Photoshop, and in additional plug-ins, called stitching. When you stich two images together, the program looks for areas where those images share the same information—for example, the same tree on the same horizon that is on the left of one image and the right of another. The program then creates one larger image composed of the two initial images. This is a powerful tool because it allows you to not only create a larger image of the scene (both file size and physical size), but you can also capture an undistorted version of a panoramic scene that might not otherwise be visible in a single capture.

The Possibilities

The software that handles stitching is powerful enough to try to find components that are similar in two or more images and link them together with cropping, rotating, and elimination of ghosted elements (one element that looks different in both images, such as a flag moving in the wind), but stitching is most accurately completed when the original images were carefully captured by rotating the head of a stable tripod. Sound familiar?

The Images

In this set of images, Philipp took panoramic shots at night. Each contributing image was a single shot, but multiple images were used with the stitching method to create wider, larger images. These are some examples of how you can create stitched images at night.

Moored Barges at Yuejin Port, Grand Canal, Jining, Shandong Province, China © Philipp Scholz Rittermann

Dusk View from Jingang Bridge, Tianjin City, China © Philipp Scholz Rittermann

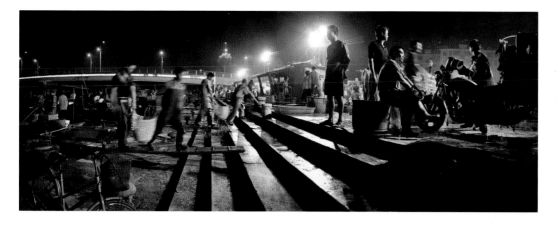

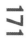

Off-Loading Fish,
Live Fish Market,
Grand Canal, Wuxi,
Jiangsu Province,
China © Philipp
Scholz Rittermann

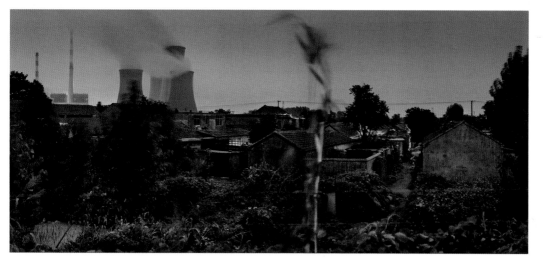

Residential Neigh-
borhood & Coal-
Fired Power Plant,
Jining, Shandong
Province, China ©
Philipp Scholz
Rittermann

13.3 Panoramic HDR Imaging

If you are comfortable with shooting panoramic images and stitching them together, and shooting a widely bracketed range of night shots then using a high dynamic range compositing method to create one image, why not try to do both at once?

Most people would answer, because that's crazy. It is a ton of work, with possibly dozens of final contributing images to a single scene, and if even one of those images is shot inaccurately, the whole scene is bust. But others, like Philipp, see it as the greatest night and low-light photography challenge.

Let's emphasize that again. These images are a *challenge*. Think about everything you have done to get that perfect HDR image, and now multiply that by the number of panoramic frames that you would like to capture. If you multiply your three HDR images by your four panoramic images, you'll create one image from 12 contributing photographs. And now control each of those exactly.

On top of that, the scene has to be unchanging. Notice we have titled this chapter "Panoramic HDR Imaging at Night." If you try to start this process at sunset, the light will have changed too much between sets to create a fluid final image. Where, and *when,* you choose to set

San Diego Bay & Coronado Bridge, San Diego, California © Philipp Scholz Rittermann

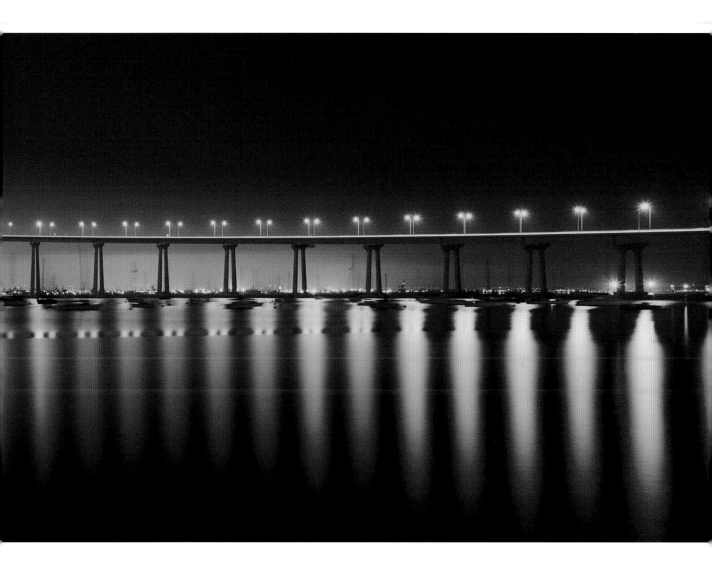

up for some of these images will greatly impact the final result. So if you do decide to try something like this, do a little scouting before you try to create your masterpiece. That doesn't mean you have to be in the desert away from all contributing light sources, it just means that you need a stable enough environment for repeatable lighting in each set of HDR images.

If each phase of your HDR images isn't exact—precise exposure, unwavering framing, and consistent focus—then your final image will have flaws. In our previous HDR process, there is a little wiggle room. If you want a five-stop range, you can have exposures of approximately 1 minute, 2 minutes, 4 minutes, and so on. If you want to create a panorama of those images after capture, there is no wiggle room. Now it must be exactly 1 minute, 2 minutes, 4 minutes, and so on. And it needs to be exact in each frame; and your focus has to be the same; and all your images must be turned into individual HDR images that can be used to create one giant panoramic image. It's a tall order for control and precision.

The Possibilities

The goal of this final chapter isn't to teach you another technique, but rather to expand your mind to the possibilities. What you are capable of doing with your digital photography is entirely up to you. You don't need us to hold your hands anymore. If you want to try this process, go and try it! Try something else! Be creative and bold and don't limit yourself. Philipp didn't, and we think the results are amazing.

The Images

Here are some examples of Philipp's panoramic HDR images at night. With Philipp's HDR work, he uses a minimum of three images. With these panoramic images he has used up to 48 single captures to create one composited final.

Zaochuanchang Bridge under Construction, Grand Canal, Jining, Shandong Province, China © Philipp Scholz Rittermann

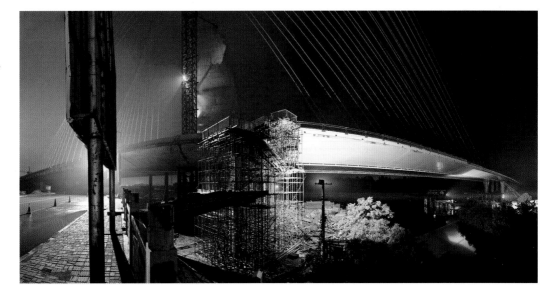

*Residential Neighborhood & Coal-Fired Power Plant, **Dezhou, Shandong Province, China** © Philipp Scholz Rittermann*

*Midnight on the Williamsburg Bridge, **New York, New York** © Philipp Scholz Rittermann*

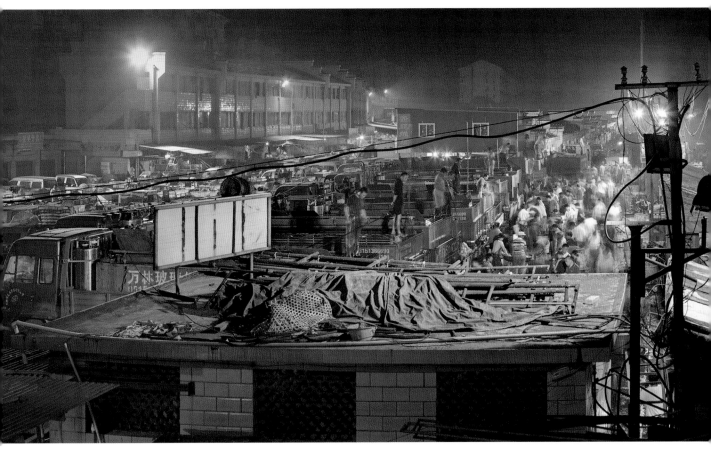

Overview, Night Fish Market, Grand Canal, Wuxi, Jiangsu Province, China © Philipp Scholz Rittermann

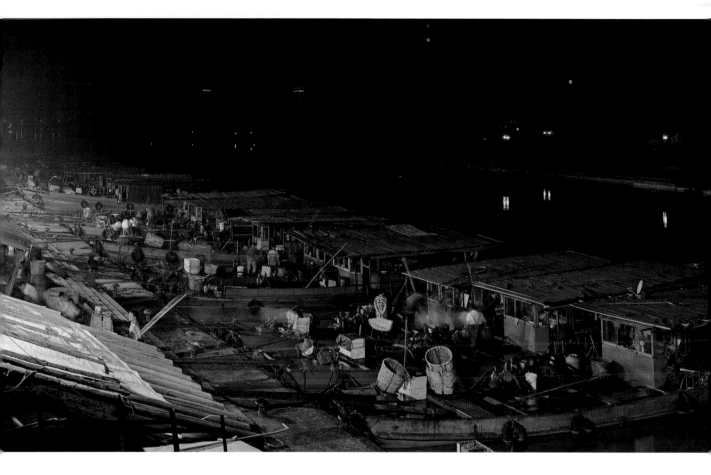

Night Construction,
Historic Building
and High-Rise
Apartments,
Changzhou, Jiangsu
Province, China
© Philipp Scholz
Rittermann

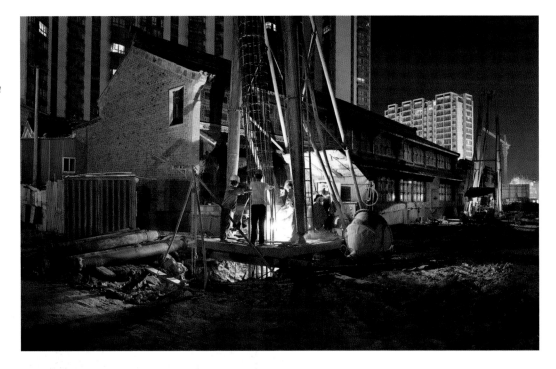

Welder, Night
Construction,
Changzhou, Jiangsu
Province, China
© Philipp Scholz
Rittermann

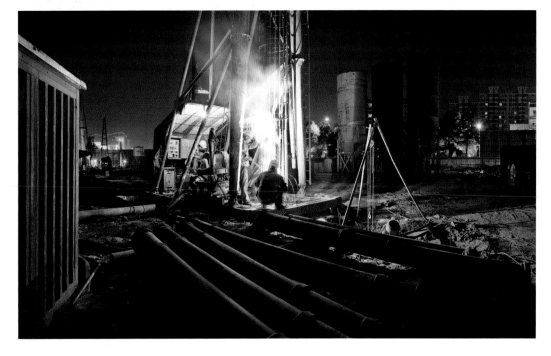

Conclusion

Indeed, at the end of the day, the world is different. Before this journey, you may have approached everything about your life in patterns, and for most of us, that meant winding down, settling in, and taking stock of the day. But we hope to have shown you something new, something you haven't seen before, something just beyond the circle of light and outside your comfort zone. In that blissful unknown is a world waiting to be discovered and photographed. Full of subtle colors, impossible lighting, and fluid time, night photography creates something truly unique. Through the lens we can see the impossible. With patience and mastery, we can create tapestries of nightlife full of vivid detail. At the end of the day, your skills will be put to the test. At the end of the day, our day begins.

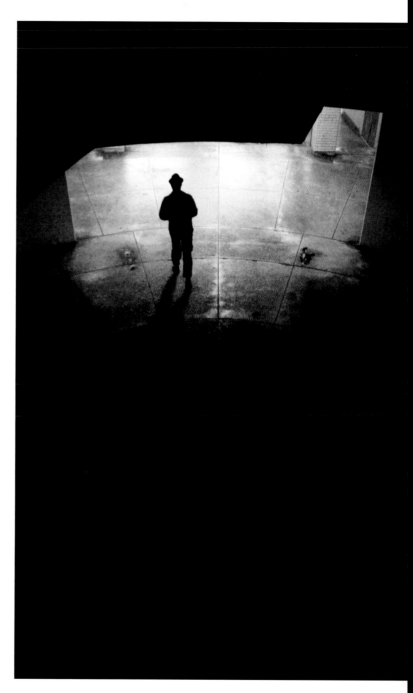

© Michael Penn

Index